PHOTO PORTFOLIO SUCCESS

JOHN KAPLAN

WRITER'S
DIGEST
BOOKS

CINCINNATI, OHIO
www.writersdigest.com

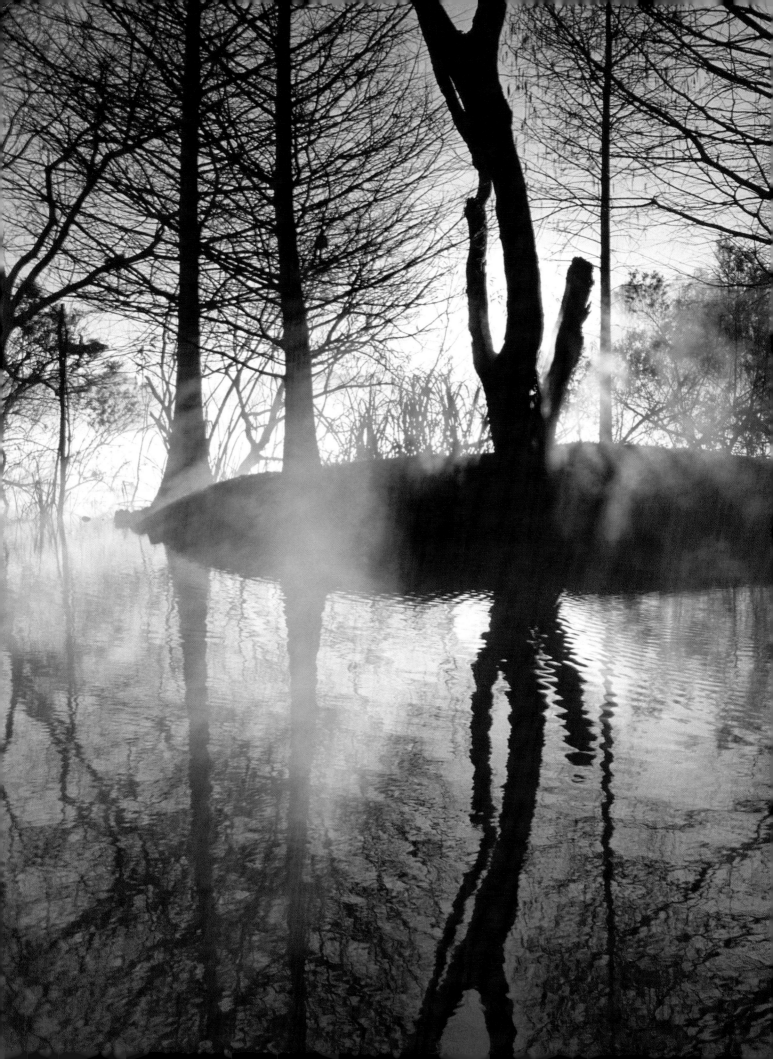

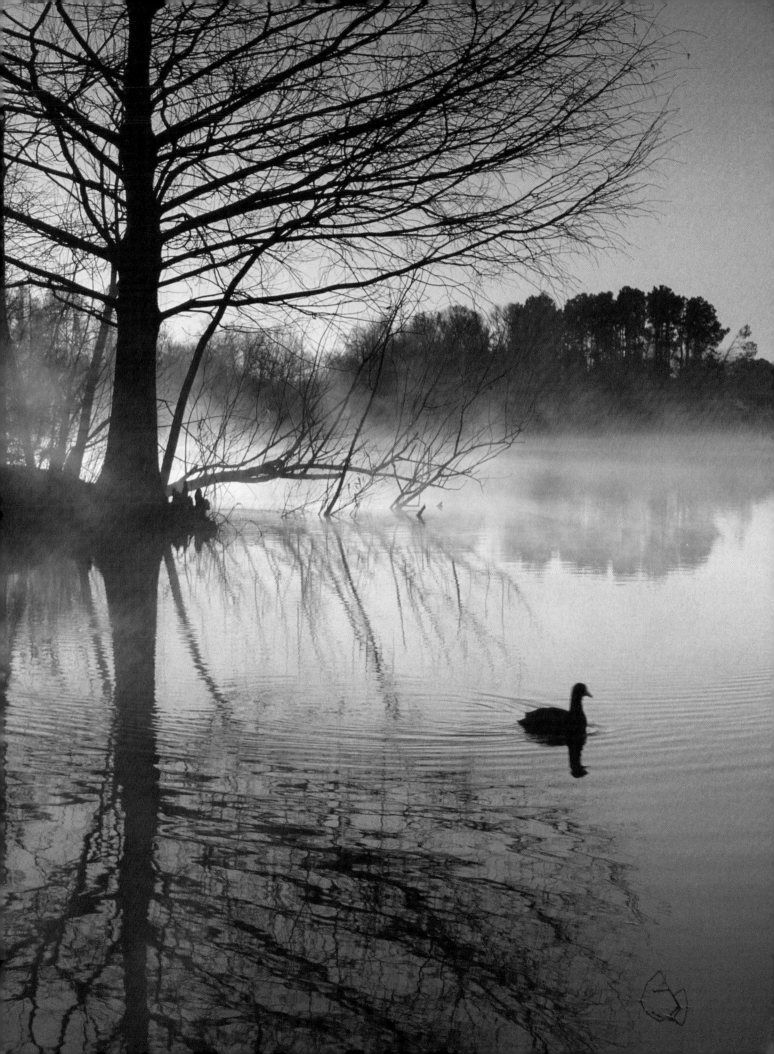

> > **ACKNOWLEDGMENTS** Thanks to editors Jerry Jackson, Brad Crawford, Jack Heffron, and Donna Poehner; art director Brian Roeth; and all of the inspiring photographers, educators, editors, and agents who generously shared work and wisdom. Thanks also for allowing me to show outtakes as well as your best photographs as teaching examples. < <

COVER PHOTOGRAPHER | J. Kyle Keener

PHOTO ON PAGES 2-3 | Florida's Lake Alice by nature photographer John Moran.

PHOTO ON PAGE 6 | © Natalie Fobes

Visit our Web site at www.writersdigest.com for more information and resources for writers.

Other fine Writer's Digest Books are available from your local bookstore or direct from the publisher.

07 06 05 04 03 5 4 3 2 1

Cataloging-in-Publication data is available from the Library of Congress at <http://catalog.loc.gov>.

EDITOR: Jerry Jackson Jr.
DESIGNER: Brian Roeth
INTERIOR LAYOUT ARTIST: Karla Baker
PRODUCTION COORDINATOR: Michelle Ruberg

© David Spencer

table of contents

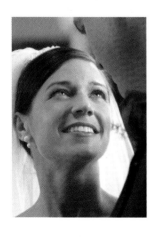

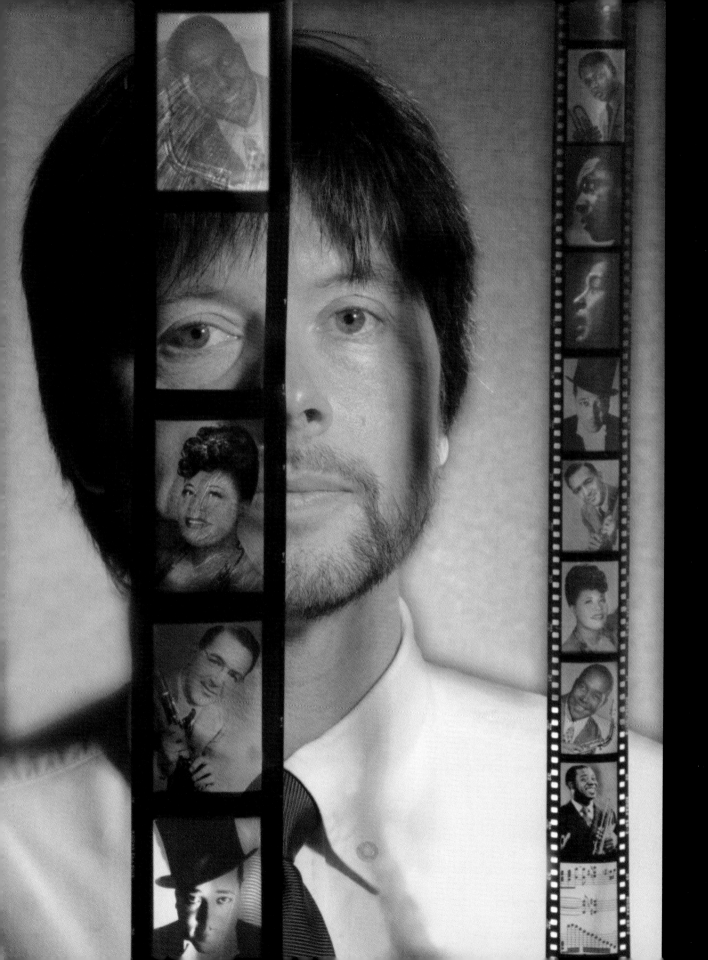

I have been asked to look at hundreds of photographers' portfolios over the years and I always try to provide worthwhile feedback and advice. If I had to make an overall generalization about the variety of work that I see, one thing is abundantly clear: Photographers love what we do.

Writer James Thurber once created a character, Walter Mitty, who was stuck in a boring office job and mundane life. As he looked out his window and day-dreamed, Mitty could only fantasize about being an airplane pilot, a sports hero or a mountain climber. He knew his dreams would never be realized and retreated into a world of fantasy.

As a working photographer, I have been able to witness all of those things and more. For most people stuck behind a desk, it would be an absolutely implausible idea that a photographer on the sidelines of the Super Bowl or backstage at a fashion show surrounded by the world's top models might actually think of such activities as "work." A camera truly does open doors to the great wonders of the world.

Whenever I feel frustrated with my creative growth or career direction, and all creative people invariably do at times, I am reminded that I actually get paid to take pictures. Seasoned photographers sometimes forget there are few other jobs on earth that offer the rewards and freedom of photography. When I have my camera in hand, I truly feel lucky. Every now and then, I think that a grand mistake must have been made somewhere up in heaven; some wise soul actually thinks I am deserving of making a very good living simply by holding a camera viewfinder up to my face. The most difficult decision in my world may simply be when to click the shutter.

As joyful as making a living through photography can be, we all know that it is also an extremely difficult and demanding craft and indeed not as simple as it may seem on the surface. Anything that can be this much fun is bound to generate the interest of lots of other folks who want to do it, too. Competition to land the best jobs and assignments has never been stronger. The strength of your portfolio is the absolute key to landing the assignment, job, or exhibition of your dreams. Your portfolio can also be instrumental to the peace of mind that comes with the often-elusive goal of finding job satisfaction.

Ken Burns by J. Kyle Keener

overview >>

Photographers with a great eye are many.
But photographers with a great portfolio are few.

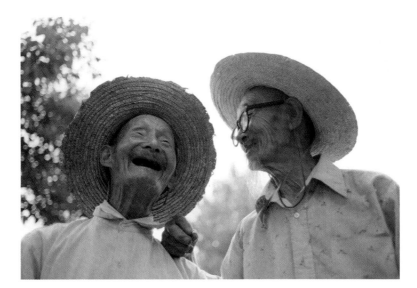

Always be willing to wait for the moment. After shooting three rolls of portraits of the 82-year-old at right in a small Chinese village, his 84-year-old uncle wandered by. That's when the real picture happened.

When it comes to portfolios, the biggest cliché is also the one that is most true: "Your portfolio is only as good as its weakest image." I don't know why exactly, but when art directors, picture editors, curators, and contest judges look at portfolios, the process is an inherently negative one. Portfolios are not selected based on their strengths; they are instead eliminated based on weaknesses. When someone looks at your work, it is invariably a process of comparison, of weeding out the competition until a final choice rises to the top. No matter what genre of photography you hope to work in, whether you are trying to land a freelance assignment or have applied for a job, your work will always be scrutinized for its faults.

It is not that the people looking at the pictures are themselves negative; the process of elimination involves removing portfolios based on why they are not liked as well as others. I have witnessed this phenomenon virtually every time, even as a Pulitzer Prize judge.

I have served as a judge for many of the top awards in photography, worked as a corporate hiring consultant, and as a professor asked to review student applications. Quite often, the process involves evaluation by a committee. Together, the committee has to make the difficult choice of deciding which work is deemed the favorite. In a process of compromise, portfolios are usually eliminated until one rises to the top not based on why particular images are superb but because of which pictures are not as good as they could be. Sometimes, the portfolio ultimately chosen as the best does not hit the highest of the high notes that others may, but always has a consistent and confidence-inducing quality about it.

What can we learn from this? First of all, do not believe that since weaknesses are scrutinized, good pictures do not count. Of course

PHOTO AT RIGHT | In one of the world's most remote regions, I made a grab shot of a Tibetan peasant dressed in animal skins tending to her grandson. A 300mm lens isolates the moment. As you edit your portfolio, look for variety in angle, composition, and perspective.

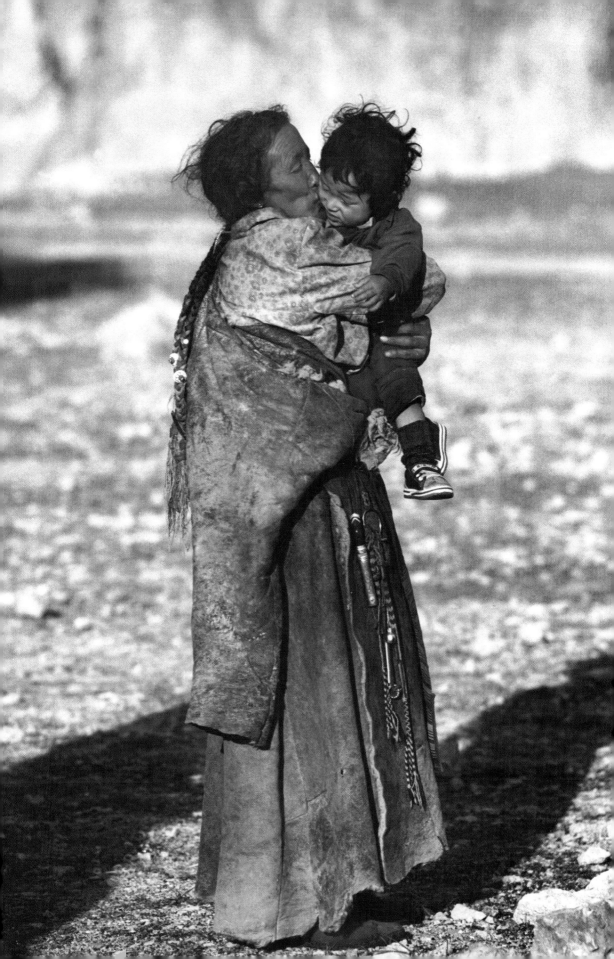

they do. If an editor can no longer pick apart your weaknesses because of smart and succinct editing, he or she will instead start to admire the marvelous photos you have worked so hard to capture. Second, eliminate all perceived weaknesses from your portfolio and instead submit a tightly focused body of work.

The tips and guidelines to follow will help you reach the next level and get your portfolio noticed:

FIND SOME HELP

Whether you are an aspiring professional, student, advanced amateur, or experienced pro, it is my hope that this book will help you on the path to a satisfying and truly successful future in photography. Remember, it is hard to be good at what you do if you are not sure what "good" really means in the area you aspire to excel in.

Even though competition has never been more intense in the photo world, in my opinion, the professionals who are truly "the best" are more than willing to provide a helping hand to others. It is important that you find out who are the absolute top shooters in your hometown and also in the overall field of photography that you most admire. Go to workshops and conventions and join professional organizations, even if you do not intend to become a full-time pro. Find a way to meet such people and hope that in addition to being

YOUR BEST MOVE

"Show your work and get feedback. Don't ever pass up on a good opportunity."

RUTH ADAMS
Photographer, Educator

great shooters, they still remember that they, too, had plenty of help on the way up. Even though each photographer ultimately has to make it on his own, the photographic field is truly a community.

When I was a rebellious fourteen-year-old in my hometown of Wilmington, Delaware, my mother, the newspaper's art critic, decided it best to keep me out of trouble by bringing me down to the paper on weekends. I started hanging around the photographers, going on assignments, and carefully watching how they worked. They sometimes even allowed me to shoot alongside them and we later compared our work over the light table. Before long, my photography was beginning to mature and my pictures were being published and winning contests as well.

I had no idea at the time just how good those photographers really were. To me, they were just nice folks at my hometown newspaper. Three of them, including Jodi Cobb, Bill Ballenberg, and Kevin Fleming, went on to coveted assignments at *National Geographic*. Two others, Pat Crowe and Fred Comegys, became National Photographers of the Year, an award that I was fortunate to later win as well. They were all great shooters, but truly great in that they were willing to take the time to provide honest advice and constructive criticism. Like the process of osmosis, I was able to eventually rise to their level simply by spending time with them, by being allowed to see their work ethic in action, and by believing that I, too, could shoot

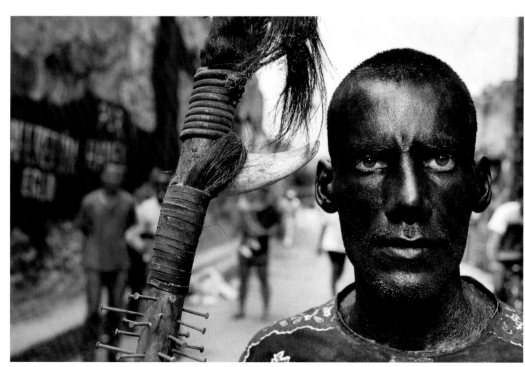

Whatever your specialty, portraiture can be a vital portfolio component. When working abroad, I look for portraits that capture what makes a culture unique. In Cuba, I found "Egun," who represents a spirit of the Santeria faith.

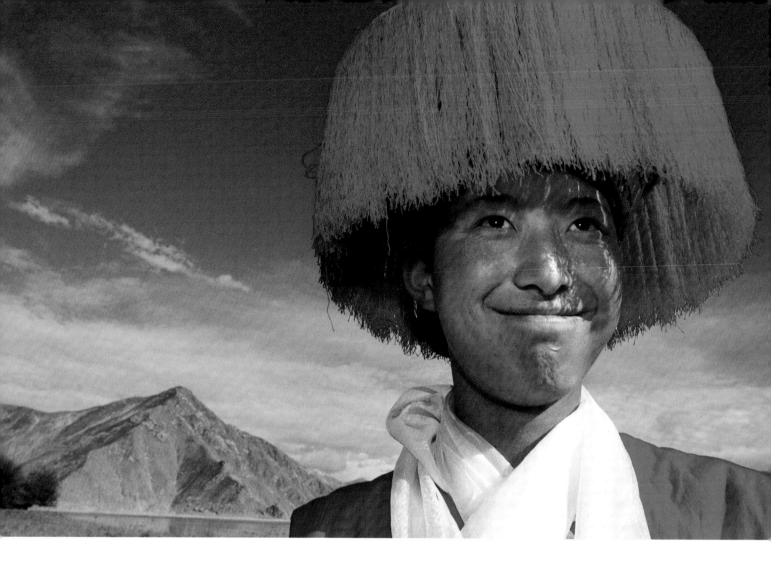

passionately to make great photographs.

Not everyone is as generous as my mentors were. We have all experienced the disappointment of being rebuffed when asking for portfolio feedback. Do not give up! Talented people are also busy people. However, if you are polite and persistent and keep trying, you are bound to find a great shooter willing to lend you a hand.

KNOW YOUR COMPETITION

I tell the college students I teach not to become too comfortable in comparing themselves to their immediate competition around campus. Upon graduation, an undergraduate's peer group suddenly changes from other eighteen- to twenty-two-year-olds to everyone aged twenty-two and up. It is good to know that your work ranks high among your closest peers but it is important to understand that peers are actually everyone at the highest level of photography. A soon-to-be photojournalist quickly learns the daunting truth that he or she has James Nachtwey and Sebastio Salgado as standard bearers just as a nature shooter might ask, "How can I ever make pictures like Jim Brandenburg or Art Wolfe?"

My suggestion is to not be intimidated.

Believe that you are worthy, talented, and absolutely able to make great images. To do so, you have to believe in yourself and become a student of the craft. Surround yourself with books of photographs. Rather than admire a great photo from afar, scrutinize it carefully. What lens could it have been made with? What direction is the light source coming from? What time of day was it likely taken? Where was the photographer standing (or crouching, or even lying on the ground) when she took it? Did the picture require any special access for the photographer to have been able to take it?

When you can analyze how pictures you love were made, it is not difficult to make the jump toward taking similar ones. And soon, your work will no longer imitate but will take on a style all its own as you naturally concentrate more on communication and less on mechanics.

Knowing your competition means knowing the level of the very best in the business and how they have achieved success. Whatever your skill level, join organizations such as American

Like many pros, I often underexpose for color saturation. For this portrait of a Tibetan horseman before a race, I popped in a very slight amount of fill flash to add "catch light" in his eyes.

YOUR BIGGEST MISTAKE

"Don't be afraid to show your portfolio to those you admire. Be willing to take criticism."

BRIAN PLONKA
Photographer

For a picture to go beyond routine and be portfolio worthy, seasoned pros suggest carefully considering light and composition. I visited this spot on three occasions in the "sweet light" just before sunset before finding a situation that brought the right elements together.

professional organizations

Find a sponsor and try to join if you are not yet a full-time pro. Most organizations have state and local chapters, too.

COMMERCIAL:

Advertising Photographers of America (APA)
www.apanational.org
For advertising freelancers.

American Society of Media Photographers (ASMP)
www.asmp.org
For commercial and magazine free-lancers.

Editorial Photographers (EP)
www.editorialphotographers.com
For all freelancers who sell their work in editorial markets.

Professional Photographers of America (PPA)
www.ppa.com
For professional photographers and imaging specialists.

Also see listing in this section for **Photo Imaging Educators Association**, which is for students at any level in all areas of photography.

WEDDING:

Wedding and Portrait Photographers International (WPPI)
www.wppi-online.com
For wedding and commercial portrait specialists.

Also see listing above for **Professional Photographers of America**, which includes many wedding photographers.

NATURE AND WILDLIFE:

North American Nature Photographers Association (NANPA)
www.nanpa.org
For nature and wildlife photographers.

Nature Photographers Network (NPN)
www.naturephotographers.net
For nature and wildlife photographers.

PHOTOJOURNALISM:

National Press Photographers Association (NPPA)
www.nppa.org
For photojournalists, picture editors, and multimedia specialists.

Also see listings above for **American Society of Media Photographers and Editorial Photographers**, which include editorial photographers who shoot for magazines, wire services, and other media.

FINE ART AND EXHIBITION:

Society for Photographic Education (SPE)
www.spenational.org
For university fine art and documentary photography students and teachers.

College Art Association (CAA)
www.collegeart.org
For photographers and other artists at the college level, including instructors.

Photo Imaging Educators Association (PIEA)
www.pieapma.org
For fine art and documentary photography students and educators at the elementary, junior high, middle, senior high, or university levels.

National Association of Independent Artists (NAIA)
www.naia-artists.org
For photographers and other artists who display their work at arts festivals and fairs.

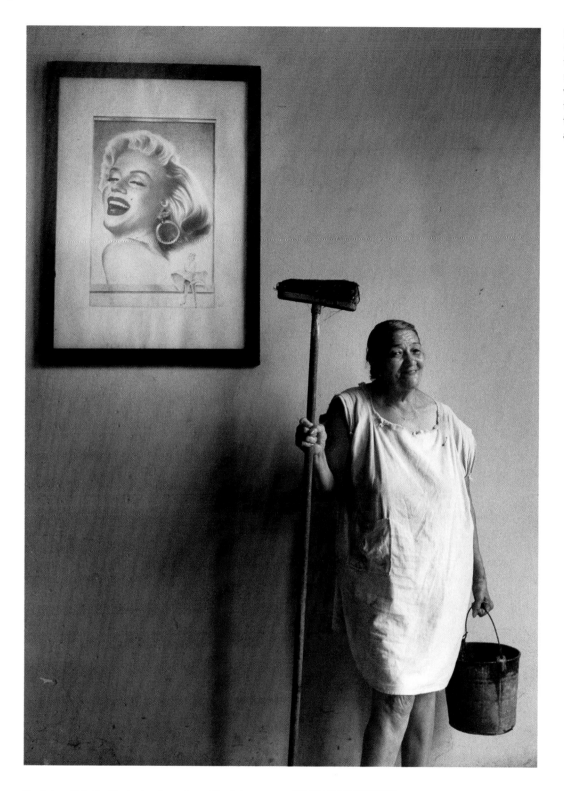

For editorial portfolios, or even in advertising, a touch of irony can be a nice addition. For this window light portrait, I found a Cuban housewife to be every bit as radiant as Marilyn Monroe.

Society of Media Photographers for editorial shooters, Wedding and Portrait Photographers International for wedding photographers, Society for Photographic Education for fine art photographers, National Press Photographers Association for photojournalists or North American Nature Photographers Association for nature and wildlife specialists. Local camera clubs are also a terrific way to network and refine your talents.

GO TO WORKSHOPS

We all go through creative peaks and valleys; workshops and conferences are great for being exposed to new ideas and recharging your batteries. They're also invaluable for facilitating networking and offering portfolio reviews with leading photographers. I encourage you to take as many as you can afford. Many offer student and reduced rates for those not able to pay full tuition.

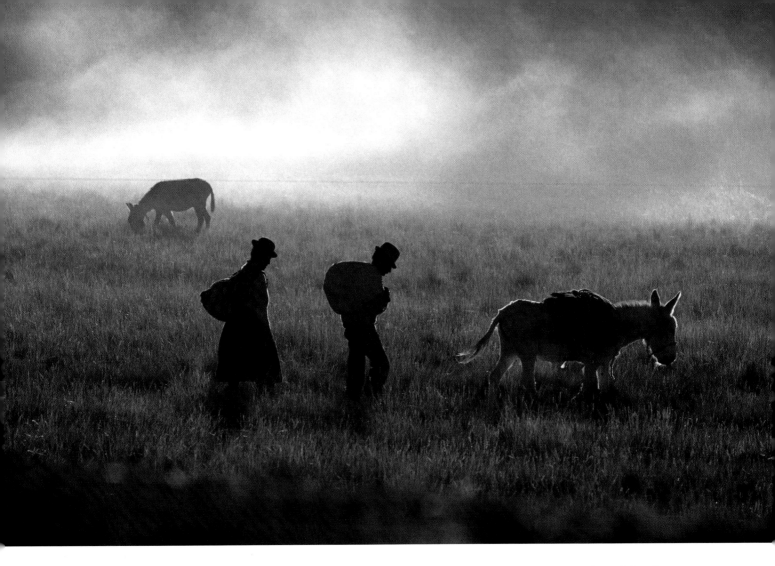

Like other editorial shooters, I know that scenics are always in demand by clients. Pictorials are key elements in nature and wildlife as well as photojournalism portfolios. On Bolivia's Isla del Sol, known for its legendary mysticism, "Mystic Journey" captures peasants at sunset through the smoke of the autumn harvest.

YOUR BIGGEST MISTAKE

"A huge mistake is to confuse somebody by putting a lot of unrelated material in the book."

GEORGE WATSON
Photographers Rep
President, Society of Photographers
and Artists Representatives

(*See the workshops index at the back of book on page 158.*)

If you attend meetings or workshops to improve your skills, and thus your portfolio, I realize that it is not always easy to show personal work to strangers. It can be intimidating to walk into a room filled with accomplished photographers that you do not yet know. Photographers are often mistakenly thought of as extroverts. After all, it is the photographer who is seen marching up and down the sidelines of the football game or bantering with models at a fashion shoot. If you are like me, your camera might actually be a healthy crutch to help you overcome your natural human shyness. After all, with a camera in your hand, you have a reason to be in an environment that you might not ordinarily feel comfortable in.

Some photographers find it difficult to show their portfolio for fear of negative comments. My best suggestion is to go for it! You have many reasons to feel good about the strengths of your work. Remember that any criticism you

may hear is not a criticism of you; it is only a subjective commentary on the relative merits of your images.

When it comes to competition, the most important thing to remember is to only compete with yourself. You cannot control what others do or how they shoot. Contests can be good motivators but are inherently subjective. Five different judges will often yield five different winners. Go ahead and enter them but have the fortitude to follow your own personal sense of vision. Do not chase the style of others. To get a more true barometer of your growth, at the end of each year gather your best work and compare it to what you shot the year before as well as your overall portfolio. Chances are you will see noticeable improvement.

KNOW WHEN TO CUT AN IMAGE

By the time you have shown your portfolio to enough people, you will quickly realize just how subjective the process can be. Some will love an image that others will tell you to cut. Such widely differing feedback can be confusing and in the end, your portfolio must be a reflection of your personal vision and what you are trying to com-

municate about the world through your photography. However, if everyone you show your portfolio to thinks a particular image needs to be cut, then by all means, take it out.

Photographers take great pride in their efforts and can be stubborn about editing their own work. Just as any good broker will tell you not to fall in love with a particular stock, do not make the mistake of falling in love with a particular image. What can happen is that a photographer internalizes the experience of shooting and confuses the effort involved with the picture itself.

For example, when I was in college, I took a photo of Senator Edward Kennedy. I was so proud of the effort it took to gain access to him that I was blinded to the fact that the picture itself was nothing special. The editors I showed my portfolio to had seen hundreds of Associated Press pictures of him. They knew my image was routine. But, as a young photographer, I needed to accept the fact that it really was not a portfolio shot. Pictures of celebrities need to be much better than a routine shot to merit placement in a portfolio. A famous face is not enough.

Another photographer I knew in school took great pride in taping a camera rigged with a remote to the wing of a vintage airplane. The resulting picture was good but not at all unusual and it took years for him to pull it out of his portfolio because he still had fond recollections of how hard he worked to get the shot.

KNOW YOUR CLIENT

Getting in the door is never easy but when you finally do, you must first know the client's needs and desires. There is no point in attempting to show a portfolio filled with work that is not the type used by the organization in question. If you show the wrong type of work, your chances of ever being invited back are slim. Photographers who land top jobs, assignments, and exhibitions are the ones who submit work that contains the right style and content.

How do you know the client? If it is a publication, take a look at several issues. Notice both style and substance. General interest magazines such as *Life* are no longer with us and today's picture editors are looking for images that fit a specific demographic niche.

For editorial photographers, walk in the door not only with a portfolio filled with images that the publication would be likely to use, but also with story ideas. There are many photographers out there but very few good idea people.

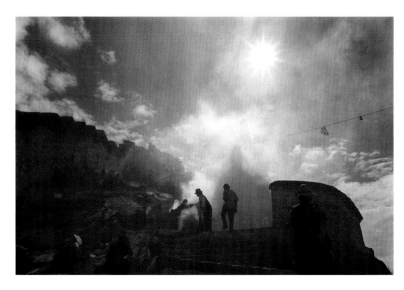

I crouched for two hours in wafting smoke to try to capture the reverence that Tibetans feel for one of their most holy shrines, Potala Palace, the Dalai Lama's former home. Many Tibetans save their entire lives to be able to visit it.

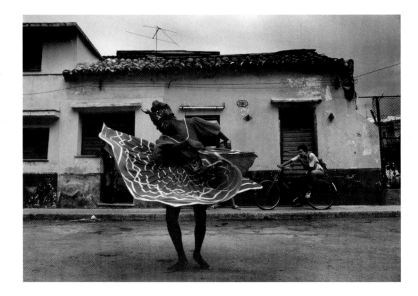

Any editor knows how to assign to obtain great images but always needs help in fleshing out relevant story ideas. A good idea is often rewarded with an assignment. Books such as *Photographer's Market* are also a strong source for background information on publications and which types of pictures they seek.

For commercial shooters, art directors are subjective in their tastes and value a variety of approaches. If your portfolio impresses with a cohesive vision, when a job opens up that is right for your style, you are likely to get a call.

For fine art photographers, curators want to see a point of view, a strong artist statement, and a pointed group of photos that convey an aesthetic message. Many gallery owners will evaluate work based on their ability to sell it, since

Cluttered backgrounds are portfolio killers. When photographing in complex surroundings, I look for ways to clean up the composition. Although this Cuban folk dancer was moving quickly, her profiled face helps add interest to the photo.

Every photographer needs an online portfolio. A producer for PBS found my Cuban work through a Web search, leading to a nice surprise—a profile and interview on the Bill Moyers NOW program.

galleries survive through print sales.

For wedding photographers, the client is not a professional but instead a couple wanting to remember their most important day. Be sure that your portfolio contains upbeat and pleasing images with all of the elements that families want to see.

CREATE DIFFERENT PORTFOLIOS FOR DIFFERENT NEEDS

Good writers know never to mix their metaphors and photographers should also not mix radically different styles in the same portfolio. For example, a commercial product photographer may also aspire to do fashion work. Because art directors and buyers seek out specialists with highly specific and stylized approaches, you may hurt your chances of being hired by showing too much diversity. If you want to pursue more than one type of photographic work, and many do to help pay the bills, build a minimum of two distinct portfolios. If you are able to show your portfolio in a face-to-face meeting, it never hurts to bring along the second in case the art director assigns a variety of types of projects.

Similarly, many photojournalists make ends meet by doing weddings on the side. Weddings often pay better and the spontaneous "shoot from the hip" style now in vogue fits well with the way they like to work. But wedding clients and picture editors will each be confused if you mix the two types of work in the same portfolio. A picture editor is likely to question your dedication to the mission of photojournalism if you too eagerly show that you spend your free time doing something completely different. A bride and groom only want to see a wedding portfolio and sample album, not unrelated work.

NEVER SETTLE FOR LESS THAN EXCELLENCE

All photographers have strengths and weaknesses. Do you know yours? Some shooters have a naturally gifted eye but may perhaps need help with organizational or technical skills. Others may be detail- and equipment-oriented but not as naturally creative with composition or the ability to build rapport with their subjects. Of the famous photographers in the world, it is a safe

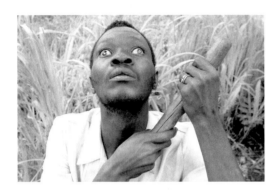

assumption to make that some are "left-brained" and others "right-brained." Whatever your natural predilection, you absolutely have the potential for greatness. Use your innate strengths to your advantage and be honest with yourself about weaknesses and how you may improve in ways that can make you a more effective photographer.

Most importantly, believe in yourself! Each and every shooter is capable of great work if he is willing to work toward excellence. When shooting, have patience and wait for the moment. Arrive early and stay late. Take the safe shot first and then dare to be innovative. Try to spend enough time with your subjects so they become comfortable with your presence; that is when the real moments will begin to happen.

It is a fact that plenty of photographers have a great eye and a collection of dazzling images. But a collection is not a portfolio. Know how to package your work for maximum impact and to build confidence in those who have the privilege of seeing your fine images. If you follow at least some of the advice in the chapters to follow, you will have a leg up on the rest of the pack by taking the time to consider the all important impression made by your portfolio.

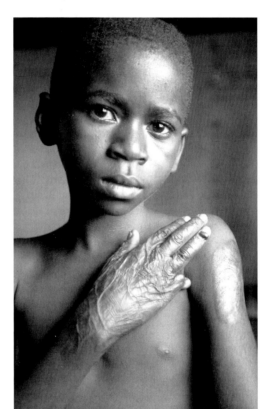

When a photographer produces a body of work in an entirely different style, it's often best to make a separate portfolio for it. My work on torture survivors in West Africa was packaged and distributed by French picture agency Cosmos in a ring bound portfolio.

A similar portfolio that I put together was awarded the 2003 Overseas Press Club Award for feature photography.

For more about digitally composited portfolios, see chapter 4.

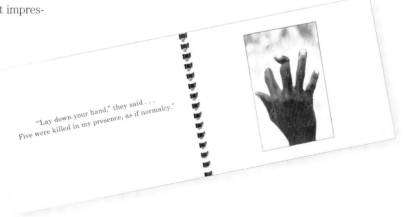

"'Lay down your hand," they said . . .
Five were killed in my presence, as if normalcy."

edit to win >>

*Learn how to edit your work with impact and build a portfolio
that emphasizes your strengths while eliminating weaknesses.*

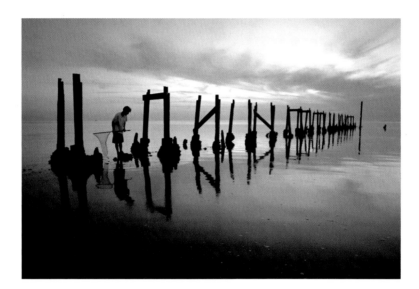

Like many nature photographers, Carlton Ward has more than one portfolio. His shot of a fisherman at dusk would be a strong addition to a commercial nature and wildlife portfolio as well as for an editorial version on environmental photojournalism. These days, nature portfolios often include human elements, too.

Few photographers possess the perfect portfolio. Each has gaps or at least minor short-comings. The trick is to captivate the viewer with your best stuff so he or she will not notice what may be missing. This is perhaps the most important chapter of the book—follow my step-by-step editing procedure as a sure-fire way to produce a portfolio that will wow those who see it. Before we get to the mechanics of the editing process, let us consider the needs of the people you hope to impress.

Smart picture editing means understanding the psychology and motivations of your viewer. Those who will be looking at your photographs are usually working professionals with plenty of demanding projects in front of them and rarely enough time to complete them. At the same time, your goal as a photographer is to get noticed, to receive helpful feedback, and to find work, whether it is an assignment, exhibition, or even a fulltime job. Your portfolio needs organ-ized and cohesive packaging. Without the need for words, it should present a clear, visual repre-sentation of who you are, your photographic intent and consistency in your shooting. This is not to say that accompanying written materials are not important—if your photographs first grab attention and communicate on a primary level, your viewer may later spend time reading the captions or bio.

With the exception of a fine art presenta-tion, avoid an overtly intellectual approach. Your pictures should first communicate viscerally. No viewer should have to guess at the kind of work you do, nor the intended meaning of images. Captions can help explain the context of an image but should never be used as a crutch to justify why a picture is important or special.

By first doing research and knowing the needs of your client, you can decide whether a customized presentation is merited. Some images that work well for a local audience might

PHOTO AT RIGHT | The famous "Yellow Woman" photo of a New York office worker fleeing the September 11, 2001 disaster is instantly recognizable. The picture tells it all and will stand the test of time in the portfolio of Agence France-Presse photojournalist Stan Honda. It will be remembered as one of the very best photos taken on that dark day.

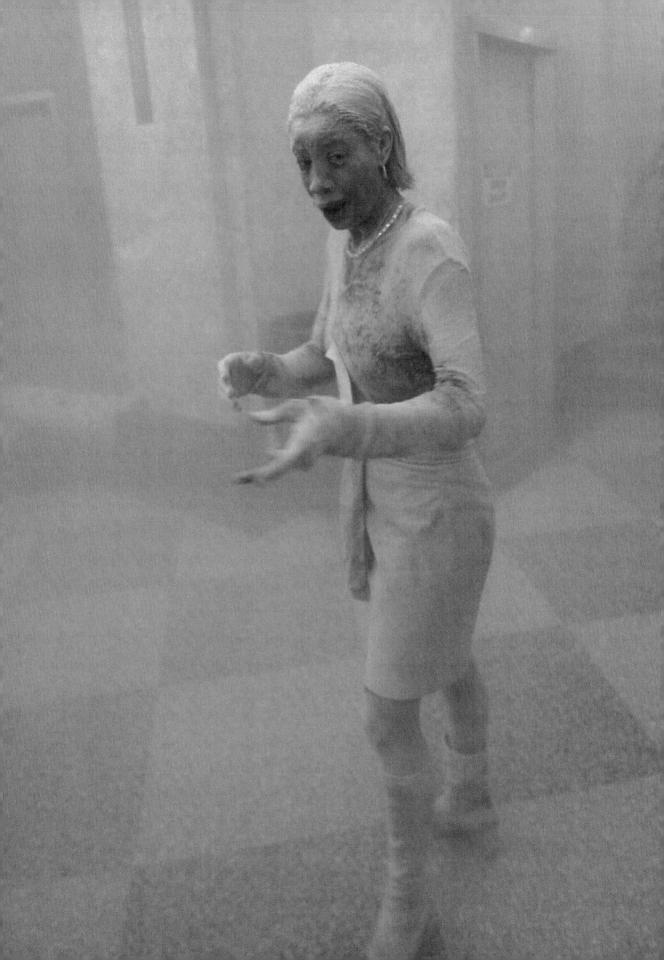

mystify a picture editor in another state. For example, a photojournalist may have covered an important local controversy such as the resignation of the mayor over a political scandal. Gaining access and shooting a photo of her cleaning out her desk would likely be easy to comprehend by local readers who know the story. For anyone else, the photo might seem to be a routine picture of any office worker. It's a good idea to get feedback from someone you trust who knows nothing of the context of particular situations captured. You will then have a better idea whether a particular picture is good enough to stand on its own in your portfolio.

UNDERSTAND THE MOTIVATIONS OF THE VIEWER

Be objective and try to look at your own portfolio through the eyes of another. Avoid the fatal mistake of falling in love with your own work. Consider the concept of ego. All successful photographers need to possess just the right amount and if you have spent time around other shooters you may have met a few who possess just a bit too much. Ego should not be thought of as a bad word; without any you would have no motivation whatsoever and would cease to be an individual, essential traits in creative people. Just the right

amount will ensure that you take pride in doing a job right, never settling for less than excellence and always having the tenacity necessary to convince others that your work is worthy. Egomaniacs are blinded to the needs of others and are so self-possessed that they often self-destruct, eventually turning off even their closest supporters. Self-confidence is usually a positive trait but we know that a picture is not good just because a photographer says it is.

To be successful, your portfolio must help someone else solve a problem. Subconsciously, the viewer will not make a value judgment on whether or not your portfolio is good; he or she will decide if the portfolio can be of help to them. The relative success of a particular image is an abstract concept. A picture is not successful simply because one wills it to be. You may hear a blanket statement about why viewers like or dislike your portfolio, or part of it, but what is truly important to them is whether it can be useful.

If you are able to take a healthy amount of your ego out of the editing process, you will be left with a stellar body of work that communicates clearly. Advanced photographers understand how to communicate on a primary level as well as how to convey personal vision and secondary meaning on more subtle levels.

A commercial portfolio should show a mastery of light and strong technique. Master photographer J. Kyle Keener decided not to pursue the big money lure of a freelance career in New York because he enjoys the freedom allowed by his full-time *Detroit Free Press* studio job.

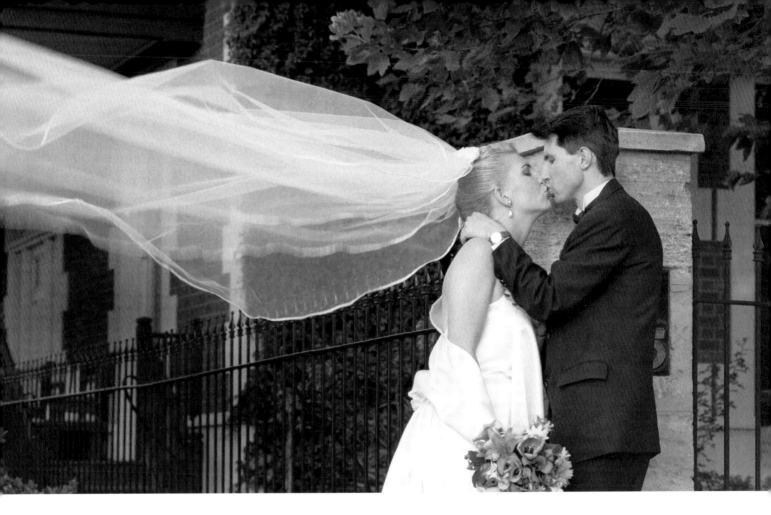

HOW TO EDIT TO WIN

To begin the editing process, try to temporarily remove your previous concept of what constitutes your best portfolio. You can always go back later and compare this version with your previous portfolio, if you already have one. Here is how to edit to win:

Gather all of your best images in any form. It does not matter if you have prints, slides, "tear sheets," or a combination. If your pictures are all stored on computer, make quick laser "work prints" of a wide range of your better ones. As I mentioned, for effective presentation keep each distinct type of portfolio separate. For example, if you are both a nature and a wedding photographer, do the following exercise twice to create your best body of work in each area.

Find a large, uncluttered workspace. The floor of a large room is ideal. If you have a frisky and inquisitive cat or dog, be aware that it might not think as much of your images as you do! Whether or not you have taken it for a walk today, your dog might be your most objective editor of all!

Place all of your images on the floor (not the slides, though!), leaving plenty of space to walk around them. Depending on your portfolio's intent, you may wish to do some pre-grouping of types of images together by category.

1. Start strong

Find your absolute best photo. It should be terrific in every way. You probably have plenty of fine ones to choose from, but the first image in a portfolio has to be an undeniable grabber. An absolute key to the success of your portfolio will be the choice of this first image. It has to be a real "page-turner" in both the literal and figurative sense. This first image must pique the viewers' interest, enticing them to want to see more.

How can an image induce this sense of curiosity? Think of the first shot in a portfolio as analogous to the cover of a magazine. It might not tell the full story of what's inside, but it begins to hint at what you are capable of as a photographer. As a fine picture, it will subconsciously build confidence in your ability.

For this first all-important selection, do not hold back. That would be a mistake. If you think it wise to save your best for later, hoping to slowly build toward a "crescendo," you run an unnecessary risk. Do not take the chance of losing the viewers' interest and confidence along the way. As I mentioned, editor-types are often busy and unintentionally a bit impatient so make sure this first photograph hits 'em over the

Great moments and a sense of surprise add spontaneity to the portfolio of Australian wedding photographer Peter Edwards.

YOUR BEST MOVE

"Make sure that your initial portfolio image is a knockout. You only get one chance to make a first impression."

SEAN FITZGERALD
Photographer

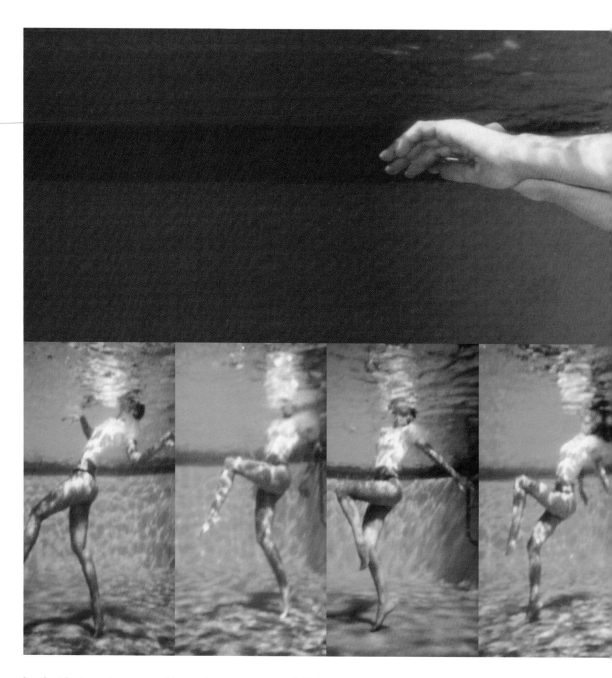

head with strong imagery and immediacy.

Now that you have agonized over which photo is truly your best, place it on the floor to the left of what will be added. Most portfolio presentations are linear, meaning that the images are viewed in order. Exceptions would be online or electronic portfolios, when the viewer can choose the order.

If it has taken quite a long time just to choose your "opener," take a break now and come back to the process a bit later on. If you are ready to see your portfolio begin to take shape, let's move on to the next step.

2. End strong

Find another simply great image. A variety of types of fine photos can work as "enders" depending on the type of impression you want to close with. Again, do not over-intellectualize. Be sure that the final impression you leave is of a terrific and memorable picture. If the last picture is remembered, you will be too.

Sometimes the ender has strong emotional content; at other times it is simply beautiful to look at. If this picture surprises and is not easily accused of being common or cliché, then you likely will have a winning choice. In terms of demonstrating both technical ability and strong content, it should be above reproach. This advice goes for your opener as well.

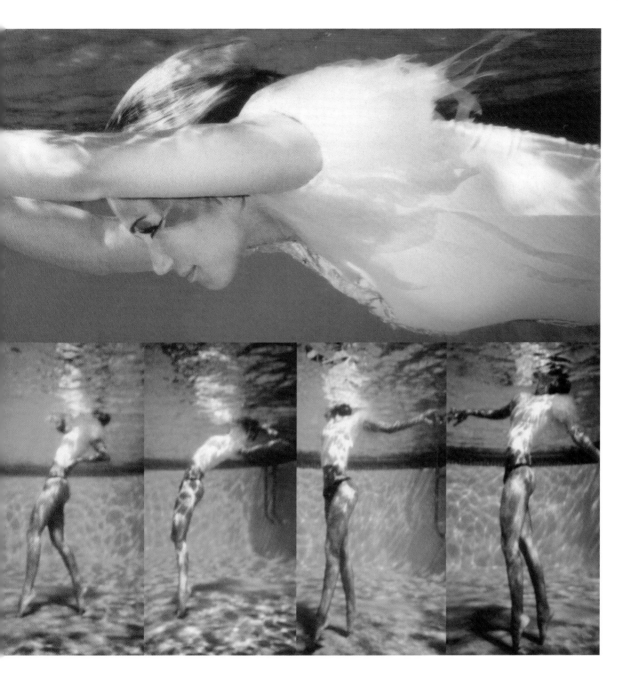

Underwater ballet" from the unique fashion and music portfolio of Yaro captures mood and motion in a saleable mix.

Displaying photographs that surprise and provoke can be an effective tool. However, depending on the audience, should you have images in your portfolio that some might view as controversial, such as a variety of quite provocative nudes, it may be best to move such "conversation starters" toward the middle. The display of your last photo is a time of closure. Do not raise questions in the viewer's mind at the end. Instead, create confidence.

Place your ending photo at the far right of your opener, leaving plenty of space in the middle to add the rest of your portfolio pictures. Having an open workspace will ease the process.

3. Add images that you absolutely cannot live without

Next, look through the rest of your images. Add the pictures you think are the absolute strongest, those you feel must be in your portfolio. Make a quick decision and trust your instincts. Try not to ponder and analyze your choices right now. If you do, you will end up picking up marginal pictures that you know you like, but you are not sure that you love. So, if you absolutely cannot live without an image, move it to the grouping that already has your opener and ender. You can always change your mind later when you see the final group starting to take shape.

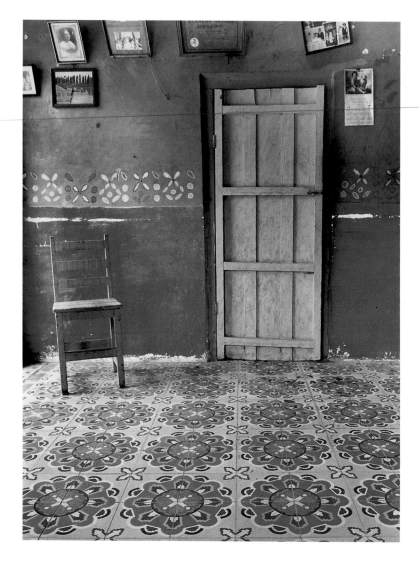

Les Slesnick's "Private Spaces" portfolio of Latin American home interiors employs lively color transitions to add continuity and interest. His photos have been called "peopleless portraits."

4. Add photographs that clients demand

Now, select pictures that may not be your absolute favorites, but are needed to round out your portfolio. By anticipating the needs of the client, you should add images that fill in gaps and answer questions. The types of images that you would be expected to include vary by portfolio type.

(Chapters 8 – 12 on each major genre of photography will help you learn which kinds of pictures clients expect to see. Feel free to jump ahead to help edit your portfolio.)

For example, today's wedding clients want to see terrific candids but many still want to remember their big day with some formal portraits of the happy couple.

A nature photographer who specializes in terrific scenics may consider rounding out the portfolio with a small sampling of photos incorporating close-ups or wildlife. A fashion photographer may want to demonstrate versatility in the studio and on the street. Note that these sugges-

tions are not requirements as many freelancers succeed with highly specialized portfolios.

By better knowing your field, and the size of the market you work in, you will be able to make an informed decision. For example, in New York, freelancers so heavily specialize that you might even be able to succeed as a full-time photographer of running water! In smaller markets, most commercial shooters need to show a more varied mix. Whatever your decision on how much to specialize, be sure that your image choices remove all doubt about your abilities.

Unlike those who specialize, photojournalists are prized for their versatility. For a photojournalism portfolio, add your best in all of the major categories of the field, including news, features, portraits, sports, pictorials, and picture stories. If you have them, show at least a couple of good pictures that demonstrate skill with artificial lighting as well as natural light.

Interpreting what clients expect to see in fine art portfolios is by far the most subjective of choices. After all, in fine art, to make a strong statement you only have to succeed at self-expression. If you also hope to win the favor of gallery owners and curators, you need your artistic intent to be clear and to create pictures they will want to show. Their decision will likely be based on whether they believe others will buy your work. Your portfolio should be segmented by each thematic body of work; each should include a brief abstract of your artist statement. My usual suggestion to fine art photographers is to include only a portion of each project to whet the appetite of the viewer. Once you have them hooked, you can always show more later.

Whatever your specialty, don't worry about presentation order just yet.

5. Eliminate redundant images

This is perhaps the hardest part of the editing process. Letting go of terrific shots for the greater good of the portfolio is a difficult concept for many to accept. To sum up why this is important, I turn to another well-worn but all too true cliché: "Less is more."

Tight editing will always impress a viewer. A portfolio is the best representation of your finest work, but not all of it. Look closely at all of your "keepers" and remove the redundant ones. Be tough on yourself. You may be surprised at just how strong your portfolio is now starting to look.

If a wildlife shooter specializes in pictures of African animals, do not fall into the trap of believing that the viewer always shares the depth

of your interest. If you have an amazing shot of a vervet monkey leaping in mid-air, take out a less spectacular one of a colubus monkey, for example.

If a photojournalist has three or four great pictures that show a tender hug, that's probably at least two too many. Also, if you have a wonderful football action shot, do not make the mistake of including an only marginal basketball action picture. Remember that the portfolio must induce a feeling of confidence. By including a so-so shot, the viewer will suddenly wonder if you can really shoot sports consistently at all.

A studio shooter may wish to demonstrate an ability to light glass well. However, make your visual point just once. Include only your single very best image of glass; the viewer will then have confidence in your abilities to succeed with a future assignment. Similar parallels can be drawn for all genres. For example, fine art photographers do not need to show every nude they have ever taken, only the very best.

6. Take out anything even the least bit marginal

Look through your group of near-final selections. Eliminate the "almosts," "could have beens," and any photograph you have to justify.

There is nothing that annoys an editor more than a photographer explaining why a picture is not as good as it could be. We all realize that

photography is not a science and that some shooting situations do not always go according to plan. That's what makes us human. However, your portfolio is a showcase. Include only the images where all of the elements work on every level. If you are lucky enough to get a face-to-face critique, don't ever explain "the fish that got away" unless asked.

Remove any image with any technical snafu whatsoever. Out-of-focus images are portfolio killers. In almost every circumstance with the exceptions of moody artistic images or compelling news, eliminate pictures that are not tack-sharp. Check each negative with a good quality loupe and make sure that the eyes of your subject are in focus and that you have used appropriate depth of field. If your pictures are made on a digital camera, blow up key areas of the frame in Adobe Photoshop or other imaging software to check for absolute sharpness.

The same logic applies to lighting. If you show an image in the portfolio with a lighting problem, the viewer will instantly doubt your ability and will not likely give you an assignment.

Remove all doubt. Do not show images that

YOUR BIGGEST MISTAKE

"Being too easy on yourself, not being critical enough of your own images before sending them to a photo buyer."

ANN GUILFOYLE
Publisher and Editor, *AGPix*

A peak moment of cranes in flight enlivens the nature and wildlife portfolio of Florida's John Moran.

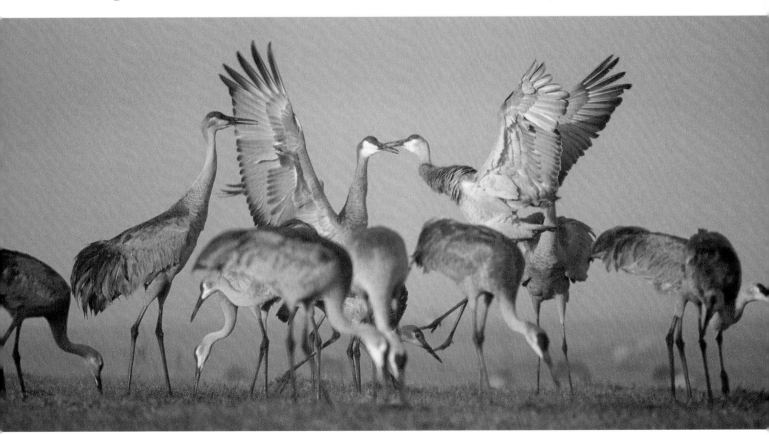

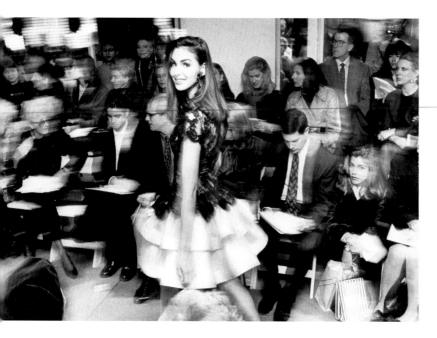

can be picked apart in any way. There is nothing wrong with seeking out criticism from accomplished shooters on less-than-perfect pictures, but the portfolio is not the place to include them.

If you follow these suggestions and remove anything the least bit marginal, you will be amazed at how much stronger your portfolio will become. By having the courage to be the toughest editor of your own work, your chances of reaching your future goals may be forever changed!

7. Keep it moving in the middle

Place your pictures in a logical order, from left to right. Sprinkle your best images throughout, interspaced with those not quite as strong. There are two schools of thought on whether to group similar types of pictures together by theme or whether to mix them throughout the portfolio. The first approach sounds logical but, for most portfolios, I believe in the second.

Whatever your specialty, strong portraits can be an important portfolio addition. These of model Tanya Mayeux and rock star Phil Anselmo, of Pantera, are from my Pulitzer-winning project on American 21-year-olds. The winning entry was a stand-alone print portfolio bound in a 17x12 inch horizontal book format.

We all have gaps in our portfolios. The trick in editing is to not let viewers concentrate on the shortcomings; instead create an opportunity for others to marvel at your best photos. If you take the first approach, it will be easy for anyone to pick at your weaknesses and also notice any redundancies.

For the wedding shooter, if spontaneity is not your strength, sprinkle an occasional lively shot throughout to break up your superior posed images. For any photographer, always play to your strengths. By following this editing approach, you'll hide weaknesses.

For the photojournalist, it may seem logical to place all sports pictures together, but it will also be far too easy for any editor to make a value judgment on whether you are a good sports shooter or not. Leave the editor with a positive impression of your overall versatility and you are far more likely to land the job. If sports is your weakness, it's better to sprinkle fewer "good enough" sports images throughout a portfolio than to place several marginal ones together.

Although mixing works well for many portfolios, others are best organized in natural groupings of sub-specialties. For example, if you spe-

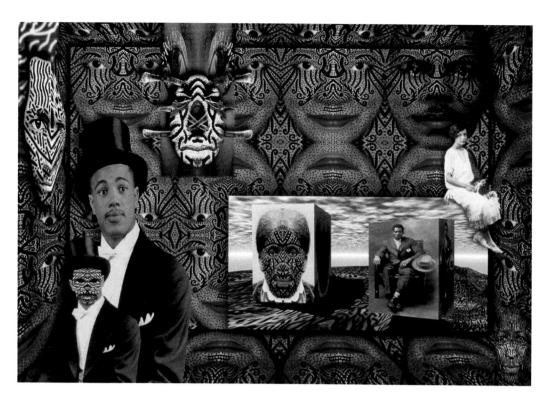

This montage from the evocative "Soul Searching" series by Stephen Marc is a good example of how digital imaging software can be used by photographers to explore conceptual themes. The result is a powerful fine art photograph of personal expression and also a saleable stock image. Agencies like Art + Commerce bridge the art and commercial worlds.

cialize in fashion and have a small grouping of accessory shots, it may make sense to group these together. Be sure not to make the same visual point twice, however.

As easy as it sounds to eliminate redundant images, it is not a simple task to convince yourself to do so. At this point, your select group may still include a couple of images with similar content that might be deemed redundant. If you cannot bring yourself to cut one, simply spread them far apart in the portfolio and hope that no one will notice.

When deciding on the order, pace your best work carefully. As long as you have followed my advice to start strong and end strong, and to keep it moving in the middle, the exact order is not crucial. Spread your best work around to keep the viewer interested and curious about what is to come.

8. Demonstrate versatility

By now, your portfolio choices should be looking pretty good. Have you included only your best work? Tinker with the order to help create interest. When deciding on your final order, mix up wide angle and telephoto shots, tight and wide compositions, along with horizontals and verticals. However, if you are like many photographers who inexplicably forget to turn the camera on its side every now and then to take a vertical, don't sweat it.

Try to eliminate jarring segues. Notice the transition of color and types of lighting approaches but try to stay focused on quality and content. We all have personal preferences in types of images that most appeal to us. At the same time, any good portfolio needs to show versatility. Your portfolio will have a more professional and intriguing feel if your images portray a variety of situations and show technical ability. The best portfolios go beyond the literal and expected, they show intimacy and a point of view.

9. Get feedback from someone you trust

Before deciding the best format to choose for portfolio presentation, solicit feedback. Do not walk into a client or curator's office blind. Find the best person you know to give you some constructive criticism. A teacher, a working professional in your area, or a fellow camera club member would all be good choices for a guest editor. It is important to take this last step before you invest in fancy print cases, expensive printing or scheduling crucial portfolio showings. Chances are that your will learn new insights that might make your edit an even stronger one.

HOW MANY IMAGES ARE APPROPRIATE?

Shoot for a tight edit. Anywhere between twenty and forty images will showcase your work nicely. There is no absolute number of necessary images

YOUR BEST MOVE

"Your goal is to be remembered so include work that breaks you out of the pack."

DAVID FRIEND
Creative Development Editor, *Vanity Fair*
Former Director of Photography, *Life*

though, unless a potential client insists. Early in your career, keep that figure closer to twenty, not counting a series or picture story.

Years ago, portfolio showings were almost always done in slide form. If you were lucky enough to get a face-to-face critique, you were told to, "Bring your tray," meaning a carousel tray of eighty pictures. Like so much in life, people are busier these days and it's rare that a slide portfolio is projected. It usually gets a rapid look with a loupe on the slide table. Just as news stories are getting shorter and shorter, the general trend today is toward a tight portfolio.

Don't play "the counting game." You are neither strong nor weak because of a particular number of images contained in your portfolio. Similarly, don't make it easy for the viewer to be able to count a certain kind of photo in your portfolio and, thus, quantify your success rate. Since photography is a subjective art, your chances of portfolio success are greatest with a qualitative evaluation of your best work. It's not the numbers that count, it's the quality. If you don't yet have twenty images that you want to show, by all means, show ten.

WHAT IF I'M NOT SATISFIED?

Whatever your present level, get as much feedback from others as possible. Assuming that you have been able to locate at least one guest editor, ask if he or she will have time to look over a handful of contact sheets or near misses that you've eliminated. Ask what your strengths and weaknesses are. If you agree with the critique, go back through your outtakes or negatives on file. Chances are you'll find a few gems in waiting.

If you do not feel that your portfolio choices reveal your true ability, just pick up the camera and head out the door toward your next adventure. All photographers start at the beginning; the process of improvement is incremental. Building an excellent portfolio takes time but begins with a drive to excel. Notice which pictures in your current portfolio are least strong and replace them as you take better ones.

Just do your best. That is all you can ask of yourself. Do not believe for a moment that you

> **YOUR BIGGEST MISTAKE**
>
> "Trying to please every potential client. You can't change your portfolio around to please everybody."
>
> JULIAN MEIJER
> Photographers Rep

>> **CASE STUDY**

Like many pros, I have more than one type of portfolio for different client types. Here's a selection from my work on ethnic minorities throughout the world. Any portfolio needs a variety of lively compositions but must be carefully edited to eliminate redundancy. Which picture do you think should be cut? See page 156 for the answer.

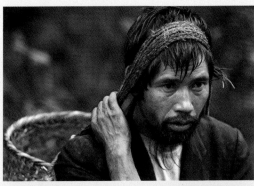

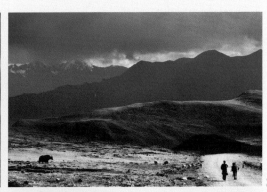

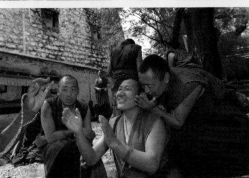

are deserving of less than excellence or that you cannot attain it. I always enjoy teaching beginners and am amazed that in a fifteen-week semester, (or even a one-week workshop), novice photographers make the transition from fear and technical fumbling to making terrific, professional-level pictures. This occurs every time. To make this happen in your own work, surround yourself with the finest photographic examples you can get your hands on, at the library, bookstore, museum, or on the Web. Even more important, find a photographer willing to mentor you. I firmly believe that all of us are capable of producing fine work. In time, and by working through mistakes, emerging photographers will build consistency and confidence.

Just because I am a Pulitzer Prize-winner, I certainly do not believe I have "arrived" as a photographer. If I thought I could no longer grow, then it would be time to retire. (Actually, by teaching senior citizens at workshops, I have learned that those retired from other professions have terrific photographic ability.) Whatever your feelings about your current portfolio, remember that it will always continue to grow, as

how to edit to win

Gather your best images and throw away your preconceptions.

START STRONG. Find your very best photo.

END STRONG. If your last picture is remembered, you will be, too.

ADD "MUST-HAVE" PICTURES. These are the pictures that you absolutely cannot live without.

ADD PHOTOS THAT CLIENTS DEMAND. See the chapter on your specialty to learn what is expected in your genre.

ELIMINATE REDUNDANT IMAGES. Take out everything that makes the same point twice.

REMOVE ANYTHING THE LEAST BIT MARGINAL. Do not rationalize situations that could have been better, stick with only the very best.

KEEP IT MOVING IN THE MIDDLE. Pace your photos and mix different types throughout.

DEMONSTRATE VERSATILITY. Vary the content mix as well as lens choices and types of composition.

GET FEEDBACK. For the final polish on your edit, find a guest editor for constructive criticism.

long as you do. The journey is what is important. And enjoying the path.

Don't be too hard on yourself. Rediscover the joy of shooting and your portfolio will continue to grow along with your love of photography. Don't be perfect, be passionate. Great pictures will follow. Above all, keep shooting.

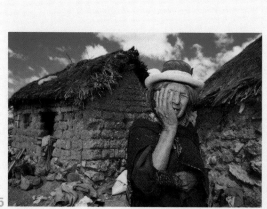

5

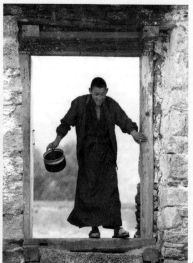

6

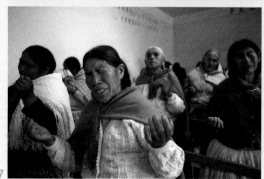

7

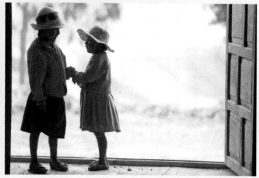

8

portfolio types >>

Now that you have strengthened your portfolio through the power of smart editing, decide on presentation style.

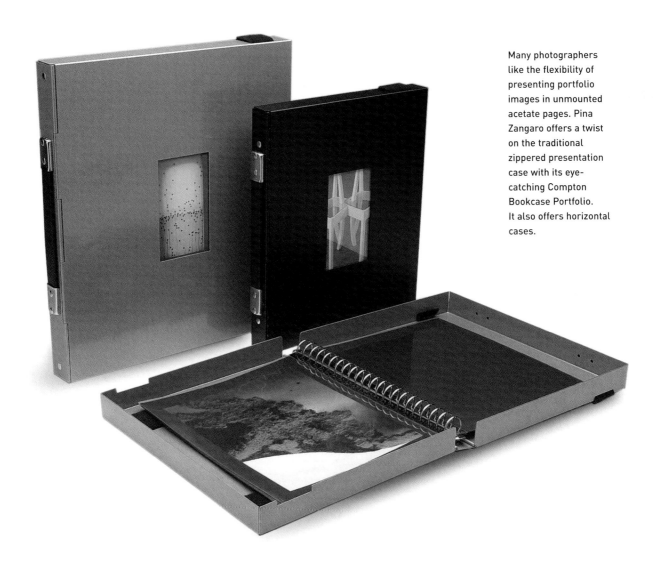

Many photographers like the flexibility of presenting portfolio images in unmounted acetate pages. Pina Zangaro offers a twist on the traditional zippered presentation case with its eye-catching Compton Bookcase Portfolio. It also offers horizontal cases.

The truth is this: If your portfolio now contains the world's finest images, you could send your work in a paper bag and still land the job. For the rest of us, presentation is synonymous with impact and professionalism. An exquisite presentation gives you an all-important edge.

Your portfolio is your most crucial marketing tool. It is your primary vehicle of communication. The goal of going through the hard work of putting it together should always be to help others easily access your photographs. After seeing your presentation, the viewer should be left with a strong and positive impression. Most important, the portfolio should produce results.

Years ago, the choice of which type of portfolio to show was a simple one; prints were expected and most reviews were in person, allowing face-to-face feedback. Later, slide copies also became a second acceptable standard and editors and curators often asked to see a full tray. Now, prints are back in vogue.

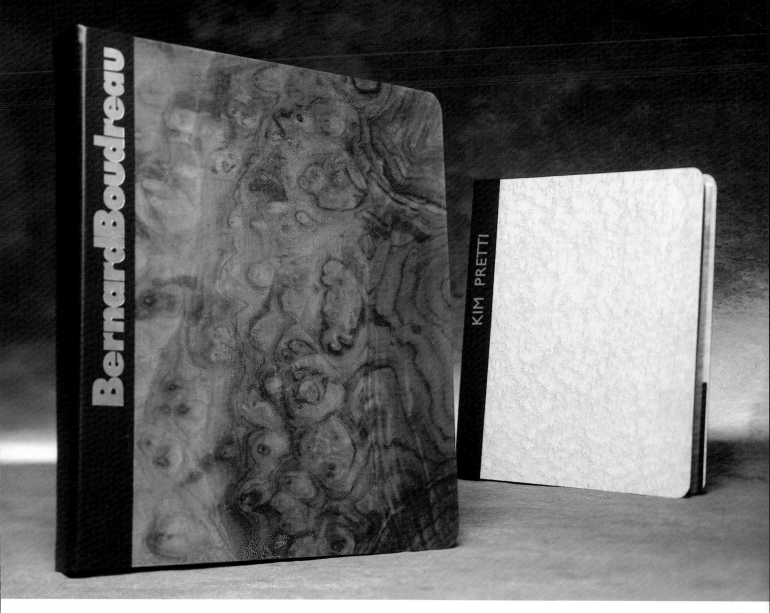

Today, no single presentation style is required by all clients. Slides are still used prominently in the fine art world but are no longer preferable in advertising.

The presentation process is often less personalized. In larger cities, photographers are often asked to drop portfolios with a receptionist to be picked up later or to send their work through the mail.

During the past decade a positive new change has taken place; portfolios viewed on screen are now a great way to showcase your work. The Web has become the most important new marketing tool; every savvy photographer should have a Web site with an easy-to-remember address, or "URL." CD or DVD presentations are also an option.

ENVISION YOUR PORTFOLIO

Before starting to print or putting together a Web site, look over your selections one last time.

Ask yourself, "What kind of photographer am I now and what direction do I want to take my work in the future?" Your choice of presentation style and case are interdependent with these goals. Are you a fashion photographer, hoping to make inroads with youthful fashion "zines"? (Those are hip, cool magazines, for those of you over thirty.) Or are you a large-format fine artist who hopes that your well-crafted landscapes will stand the test of time as collectibles? Or, are you a commercial freelancer specializing in high-end corporate portraiture and annual reports?

Career consultant and photographers' rep Henrietta Brackman wrote in her 1984 book, *The Perfect Portfolio*, "The idea is not to produce what the market wants, to do almost anything to sell, but rather to ask yourself some searching questions about your natural talents, abilities, and interests." Her advice is still valuable twenty years later.

Be sure that your print portfolio reflects

The dramatic print portfolios of Advertiser's Display Binder feature exotic woods like Birdseye Maple and Pommele Sapele.

Wedding photographer Jeffery Woods uses the innovative design and binding services of Digicraft to create coffee table wedding album books for clients.

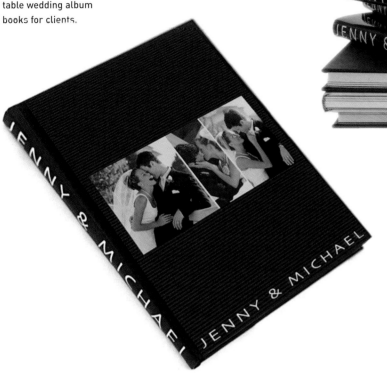

Elegantly presented, no other type will have the same impact. No computer screen can rival the quality of a great print. Just as it is easy to create a digital portfolio, it is also easily forgotten. Showing high quality prints represents the culmination of our art form, whether in a gallery or in a one-on-one critique. Just as copy slides of a painter or sculptor's work would fail to communicate texture and subtlety, so do all other types of photo portfolios.

Print portfolios are a must for face-to-face meetings. Producing one involves effort and great pride. To be successful, each print has to sing. No detail should be overlooked, from eliminating dust to being sure each print has consistent sizing and presentation. Your choice of portfolio case also has the potential to help you create a winning impression.

I am often approached by students at conferences eager to show me their work, which occasionally consists of nothing more than color laser prints quickly tossed into a binder. While I am always happy to talk about a photographer's images based first on content and communicative style, when I see such haphazard presentation I cannot help but wonder about work habits and the true work ethic of the shooter.

If you are reading the advice in this book for the first time and have never before considered the importance of such details, please do not feel embarrassed. It's always more important to share your work in whatever its current state than to not receive feedback at all. In the end, it is the power of your images that really counts. But as we have discussed in earlier chapters, to be truly successful, even as a serious amateur, you must find the resolve to eliminate all perceived weakness in your portfolio. You might not be able to control how fast your portfolio evolves, or whether a bald eagle suddenly happens to fly

how you see yourself, recognizing the realities of the business, but also showing what you really like to do. Like no other sales and marketing vehicle, your portfolio presents the image of who you think you are and even what you deserve to get paid. The presentation style must project confidence and ease. Your portfolio must subtly reinforce these themes.

Once you have a better idea of how you see yourself in your field, and how you hope your career will evolve, it will be easier to decide on format and case style. Make sketches and explore your options. Do not skimp on any of the details to present yourself well.

Let us discuss the main types of portfolios along with their advantages and disadvantages:

PRINT PORTFOLIOS

Even though we live in a digital age, all photographers still need to have a print portfolio of the highest quality. After all, photographs must be seen as more than a collection of bits and bytes to be quickly glimpsed on a computer screen. Your fine work is worth far more than that.

YOUR BEST MOVE

"Understand that this is not a dress rehearsal. If you don't do it now, it won't get done."

J. TOMAS LOPEZ
Photographer, Educator

into the frame of your viewfinder, but you can certainly control how your prints are presented.

Today, any photographer can make inexpensive digital prints on a home computer that rival and even surpass the best custom labs.

(*Read Chapter 4 to learn how to make the process of creating fine prints a less taxing one and for a detailed guide on types of presentation cases.*)

One disadvantage to print portfolios is the expense and time involved in creating them. Few photographers have more than two or three copies of their print portfolio, so it's wise to also produce several copies in other formats.

ONLINE PORTFOLIOS

Simply put, every serious photographer needs a Web site. If you have been putting off building one for fear of time needed or the complexity of the technology, put those fears to rest.

Many photographers get so caught up in the production of their site that they forget its purpose. Just like any portfolio type, a good Web site should communicate your photographic mission clearly. It must be easy to navigate. Although plenty of companies advertise Web design services, they don't always understand the unique needs of photographers.

Putting your portfolio online allows potential clients to see your work anytime, anywhere in the world. Having your own Web site is an absolutely fantastic way to advertise your work but is usually not a substitute for other portfolio types. Rather than only show your pictures, it also has the potential to generate income as clients that you did not even know existed locate your images online through "search engines."

Driving traffic to any Web site is not easy, even with a large advertising budget. Most photographers should not expect a surprise windfall of income. Still, you may be delighted to occasionally receive an unexpected E-mail from a faraway company that finds your work online and wants to use it. For example, two television networks and a major gallery have found my projects online through keyword searches, leading to rewarding opportunities.

Instead, concentrate on using your site as a reference for both new and established clients. Pick a URL that is easy to remember. Even with a name that quickly comes to mind, you will need to continually remind clients where to find your work online.

One advantage to having a Web site is the reasonable cost. You can register a name (e.g. www.johnkaplan.com) for less than twenty dollars a year and find a reliable host company that should charge less than fifteen dollars a month. These costs are well worth the potential return. At Web sites such as Verisign (www.verisign.com) you can instantly find out if the name you wish to use is available.

portfolio types

An exquisite presentation gives you an important edge.
Consider having more than one type.

PRINT PORTFOLIOS
All photographers should have one.

ADVANTAGES | Strong impact, best potential image quality, attention to detail.
DISADVANTAGES | Cost, lack of portability, time to put together.

ONLINE PORTFOLIOS
Every photographer should have his or her own Web site.

ADVANTAGES | Instant access anywhere in the world, inexpensive, great marketing tool, easily databased by Web search engines.
DISADVANTAGES | Image "res-in" time, low resolution, inconsistent monitor calibration.

DISK PORTFOLIOS
CDs, DVDs, and zip disks are now an acceptable method of sharing work.

ADVANTAGES | Least expensive method, easy to duplicate, ability to incorporate multimedia.
DISADVANTAGES | Computer systems and software incompatibility, resolution, inconsistent monitor calibration.

SLIDE PORTFOLIOS
Once an industry standard, curators and some editors still ask for them.

ADVANTAGES | Easily viewed, relatively inexpensive, easy to make several copies.
DISADVANTAGES | Duping quality varies, viewer must have a loupe. No longer an industry standard in advertising, fashion, and corporate work.

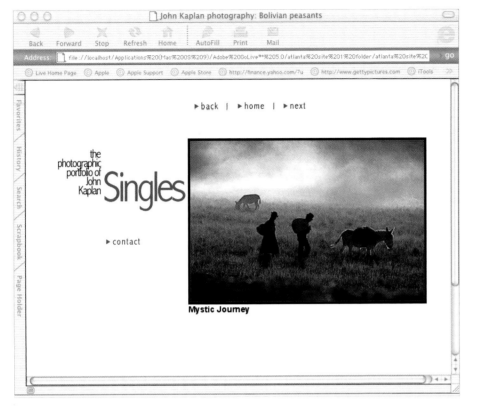

A well-designed online portfolio must be easy to navigate. Allow clients to control the viewing process and return "home" to the main index from any page in the site.

Potential disadvantages include concerns about image loading time. We have all experienced the impatience of waiting for a Web page to load, a sure way to lose viewers. Your site can easily be optimized to keep file sizes big enough to retain reasonable image size but small enough to load fast. Don't assume that all potential viewers have high-speed Internet connections.

Many photographers with otherwise well-designed Web sites make the mistake of forcing the viewer to hunt around for important navigation tools such as "Next," "Back," and "Home." Simplicity and ease of use should be of primary concern; avoid the trap of cluttering your site with gimmicks. Let viewers control the experience to keep them on your site and not clicking away to someone else's. For example, if you add a brief multimedia opening using software such as Macromedia Flash, allow the viewer to bypass it or to return home at any time.

For your online portfolio, a smart edit of only your best work is still crucially important because Web sites often allow the viewer to choose the image order. A Web site allows virtually unlimited space to create pages but this does not mean you should put every picture you have ever taken there. Again, less is more. A tight edit will always impress. Just as you would rarely put several images on a page in a print portfolio, in most cases place just one image on each Web page. This will help ensure fast page loading and impact for each of your best images.

If the goals of your site go beyond using it simply as a portfolio showcase, you may consider creating a "mirror site" to database many more of your saleable stock images by topic.

Some photographers worry that putting their pictures on the Web will increase the likelihood that they will be stolen. To my mind, this is not a serious concern although it certainly does happen. Online images are only 72 dots per inch and are rarely displayed larger than 5 or 6 inches. Someone might end up stealing a picture for a school report but serious clients need higher resolution files. Adobe Photoshop software includes an easy to use "Digimarc" feature that helps to prevent copyright infringement through the use of a digital watermark. Give it a try.

One disadvantage to a Web site is that it exists only in cyberspace. An online portfolio does not sit in an editor's inbox, demanding attention. It does not require a reply and cannot be held in the hand to be appreciated. Without someone wanting to take the time to look at your photographs, they can be easily ignored. Excellence in printing and larger image format quality such as 4 × 5 is lost when pictures are scanned at low resolution. Still, the pros far outweigh the cons. Done well, your Web site can only help you share your fine work.

(Chapter 5, Online Portfolios, provides a step-by-step tutorial to help you put your portfolio online, quickly and without hassle.)

DISK PORTFOLIOS

In addition to online presentations, disk portfolios have become a standard in journalism for internships and job applicants. Those who apply to become assistants or interns at studios often show them as well.

Instead of using traditional photographic methods, portfolios on CD, DVD or zip disk format are viewed on the computer. Whether or not the pictures were originally shot on film or with a digital camera, a disk portfolio is portable. Additional copies can be duped in CD or DVD format for pennies a disk. With cost not being

much of a factor, you can easily send your work off to a great variety of potential clients.

Some digital portfolio presentations add multimedia. Wedding portfolios are especially dynamic with added royalty-free sound or even video.

As great as all of this may sound, digital portfolios present several technological challenges. The first is resolution. Because computer monitors resolve only 72 dots per inch, even high-end monitors will not be able to show the finest nuances of your work. This is not always a major down side for most photographers, just be aware that looking at pictures on a computer always involves sacrifices.

A related disadvantage is that there is no consistent calibration among monitors nor among operating system types. Your images might look fine on your monitor at home but a bit overexposed on someone else's computer. The vast majority of photography and graphics professionals use Apple Macintosh computers, which poses compatibility challenges to those who work in Windows. Even within the same operating system, a CD may be compatible with one viewer's Mac while unreadable on another.

Apple and Microsoft update their operating systems frequently, constantly creating new compatibility problems. As hardware changes as well, some CD and DVD players may be able to view your disk while others will not. For example, disks burned beginning with Apple's OS X software that debuted in 2001 are often unreadable on older machines and visa versa. The use of sophisticated multimedia software such as Macromedia Flash or Apple Final Cut can be impressive and can utilize sound and even animation. However, you must first be certain that your software and the operating system of those viewing your work are compatible, which is no easy task.

One way to work around such challenges is to produce your digital portfolio using HTML page files, the same method used for creating and viewing Web pages. With this approach, the viewer opens your disk and clicks on your first "page." A live connection to the Internet is not needed, only a Web browser, such as Netscape Communicator or Internet Explorer.

If you send a disk of your work in a Web-friendly format, Mac and Windows computers will both be able to read your images as long as you include some simple navigation tools. Since an actual Internet connection isn't needed, the viewer doesn't need to wait for pages to load or for images to "res-in."

If all of this sounds too daunting and complex, have no fear. No programming knowledge is needed. Easy-to-use Web authoring software such as Adobe GoLive or Macromedia Dreamweaver can help you produce a simple digital portfolio in one weekend. Making your own Web site and getting it online is also a snap.

(*Chapter 6, CD Portfolios and Multimedia, tells you how to make a disk version of your portfolio. Chapter 5, Online Portfolios, explains how to create HTML pages*

YOUR BIGGEST MISTAKE

"Trying to be somebody you're not. Have an authenticity of vision with something intensely personal to say."

TOM KENNEDY
Director of Photography, *Washington Post Newsweek Interactive*
Former Director of Photography, *National Geographic*

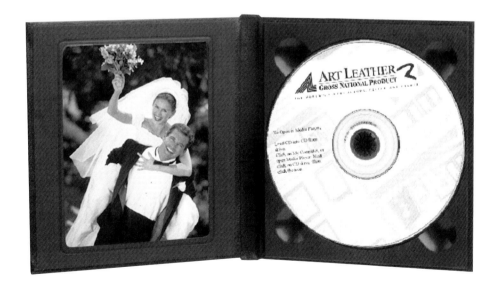

The CD Folio from Art Leather nicely packages a CD or DVD with a representative photo.

to view digital portfolios with a Web browser.)

Today, many photographers go to workshops and conferences with a laptop in hand and show their work digitally rather than in slide or print formats. This can be a great approach to sharing your photos as long as you allow the person doing the critique to control the viewing process. Remember that you want to have pictures remembered, not the "razzle-dazzle" of your computerized presentation. Easy-to-use navigation tools are far preferable to forcing the viewer to watch a fixed-length presentation.

By the way, do not E-mail your portfolio image files, unless specifically invited to. That's a sure way to clog any potential client's inbox and will cause you to be thought of as annoying "spam" and not as a serious photographer.

SLIDE PORTFOLIOS

Not many serious color photographers shoot Kodachrome anymore, which used to be the must-have film for all *National Geographic* photographers. Kodachrome is expensive and difficult to process; many other color slide films that use the standard E-6 developing process give great results, too. In fact, color negative films, once looked down on by pros, are absolutely terrific these days; I use them almost exclusively to take pictures that produce results rivaling any slide film.

If you do not take pictures using slide film at all, you still may have use for a slide portfolio. Some editors and most exhibition curators still ask for copy slides of your work. Wedding competitions often require them as well. Whether you prefer to use black and white negative film, color negative, or slide film, it is easy to make several copies of your portfolio in slide format.

Making a good slide portfolio is not difficult but several common mistakes can hurt its ability to help you sell your work. Poor duping quality by so-called "professional" labs is commonplace and will make others wonder whether your pictures are really in focus or properly color corrected. Slide portfolios that lack proper identification on the back of each image are easily lost. Without the right presentation packaging, a couple of sheets of "Vue-All" slide pages can be forgotten in the vast pile of other work that faces any busy editor.

Digital technology is changing how slide portfolios are made, for the better. "Film Recorders" are expensive machines that convert any scanned photograph into a top-notch slide. Most major cities have a commercial photographic lab that specializes in the use of such newer imaging technologies to make digital slides. By first scanning your photograph, or having a lab do it for you, images can be color and exposure corrected. Next, as long as your scan is a good one, a film recorder can output slides that surpass the quality of originals.

Until the mid 1990s, all slide copies were made the traditional way, literally taking a picture of a picture to make a "dupe." This method is still popular and has the advantage of saving the photographer money if you are willing to do the copying yourself. Disadvantages include being time consuming and sometimes aggravating in terms of getting consistent exposure of dupes.

(*Chapter 7, Slide Portfolios, explains how to obtain high quality copy slides using either method, digital or traditional duping.*)

Slides offer two big advantages as compared

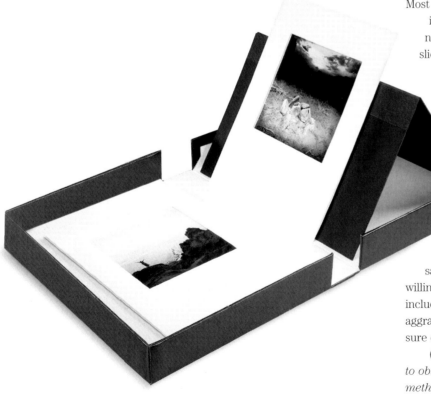

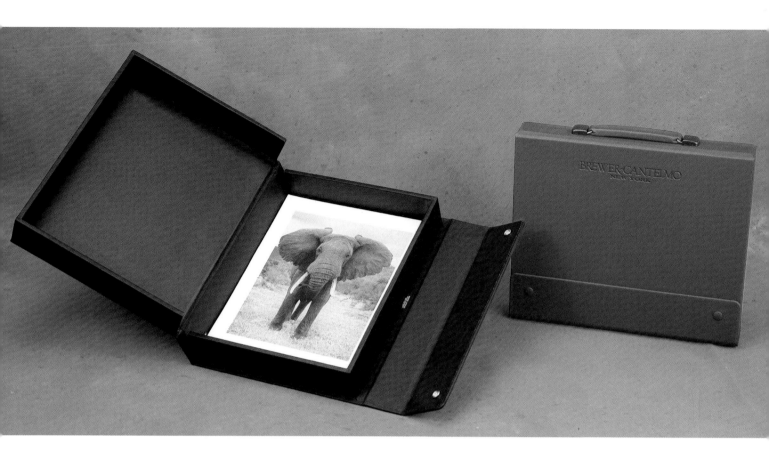

with having only a print version of your portfolio. The first is portability. Slide portfolios are easy to ship and easy to store. Try getting a 20×24-inch print case in an airplane's overhead bin and you'll appreciate the ease of carrying slides to a conference or workshop.

By the way, when you do show your slide portfolio, always bring along your own loupe. As I mentioned, it is rare indeed these days that your slides will be projected unless you are lucky enough to shoot for *Audubon* or *National Geographic*. Without a loupe, you are at a distinct disadvantage of having to ask the viewer to squint at tiny slides, creating a no-win situation. Always have one with you; even if you sign up for a formal portfolio critique at a seminar do not assume that the editor will have one.

I keep a high quality loupe at home, such as the impeccable Schneider 4X, and travel with a less expensive one. For 35mm work, I recommend the Peak 8X, a bargain at less than thirty dollars. Some shooters even take along a tiny light box when they travel to conferences but I don't think that's necessary.

Because slides are relatively inexpensive to dupe, another advantage to this portfolio type is that you can easily make several copies. Make as many sets as you can afford and distribute them far and wide. For example, fine art photographers build their reputations by submitting work to juried group shows and eventually landing solo exhibitions. Depending on the theme of the exhibition, send slides to several at once across the country to increase your chances of acceptance.

A college student wishing to apply for a photographic internship would be wise to send a minimum of ten slide portfolio copies to newspapers of all circulation sizes. Sometimes internships are cancelled or another candidate has the inside track. Use the "safety in numbers" approach by sending out several copies so you do not put all of your eggs in one basket. Be aware, though, that online and CD portfolios are replacing slides as standards. In many commercial areas, such as fashion and advertising, slides are no longer desirable.

Brewer-Cantelmo's Presentation Box comes in a variety of colors and materials and can be imprinted with your name or logo.

YOUR BEST MOVE

"Have your work reviewed by a lot of top editors and photographers before you start sending it out."

DAB HABIB
Photographer, Picture Editor

print portfolios >>

When it comes to print quality and presentation, never settle for less than excellence. Your portfolio should show attention to detail and a strong work ethic.

The Wood Book & Attaché Combo from Advertiser's Display Binder makes an impressive duo.

reputation and wallet are both likely to take a hit.

DOES SIZE MATTER?

In matters of love, probably not. In a print portfolio, absolutely! Choose the largest print size format that is realistically possible. Bigger pictures have greater impact. Shooters of "chromes" used to have an advantage when clients would project their slides because a large projection can really sell an image. For prints, choose the largest size that will not cause your case to be too heavy or unwieldy. A safe bet is always 11×14 inches, a size often preferred by photographers' reps.

Print sizes are changing. Standard sizes used to be 8×10, 11×14 or 16×20 inches. With the advent of digital printing, paper is available in new formats, 8.5×11, 11×17, or 13×19. You are free to choose any available size, but be sure that you choose a presentation case that can display it well. Many photographers print using the greater size of the new formats but still mount on standard sizes. The reason? Not many cases are yet available in newer sizes.

Consider whether you want to display your prints mounted or unmounted. Mounted prints are sometimes window matted, the norm for fine-art photographers but an uncommon approach for photojournalists and many freelancers. Unmounted prints are easy to move in and out of a portfolio, and are usually presented

Putting together your best print portfolio is time-consuming and challenging. However, the rewards and satisfaction that come from doing the job right are wonderful. For professionals and even serious hobbyists, attention to detail is a must. If your prints are high quality and your presentation is well thought out, your print portfolio will further your career goals immensely. However, if any necessary elements are presented sloppily, your

in a binder with acetate pages. If you prefer matte or textured enlarging paper and don't like the glossy look, mounting prints makes sense. Some photographers feel that seeing their prints behind plastic takes away from image quality.

DON'T BE A FLIPPER

Make it easy for people to look at your prints, not a chore. Most photographers shoot a majority of horizontals, but many cases are vertically oriented. Even though you should print as large as is practical, avoid making the viewer turn the portfolio just to see horizontal and verticals at their largest possible size. There is nothing more annoying to an art director than being forced to keep turning your "book" back and forth.

There is an easy work-around. For example, if you have matted 11×14 prints centered on 16×20 boards, center the vertical pictures on horizontal boards. If the majority of your pictures are 14-inch-long horizontals, print your verticals no taller than 11 inches. The same logic would hold true for a presentation in one of the popular zippered folio cases with acetate pages; print your horizontals as wide as possible, centered on the vertical page.

Although most cases are vertical, you can find nice horizontal ones, or custom order what is right for you. Some portfolio boxes appear to be vertically oriented but can be rotated at the beginning of your presentation to show your work horizontally. The "clam shell" presentation box

Ideal for tearsheet groupings, ArtZ offers a narrow box that holds matching accordion panels. For professional presentation, scan and reduce tearsheets to a consistent size.

allows the viewer to look at a print right in the case and turn each print over to the far side of the box, revealing the next picture in sequence.

WHAT ABOUT TEARSHEETS?

If you also have tearsheets (also known as "clips") to present, do not intersperse them with prints. Determine a couple of possible ways to show them that will coordinate well with how you wish to display your prints. Place them at the back of your portfolio but be positive that

The zippered presentation case is a tried-and-true method for showing a photographic portfolio. Prints can be quickly edited and repositioned. Since acetate pages scratch easily, it's a good idea to change often and keep extras on hand.

they are likely to impress seasoned editors.

Tearsheets are often laminated. They may be centered on the same size board as your prints or presented together as a group in another format such as an accordion fold. You may also consider scanning them on a flat bed scanner and sizing down for a consistent display style. Large format transparencies can even be made of tearsheets to show them as an impressive group.

Show tearsheets only if the layout and design is as good as your photography. Often it is not. They may be striking additions in commercial portfolios, especially if you have landed major advertising clients or covers. But the display of routine pictures in small sizes will hurt you, as will poor design of good pictures. Go easy. Remember that you can always list prestigious accounts and publications on your client list or bio if the display was not what you had hoped for.

If you do include original tearsheets, trim them carefully with a straight edge before laminating or mounting. As with your picture editing process, choose only your best. Remember, even though you are proud that your work has been published, this is no big deal to those who work in the journalism and publishing businesses. In these fields, your pictures can help you land a client, but poorly designed clips will not.

DO PRINTS HAVE TO BE ARCHIVAL?

No they do not, unless you are a wedding photographer or fine artist. Think of your portfolio as organic; it is living, breathing, and never finished growing. Chances are that five years from now you will have a completely new set of pictures. Also, freelancers who revisit art directors and buyers need to continually "freshen" their book.

For credibility, fine art photographers should present archival prints matted with acid-free boards. If you make digital prints, buy an inkjet printer that uses pigment inks or spring for "Iris" prints made by a specialist such as Nash Editions (www.nasheditions.com) or Palm Beach Editions (www.palmbeacheditions.com).

Wedding photographs should last a lifetime and more. You may present a non-archival portfolio to display a variety of your "greatest hits," but be sure to also show a sample wedding album and explain to your clients the importance of using archival materials.

SWEAT THE DETAILS

When it comes to print quality, eliminate all doubt. Your prints have to jump off the page and

The Portfolio Box from Light Impressions sets the standard for archival quality. The clam shell design allows photos to be effortlessly transferred from one side of the box to the other during presentation.

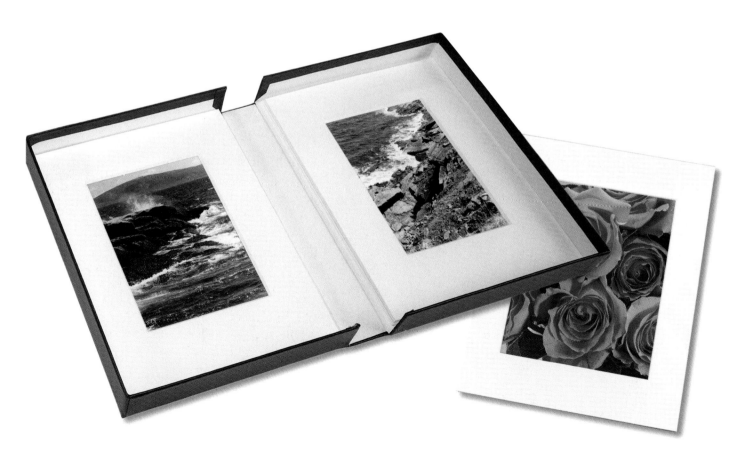

Nothing beats a customized case for creating a distinctive impression. Lost Luggage offers "screwpost" binding with a patented hinge system for durability and ease of use.

be of the best quality available. If your only choice is to "job out" your work to a commercial lab, beware. Even among labs with the best of reputations, inconsistent printing is commonplace. Attend meetings of professional organizations such as ASMP and NANPA and ask for advice to find the best labs in your region. Some pros work exclusively with an individual print maker who takes as much pride in the final product as the photographer does. The extra cost involved is often well worth it. One of the world's best black and white printers is France's Jean-Michel Malvy (jeanmichelmalvy@wanadoo.fr).

Give detailed burning, dodging, and color correction instructions. If you have a small, good quality print that you like, share it with your printer as a "proof" for an enlargement. If you do not like the results, be sure to ask for a reprint; you should have a "paper trail" of correspondence to refer to in case of a dispute. If your printer is working from an original slide, colors and cropping should be faithful to the original.

The Neon Series from Advertiser's Display Binder comes in an array of tantalizing colors.

Lost Luggage offers an array of stunning portfolios in exotic woods, leathers, plastics and metals.

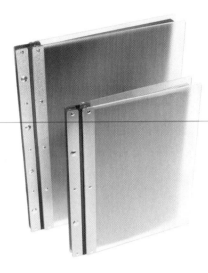

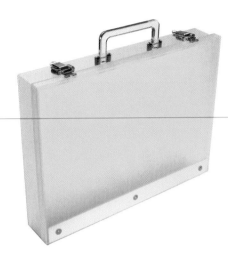

If you are working from a scan or image taken originally on a digital camera, many labs now feature high quality digital printing processes, using papers such as the highly regarded Fuji Crystal Archive. The quality can be terrific if you are able to follow your lab's instructions to best calibrate your monitor at home with their printer. Try a test image first and work with the lab to ensure consistency for the rest of your portfolio. As long as you have an excellent digital file, companies such as Ofoto (www.ofoto.com) make fine prints at reasonable cost.

YOUR BEST MOVE

"Think big, outside of your own box. If you don't show it to 'em, they can't want it."

STEWART POWERS
Photographer

Many non-custom labs will arbitrarily crop images to fit a specified format used by their machinery. For example, if you ask for an 8×10 print, you are likely to have your original cropped to fit a format that does not match the shape of 35 mm film. Always ask for an uncropped, "full-frame" print and first take your slide out of its mount, unless you have specific cropping in mind.

DIGITAL PRINTING: DO THE JOB YOURSELF

Even the best of labs will rarely share the pride you have in your photography. If you find a print maker willing to put the same attention toward excellence as you are, you have found a gem. Even though not very many photographers keep a traditional darkroom at home anymore, you can still make your own prints that rival and even surpass the best commercial lab work.

Beginning in the late 1990s, inkjet printing, called "Giclee" in the fine art world, began to catch on with professional photographers who realized that the quality was astounding while the cost was modest. Inkjet printing has revolutionized the photo world.

To make your own inkjet prints, you need only a home computer, imaging software such as Adobe Photoshop (or the less expensive Adobe Elements), and an inkjet printer. You also need a film scanner to scan your negatives or slides or simply a card reader if you use a digital camera. Your computer does not have to be the fastest on the market but be sure to buy plenty of memory, or "RAM." Shopping "bots" such as www.pricescan.com and www.ramseeker.com can help you find the best price.

HP, Epson, and Canon each make excellent inkjet printers. If you already have an inkjet printer at home, chances are good that it is capa-

print portfolio quality checklist

For a professional presentation, your prints must excel in every way:

CONSISTENT PRINT SIZE. Choose a maximum width or height and try to print each image to that size. For precise cropping, it's perfectly okay to vary the other line measurement (e.g. some pictures 14x9 and others 14x7 inches).

CONSISTENT BORDERS. If you print with black borders or other types of border treatments, use them consistently and at the same width.

REMOVE ALL DUST AND IMPERFECTIONS. Spot traditional darkroom prints carefully. In "the digital darkroom," clone out dust and use Photoshop's "healing brush" to remove imperfections.

CONSISTENT MOUNTING AND MATTING. Do not bevel cut some mats while choosing another style for others. If you have an archival print, use only acid-free materials for mounting. Don't vary the color, size, or type of mat boards.

TRIM AND MATTE CAREFULLY. No ragged edges or mounting tissue should show. Use a ruler and straight edge to avoid crooked mounting and matting.

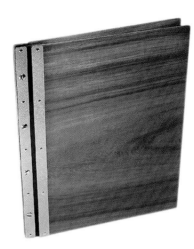

ble of making top quality prints.

Because I exhibit my work and sell it in the art world, only archival prints will do for me. For that, I choose an Epson pigment-based printer that is capable of making 13 × 19 inch prints. Because the technology seems to improve each year, I read the messages posted each day on an online forum dedicated to the particular printer model I use. To join a forum, try doing a search at Yahoo (groups.yahoo.com).

Although the printers are surprisingly inexpensive, consumables such as ink and paper can run up your bill. I buy supplies through the mail from Miami based Atlex (www.atlex.com), but lots of other good deals are out there if you are willing to do some searching.

Let's discuss quality. For color printing, most inkjet printers give great results. For optimum quality, it is best to keep your image resolution above 240 dpi (expressed as ppi in Photoshop). For color prints with inkjet printers, work in RGB mode. For most black and white printers, work in Grayscale mode. Try Duotone if you want to emulate a sepia tone or

Photoshop's *Color Balance* allows you to easily adjust the RGB settings used by inkjet printers. As the sliders are moved, the photograph adjusts automatically. Select *Midtones* at the bottom of the window.

When making adjustments in Photoshop, it's easy to return to any previous state by using the History palette found under the Window menu.

other tinted look.

To adjust color balance and tonal range, use the controls in your imaging software such as Photoshop and not the sliders in the software supplied with your printer. Consider calibrating your monitor. If you are an Apple user, first try the Colorsync software included with the Mac operating system. For more precise calibration in either Mac or Windows formats, try Monaco EZColor (www.monacosys.com) or the Pantone ColorVision Spyder (www.pantone.com).

Your results may improve dramatically with the use of software "ICC printer profiles" that are specially matched to your choice of printer and paper. I have had good success with the profiles made by Vermont-based Cone Editions (www. coneeditions.com). You may also make your own with the calibration software mentioned above. Companies such as Chromix (www.chromix.com) or ProfileCity (www.profilecity.com) can custom-make profiles using any printer, paper, and ink combination.

Digital black and white printing is trickier. Some high-end printers now include special inks just for black and white. Many pros take an older inkjet printer and optimize it just for their black

digital printing tips

You can quickly make high quality inkjet prints that rival the work of professional labs.

TRY PRINTING JUST A BIT DARK. Pros like their work slightly underexposed. Adjust your tonal range using Photoshop's Levels or Curves controls. In Levels, do most of your work in Midtones. Adjust Shadows only if you have washed-out blacks. In general, avoid changing the Highlights.

BURN, DODGE, OR "LASSO" EVERY IMAGE. Every picture needs a bit of customized tweaking. When using burning and dodging tools with software such as Photoshop, go easy when working in color or you will notice color shifts. Many pros prefer using a lasso tool or the pen tool or creating a "Quick Mask" to darken part of an image in Photoshop.

TAKE PRECISE NOTES. When your first print comes out of the printer, look it over carefully. If it is a bit warm, for example, try Photoshop's Color Balance control to add more cyan or green. Write down exactly what you have changed so you can keep track of your adjustments. If you don't like the results, use the History palette to return to any previous state.

DON'T SETTLE FOR SECOND BEST. Work toward being able to nail most prints in two or three tries. Do not stop until the results are pleasing to the eye. Save your file and all subsequent prints will be perfect. You can always automate tasks in Photoshop by using the Actions or Automate controls. Inkjet prints can look oversaturated, especially greenish tones. Use the Hue and Saturation control to tone them down. If you are just starting out, try the Variations control for quick color balance.

NEED A LARGER PRINT SIZE? Be sure that your image has enough resolution, expressed as either "dpi" or "ppi." (Avoid going much lower than 240 dpi.) If not, try LizardTech's miraculous Genuine Fractals software. It allows you to "upsample" a small file to make large prints.

FOR HELP, TAKE A DIGITAL PRINTING WORKSHOP. Excellent ones are offered by the Palm Beach Photographic Workshops, Maine Photographic Workshops, and Santa Fe Workshops.
(See the workshop guide at the back of the book and also check the offerings at your local community college.)

and white work. Cone Editions' PiezographyBW system (www.piezography.com) will give you archival prints with a tonal range that any zone system aficionado would be proud of. Others swear by the inks offered by a Michigan company, MIS (www.inksupply.com), or Lysonic (www.lyson.com).

The technology of inkjet printing is always changing. I keep up with developments through Utah's TSS Photo (www.inkjetart.com). Director Royce Bair can send you his excellent, non-invasive weekly news update via E-mail and the company also offers good prices on printers and supplies. Another great source for digital imaging advice and product tests is Michael Reichmann's The Luminous Landscape (www. luminous-landscape.com).

Several of the companies above also do custom printing if you do not wish to do your own. But I urge you to give it a try. Through a bit of trial and error, you can quickly obtain results that are truly professional level.

THE ALL-DIGITAL BOOK: TAKING DIGITAL PRINTING ONE STEP FURTHER

I regularly review fine art portfolios at Society for Photographic Educators (SPE) conventions and those of photojournalists at National Press Photographers Association (NPPA) gatherings like the Atlanta Seminar. Commercial, advertising, and nature photographers show me their portfolios at other workshops that I visit such as the FotoFusion festival held each winter in Delray Beach, Florida. Sometimes I see innovative ideas coming from the work of students, including our own at the University of Florida.

Students at a particular university often latch on to an idea that catches on with pros, too. In recent years, Western Kentucky University students have wowed me with custom made "books" that they print on an inkjet printer and spiral bind at their local Kinkos. The work of Price Chambers is a good example. Price imports his photos into desktop publishing software such as QuarkXPress, where he adds typography and captions. He prints complete layouts to his inkjet printer on heavyweight matte paper. Then, pages are dry mounted back to back, trimmed, and bound. (Some coated inkjet papers allow printing on both sides, eliminating the mounting and trimming process.)

Professionals are also benefiting from this method of all-digital portfolio production. Stone Editions (www.stoneeditions.com) offers do-it-

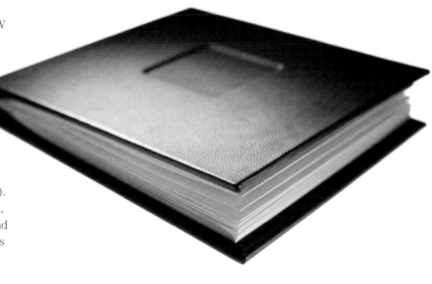

yourself cloth cover books with pre-hinged pages that can be fed through any inkjet printer.

(*Wedding photographers are now compositing and printing complete digital wedding albums. See Chapter 10 to learn more.*)

LAYOUT, PACING, AND TRANSITIONS

By now, you likely have a final edit in mind. I suggest that for book-style formats, place one picture per spread on the right hand page, where the eye naturally looks. Leave the left page blank or place a brief caption there.

Most mounted or matted presentations are on white boards. Commercial shooters and pho-

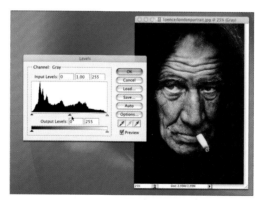
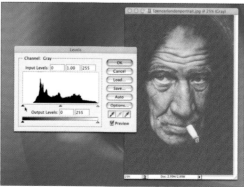

The Coffee Table Book from ArtZ adds a classy approach to traditional wedding album presentations. Acid-free 80 lb. woven paper insert pages have pre-cut window mats in a variety of shapes and sizes.

Using Photoshop *Levels*, the top picture shows a wide tonal range and properly shaped histogram. Below, notice the washed out blacks. To fix, just slide the far left triangle to the beginning of the mountain-shaped histogram. The left triangle represents *Shadows*, the middle one, *Midtones* and the right one, *Highlights*. It's a good idea to first try Photoshop's *Auto Levels* before opening the *Levels* control.

While a Western Kentuky University student, Price Chambers made his own digitally printed portfolio and had it bound at a local Kinkos. Professionals use such savvy techniques, too.

A Knoxville, TN party-goer reflects for a moment upon the enormity of his spliff while another waits his turn in the shadows. The subject wished to remain anonymous.

Ilya Khaytin from Russia waits inside the Nashville, TN Red Cross building to donate blood after the terrorist attacks on September 11, 2001. Khaytin attends Vanderbilt University Medical School and has lived in America for nine years. "I'm happy their were no nuclear weapons involved...We need to pray, bombing Afghanistan wont do anything." he said.

Donna Romaganoli of Bowling Green, KY has taught at Warren Central High School for 20 years. Here she helps Honors English students brainstorm about the subject of the sonnets they will write. "I wouldn't leave the classroom. I really, really do love them." she said.

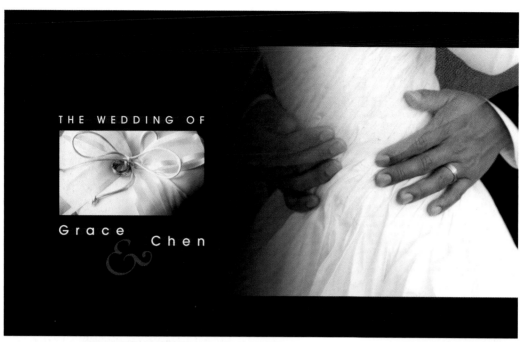

THE WEDDING OF

Grace & Chen

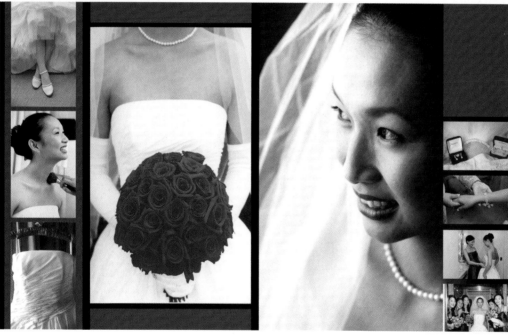

Wedding albums take on new sophistication when digitally composited and printed in magazine format. Photographers Kristin Jacobson and Sheree English utilize the elegant design and binding services of Digicraft.

tojournalists sometimes prefer the graphic appearance of mounting on black. White or black borders can be a nice touch as well.

Since the order of the pictures in the middle of your portfolio is not as important as your choice of opener and closer, take a careful look at transitions. Avoid jarring color or compositional changes. Make it flow. Consider transitioning a photo with warm, fiery tones to another with bright colors rather than a quiet, cool, or subtle image.

Even though I suggest mixing subject matter types, sometimes it makes sense to group. Perhaps a commercial shooter has an entire section with automobile shots. In such a scenario,

consider a title page for each distinct section. It's the same for photojournalists when displaying picture stories; have a title and brief caption at the start of the story. Don't assume that a viewer can tell when single images end and a story begins.

WHAT ELSE SHOULD I INCLUDE IN MY PACKAGE?

When choosing format, consider where you will fit your bio, promo card, or even a CD. Some portfolio types include handy pockets for such materials. You can make your own customized pocket for the back of the portfolio for storing odds and

print case types

No style is right for every photographer. Choose one that allows you to display your work with panache.

See the resources guide at the back of the book for companies that provide these and other popular styles.

CLAM SHELL PORTFOLIO BOXES
Made of heavyweight black binder's board, used to display mounted or matted prints.

ADVANTAGES | Inexpensive, can stay in box during presentation, easy access.
DISADVANTAGES | No handle included; slip inside a "TransPort" bag or shipping case.

LINEN BOXES
Similar in design to clam shell but covered in fabric.

ADVANTAGES | Can stay in box during presentation, easy access.
DISADVANTAGES | No handle. Protruding edges look great but can be bruised.

MUSEUM CASES
Black heavyweight briefcase style boxes with latches and a holder for your business card. Can be slipped inside carrying and shipping bags. For matted or mounted work.

ADVANTAGES | Heavyweight, classy.
DISADVANTAGES | Not all have handles. Heavy.

COMBINATION PRESENTATION CASES WITH PORTFOLIO BOXES
A presentation case as above but teamed with a sturdier box that it slips into.

ADVANTAGES | Classy, sturdier than case alone.
DISADVANTAGES | Usually no handle.

PRESENTATION CASES
Often black in color, many have zippers to protect what's inside. Usually soft leather or leatherette, some are fashioned in distinctive plastics or metals. Ring bound or with unobtrusive "screwpost" binding. The industry standard for unmounted work.

ADVANTAGES | Easy to update for customized presentations. Handle included. Lightweight. Great for large work without added weight.
DISADVANTAGES | Prints are placed behind shiny plastic. Pages scratch easily so buy extra and replace as needed. Not easy to ship.

"COFFEE-TABLE BOOK" PORTFOLIOS
Sometimes used for wedding albums, they often have a cutout on the cover to insert a square picture. Insert pages include window mats. Leather or leatherette. For unmounted work.

ADVANTAGES | Sophisticated, impressive for stylized presentations.
DISADVANTAGES | Small precut window formats for specific image sizes.

CUSTOMIZED PORTFOLIO CASES
Whatever you can imagine in exotic woods, leathers, brightly colored plastics or polished aluminum.

ADVANTAGES | Unique, feeling of importance. Customized sizes great for unique concepts. Can be imprinted and embossed. Envy.
DISADVANTAGES | Often expensive, can look dated over time.

ends or have an entire book custom made.

(Chapter 13, Self Promotion and Future Growth, has tips on how to produce effective résumés, cover letters, and promo cards.)

Captions provide additional information that may add needed context. No picture should be over-explained, though. Keep titles or captions brief and remember that any portfolio picture should be able stand on its own; captions will only be read if an editor or art director is curious about a particular image. Place captions unobtrusively toward the bottom of a facing page in book-style presentations or on the back of individually mounted prints. If you are using black pages, reverse the typography in your caption so it appears white against the black page.

If you feel that written materials placed inside your portfolio detract from your photos, by all means, create a separate caption sheet to leave with your client. "Thumbnails" of images can be a reminder of each picture. Fine art photographers should have both abstracts and full versions of their artist statement ready to leave with curators and gallery owners.

TYPES OF PORTFOLIO CASES
Your choice of presentation style is limited only by your imagination. Choose what is most appropriate for your specialty and what can help you be remembered. One caveat, don't try so hard to be original that your book might be considered tacky or amateurish.

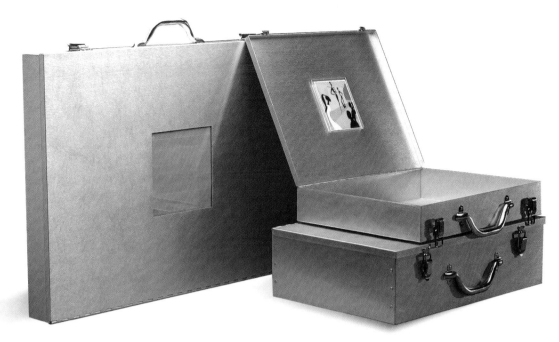

One of my personal favorites is the Boro Attaché from Pina Zangaro. A square cutout in front shows off one of your top images, a sure conversation starter.

As I mentioned, it will always be your pictures that really count, but it sure is fun to choose a stunning case. One of my favorites is an aluminum box with a square cutout for a picture on the front. It's made by San Francisco's Pina Zangaro (www.pinazangaro.com). People ask me where I got it every time I show up at a seminar.

If you are shooting for a young market or work in fashion or advertising, check out the "too-cool" innovative styles by Seattle designer Jason Brown of Lost Luggage (www.lost-luggage.com). They make stunning cases for photographers of any type. One company, Brewer-Cantelmo in New York (www.brewer-cantelmo.com) has been making gorgeous custom made cases for photographers and models for nearly a century. Another New York firm, The House of Portfolios (www.houseof portfolios.com), specializes in hand made books. ArtZ (www.artzproducts.com) makes wedding albums and presentation boxes that are classy and sure to impress.

(Wedding album companies are discussed in detail in Chapter 10.)

For unique materials such as copper, neon acrylics, and exotic woods, check out the offerings of Advertiser's Display Binder Company (www.adbportfolios.com). One old standby, Light Impressions (www.lightimpressionsdirect.com), is cherished by fine art photographers, museum archivists, and imagemakers of all types.

Must you have a custom-made book? Absolutely not. Local art supply stores have plenty of good choices and are a good source for zippered cases and acetate refill pages. If you cannot afford a fancy leather case, choose a modest "binder's board" box or make your own spiral bound portfolio at a local print shop.

If you have to ship or hand-carry your work a long distance, do not skimp. Many portfolio boxes are designed to slip into shipping and carry cases. Light Impressions sells handy TransPort Carry Bags and also specializes in fiberboard shipping cases made of strong polyethylene. Many camera stores also have good options for showing and shipping your portfolio.

Solid wood Light Impressions museum cases are great for transport and long-term storage.

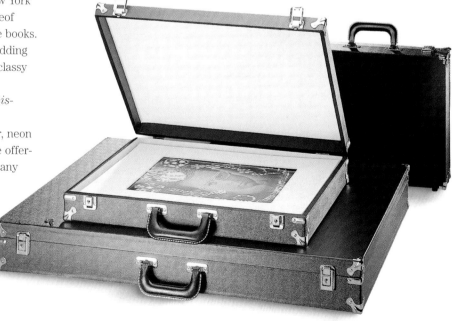

online portfolios »

With instant access to the masses, an online portfolio will showcase your work worldwide. Here's how to get your portfolio online quickly and inexpensively.

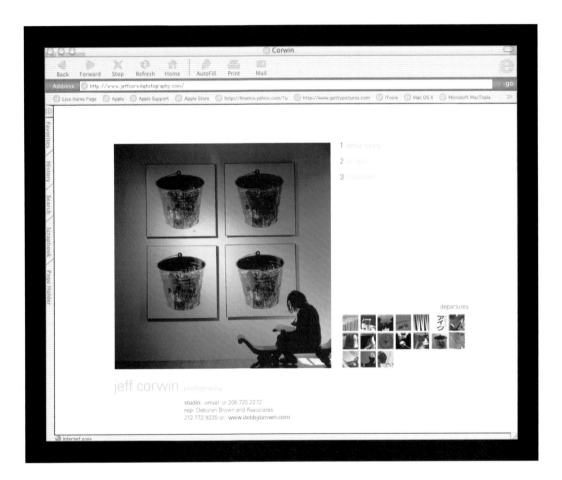

Before we begin talking about Web sites there is an important message for those of you who aren't overly computer-savvy. If you are the type of person whose eyes quickly glaze over when the talk turns to bits and bytes, do not believe that building your own Web site has to be overly difficult or technical. In this chapter, I will try to demystify the Web design process, and make it easy and fun. If you are skeptical, at least skim the chapter's sidebars that highlight key points. Even if you choose to hire a Web designer to build your site, you will pick up some common sense guidelines to make sure they do the job the right way.

If you can't find time to create your own website, be sure to find a professional designer that understands photography. Seattle's Brand Envy, a division of Lost Luggage, is one of the best. Their site for Jeff Corwin provides strong presentation combined with easy navigation. Small thumbnails serve to tease at what's to come.

No matter what, you need a Web presence. If you simply cannot find the time to put together your own site, consider a listing service such as www.portfolios.com.

Just because Web sites allow virtually limitless space, this does not mean you should use it. Anyone cruising the Net to look at portfolios can

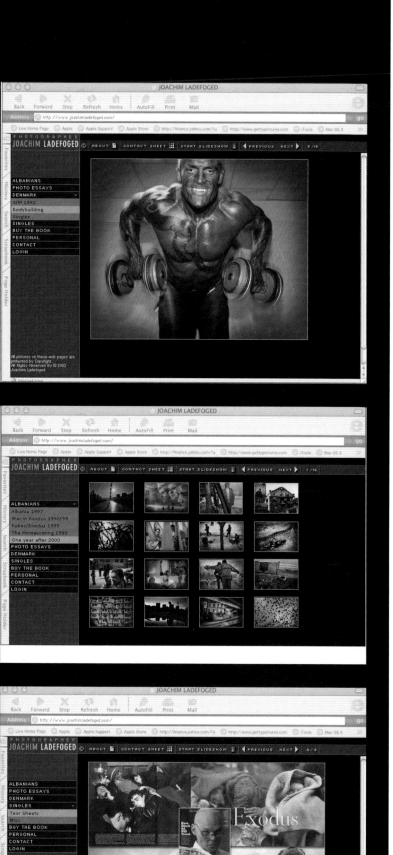

choose to look at your work, that of thousands of other worthy shooters, or literally millions of far more titillating Web sites. Keep your edit tight and you will keep others interested in your online portfolio.

When I teach Web design workshops for photographers, I remind even established pros that a good Web site should show off their best pictures, cleanly and without tacky gimmicks. "Bright as he is, man has not yet developed an electronic successor to creative thinking," says Bob Gilka, the former director of photography at *National Geographic*.

NEVER CHASE AWAY A POTENTIAL CLIENT

Many commercial photographers I talk to tell me that their Web site drives their entire business, virtually replacing other portfolio types. For in-person meetings, traditional portfolios are still required. However, busy clients love the convenience of simply looking online to find a photographer's style that fits their needs.

Avoid going too high-tech unless you are positive that all potential clients have the technology and patience to see your wizardry. For example, there is a current trend toward building multimedia photography Web sites that incorporate sound and self-running picture shows. Many of these use Macromedia Flash software, which can be a fantastic tool in the right hands. If you want to utilize multimedia options, do not take navigational control away from the viewer. By forcing someone to watch an animated show of an indeterminate length, you may also likely chase a buyer away from your site. Any site that asks viewers to download non-standard "plug-ins" will also drive away clients afraid of viruses, incompatibility, or technology in general.

Make sure that the viewer can choose what to look at and at what pace. This is accomplished through the use of a main index with subheadings. From any page in your site, let the viewer return "home" so he or she can choose to look at other picture groupings or even your online resume. Using tools such as Flash can certainly

The superb website of Denmark-based photographer Joachim Ladefoged is user-friendly and versatile. The main index along the left allows any client to navigate the site. A secondary index is stripped along the top, allowing viewers to manually click through images one at a time, choose a thumbnail view, or watch an automatic slide show. Ladefoged, of Agence Vu, posts tearsheets online from impressive clients like the *New York Times Sunday Magazine*.

be a strong addition to your site, but they often require high-speed connections that not everyone has. Make such viewing options a choice and not an automatic default.

(*To learn more about the effective use of multimedia online or on disk, read the sidebar in Chapter 6, Ask the Multimedia Experts.*)

BUILD IT YOURSELF

If you follow the Web design advice in this chapter, you will have plenty of creative control to make a unique, fun, and effective Web site. Remember, it is great photography that you want your clients to remember, not your computer programming skills. By devoting even one long weekend to this project, you will have a new online portfolio that can be appreciated by a viewer anywhere in the world.

The most crucial advice I can offer is to keep it simple. Let the pictures do the talking and make it easy for the viewer to jump to any section and return back to your main index without getting lost.

NO PROGRAMMING REQUIRED

Some well meaning "experts" will tell you that real men (and women) must build their Web site from scratch using HTML computer coding. You will hear that easy-to-use Web-authoring programs clutter up the coding and that all sorts of scary problems occur if you use them. With all due respect to my colleagues who are expert programmers, this is nonsense.

After all, when we use the computer to compose a letter or write a story, we are not expected to write in computer code. Learning a bit of HTML programming can always be helpful for complex tasks, but is absolutely unnecessary to build your first great Web site. The right software lets you create a superb design without hassle. The best programs also feature advanced tools that offer as much complexity as most anyone could ask for.

The two top programs, Macromedia Dreamweaver and Adobe GoLive, are available for either Windows or Mac platforms. Dreamweaver integrates seamlessly with Macromedia's popular Flash software but has a bit steeper learning curve. GoLive is such a great program that Adobe was forced to buy out the small company that invented it because its product was by far the best on the market. It features a simple to use grid system that allows items to be dragged or dropped onto a page, much like a design program such as QuarkXPress or Pagemaker. GoLive also integrates seamlessly

YOUR BEST MOVE

"Keep your online portfolio as simple as possible. Make sure nothing gets in the way of your photographs"

JOE WEISS
Multimedia Editor, MSNBC

Freelancer Eric Larson's Web site features a clean and simple design that sells his portfolio without the need for gimmicks.

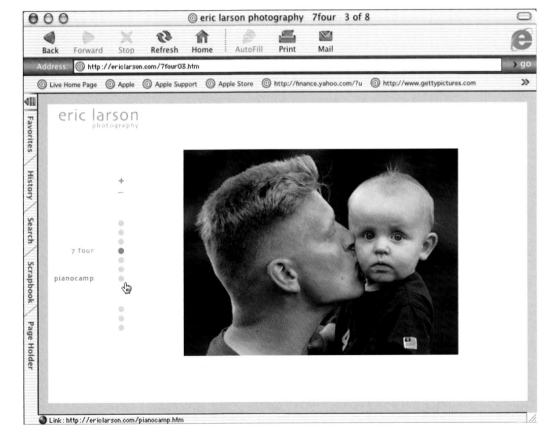

with Adobe Photoshop, making it easy to use for photographers.

Whichever program you settle on, check around for the best software price; several companies also offer reduced student deals. I prefer GoLive for its simplicity, but both are terrific.

LOOK AT PHOTOGRAPHERS' WEB SITES

Before you start to build your own Web site, check out photo sites that you admire. Portals such as Yahoo list lots of them. Then, make some sketches and plan your own design and typographic approach. For logo and category headings that look more sophisticated than the default Web fonts, Arial and Times, you can make "GIFs" using Photoshop's type tool. (Adobe Elements also has this tool.) Generally, you will want to save typography files in the GIF format and pictures in the JPG format.

SECURE A NAME AND HOST PROVIDER

Before designing the site itself, it is a good idea to choose a name and secure your server space.

To see if the name that you want is available, do a quick search at a "domain name registrar" such as Network Solutions (www.networksolutions.com). Network Solutions used to have a monopoly on names but now several other companies such as DomainBank.com (www.domainbank.com) are also allowed to register them. Try a Google search (www.google.com) to locate others. For less than twenty dollars a year, you can secure your name. Avoid specialty names such as ".tv" If you can get "YourName.com," clients will easily remember it.

Next, you need a host provider. This is the company that hosts your site by storing your HTML pages and image files on its server. Be sure that the company will host your name and not attach it to its own. You want "www.johnsmith.com" and not "www.yourprovider.net/homepages.johnsmith." Avoid free or low cost sites that force banner or pop up ads onto your page. For less than fifteen dollars a month, you can find a reliable provider. Try a search at www.tophosts.com to find one you like.

DESIGN A FLOWCHART

A flowchart ensures that your Web site will be organized and easy to access. The flowchart should include each page you plan for and all "links" to other pages. Some sites, such as my own (www.johnkaplan.com), also have what is called a "splash screen." Think of the splash screen as similar to a magazine cover. It introduces the site. The viewer then turns inside to a main index page, which is analogous to the index on page three of most magazines. Your index page will serve as the menu for each of the site's main sections. For example, my site index features sections like "Singles," "Stories," "Exhibitions," "Books," "Bio," and "Teaching."

Have an organized naming system. For example, name image files such as this:

"KaplanSingles1.jpg"
"KaplanSingles2.jpg"

"KaplanStory1.jpg"
"KaplanStory2.jpg"

The University of Florida international photojournalism Web site (www.international photojournalism.com) utilizes the "splash screen" approach. As the site's first page, it's intent is much like that of a magazine cover. Users have a choice to link directly to the index page or watch a brief Flash multimedia intro.

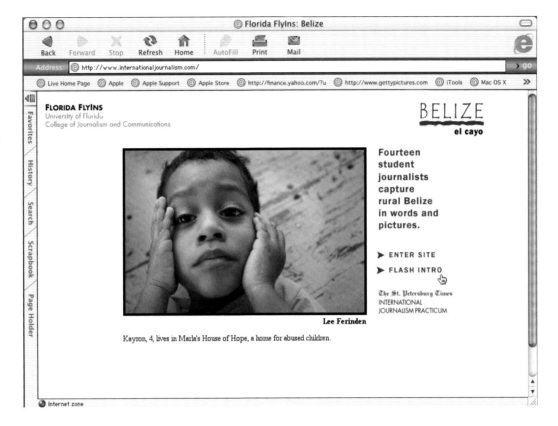

Note that there are no spaces between file names. This is very important so the Netscape Communicator or Microsoft Internet Explorer browsers can read every file without error.

PREPARE IMAGE FILES IN ADVANCE

Next, prepare all of your files before starting to build pages. It is important to keep file sizes just small enough in terms of kilobytes ("kb" or "k") to load quickly, and just large enough to display well on screen. Save all files at "screen resolution" of 72 dots per inch.

Use standard image sizes such as about 400 × 265 pixels (5.5×3.6 inches) for most of your photos to create a "design grid." Most of your pictures are probably horizontals so try a standard size such as this. Since you do not want a viewer to have to scroll through a vertical, consider a smaller standard size for those, such as 330 × 220. Pictures with unique shapes do not need to be miscropped; stick with longest measurement and adjust the crop as needed. Photoshop offers a fixed cropping option (called "Fixed Target Size" in versions earlier than 6.0) that automates cropping and choice of resolution for similarly shaped images, a great timesaver.

You may be wondering why I suggest a relatively small picture size. 400 pixels is about 5.5 inches wide at 72 dots per inch. There are several good reasons. The first is that not all users

have fast Internet connections. A color image, saved at 400 pixels wide, 72 dots per inch and compressed in JPG format, uses roughly only 50k of server space. It will load, or "res-in," quickly even with a slower modem. When you save your photos in JPG format, choose a medium quality setting such as 5; the pictures will still look fine.

The second reason for not making pictures too large is that your site needs to be created with a sensible design approach. Professional Web designers currently use a standard 800 × 600 pixel "grid," meaning that no item on your page should extend beyond 800 pixels wide. Remember that you need to leave room for section headings, captions, and white space, too. Any page that goes beyond 800 pixels wide will force some viewers to scroll from side to side, a sure sign of amateurish design.

Web authoring programs allow you to choose a standard size to work within; currently, 800 × 600 is the way to go. While it is possible to place items below the 600 pixel line, doing so will force the viewer to scroll. This is not a problem for text but never make someone scroll through part of a picture or its caption.

To avoid confusing or annoying a potential client, it is also very important not to place any navigation tools lower than the 600 pixel line. Each software program has rulers that let you place items carefully.

"Unsharp masking" is also crucial to keep your images from appearing out of focus online. Even though it is called "unsharp," this filter sharpens photos for on-screen viewing. In Photoshop, go to Filter/Sharpen/Unsharp Mask and try changing the percentage setting to about 80. Leave threshold and radius at their default settings.

(For more technical help, see Web Site Preparation Tips on page 58.)

MAKE A FOLDER FOR ALL IMAGE FILES

By first creating a folder on your desktop with all of the picture files and type GIFs for your site, you will then easily be able to drop them into your software's proprietary site folder as you build it. Before uploading all files to your host provider, be sure to remove any items not actually used by your site.

DON'T FORGET OTHER DESIGN ELEMENTS

After preparing files of your photographs in Photoshop, use its type tool to make your typographic "GIFs." The program's Edit/Save for Web feature is a timesaver for either pictures or typography. Make your navigational tools this way, too, or try various third party button-making programs.

An organized system of design should keep

navigation tools such as "Next," "Back," and "Home" buttons in the same place on every page. After all, when we watch television, we expect the buttons on our remote control to be in the same place every time we pick it up. Don't make viewers hunt just to find their way around.

BEGIN BUILDING YOUR WEB SITE

With a flowchart in hand and all pictures and type elements sized and ready to go, you can begin to build your site. By first stepping through a brief tutorial on how to make a Web site in GoLive or Dreamweaver, you will be far more comfortable and less likely to make time-consuming mistakes with your portfolio. I recommend picking up a copy of the excellent Visual Quickstart Guides published by Peachpit Press (www.peachpit.com). They provide an easy-to-follow tutorial for each program and are inexpensive. Walk through the tutorial by building a quick mock Web site and you will understand the mechanics of how Web pages are built and how pages link to one another.

Adobe (www.adobe.com) and Macromedia (www.macromedia.com) both have free online training for each of their programs. For now, do

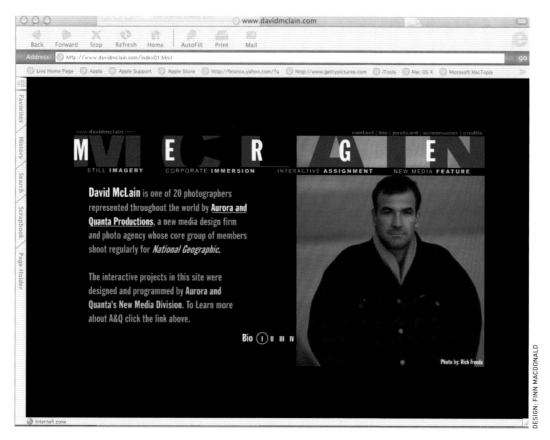

A link from the index page to a brief bio should be a part of any photographer's online portfolio. Aurora photographer David McLain's Web site gets right to the facts.

DESIGN: FINN MACDONALD

The Web site of *Sports Illustrated* contract photographer Bill Frakes features an index that is accessible from any page in the site. Scrolling thumbnails at the bottom of the page let a client quickly find and enlarge a desired image.

not get bogged down in detail, just get a sense of the mechanics of building a site.

CREATE A DESIGN GRID AND PAGE TEMPLATES

In Web design, your first page is most always called index.html. This is essential so any hosting company can read and display your site. Use index.html for your "splash screen" cover page or go straight to a main index if you prefer. On your index, create links to each of your major sections such as "Portfolio" or "Résumé." For a professional look, place repeating elements in the same place on every page, known as "designing on a grid." This includes placement of titles, navigational tools, and especially photographs.

By creating one page to serve as a template for pages with a horizontal photo and another for pages with a vertical, you can simply choose File/Save As to build each new page. Then, replace the picture and retype a new caption using the software's text editor. Quickly change the links and any new logos and your new page will be complete. Once you have designed a basic look that you like, the site can be built quickly.

web site preparation tips

Here is how to get all of the elements in place so building your Web site will be a breeze.

LOOK AT WEB SITES YOU ADMIRE. Note their typographic, design, and navigational styles. Is it easy to find your way around or do you get lost in layers of links? Are you forced to use the browser's "back" button or does the site have its own intuitive navigation tools?

CHOOSE YOUR SOFTWARE. Knowing how to write computer code is not needed. Adobe GoLive and Macromedia Dreamweaver software are both excellent. For first time Web designers, GoLive is easier to use and integrates easily with Adobe Photoshop. Dreamweaver integrates well with Flash software.

SECURE YOUR DOMAIN NAME AND HOST PROVIDER. Try a search of available names at www.network solutions.com or www.domainbank.com. Search www.google.com to find other domain name registry companies. For leading host providers, look at www.tophosts.com.

PREPARE A FLOWCHART. Ease of navigation and consistent organization will be key. Keep it simple. You want viewers to marvel at your photos, not a gimmicky presentation. Remember to edit your photos as tightly as possible.

PREPARE PHOTOSHOP FILES IN ADVANCE. For photos: Web browsers cannot read PSD or TIFF image formats. Photographs should be saved in JPG format. For picture sizing, try horizontals at about 400x265 pixels and verticals at about 330x220. Don't go beyond a width of 500 pixels unless you are sure that your entire audience has a high-speed connection. Save JPGs at a medium setting such as 5 to reduce file size while maintaining image quality. All files for the Web should be 72 dpi. Unsharp mask every photo in Photoshop or pictures will look "soft" on screen. For most images, set at about 80 and leave radius and threshold at their defaults.

FOR TYPOGRAPHIC ELEMENTS. For a professional look, prepare logos, special headlines, and navigational tools in Photoshop, saving in GIF format. Try Photoshop's Edit/Save for Web feature. Use Web-safe colors for type prepared as GIFs. In Photoshop's Color Picker, choose "Web Safe."

MAKE A FOLDER FOR ALL IMAGES ON DESKTOP. Doing this in advance will allow you to easily drag in files onto your Web site as needed. Before uploading, remove any image file not actually used in the site.

Adobe GoLive software, at left, allows the user to "point and shoot" to easily add images to Web pages. To add a picture to an image box, simply click the Source button in the Inspector box, drag the cursor to the Web site content folder, and point to the desired photo file. The software automatically imports the photo onto the page.

Similarly, below, Macromedia Dreamweaver offers the Point-to-File feature to simplify the process of adding a link.

ONE PICTURE TO A PAGE

In most cases, it is best to use just one picture per page. An exception would be if you want to create a page filled with small thumbnails that each link to larger versions of pictures. Keeping one picture to a page avoids a jumbled look while assuring fast loading time. After choosing "Save As" to make a new page from your template, do not delete a picture box to add a new photo. Instead, just change the file name. Then, your picture box will stay in place. For example, in GoLive, this is done in the "Inspector." Simply type in the new file name or, in GoLive, "point and shoot" to find a file in the software's folder. This nifty feature points an arrow right to the picture file you want and drops it into the picture box automatically.

BLACK BORDERS MAKE PHOTOS STAND OUT

Black borders are a nice touch. Both programs let you choose point size and color for a frame around a picture. Add a border to the picture box on your template pages. Then, as long as you delete the previous page's file name and not the picture box itself, the frame will stay in place as you build new pages and drop in new photos.

the photographic portfolio of John Kaplan

► come inside

Come inside

Two link types: The underlined version, called a "hyperlink," is the easiest to make—just highlight any HTML text with your software's link tool. You will be prompted to type in the page where you want the user to go. The version with the triangle was made with Photoshop's text tool and saved as a gif file. After placing any gif or jpeg on the page, use GoLive or Dreamweaver to create an "image map," turning any image into a link. Image map links allow greater type choice.

web site buiding tips

Your site can be built quickly by following these guidelines. Keep the design clean and consistent and you'll have a winner.

DESIGN "ON A GRID." Your Web site should be designed in standard 800x600 pixel format. Have items such as images and navigational tools line up in the same spot from page to page. By creating templates for pages with horizontal or vertical images, you can copy using "Save As" to build similar pages rapidly.

ONE PICTURE TO A PAGE. With the exception of "thumbnail" pages, place just one image to a page and create links to successive pages. This allows clean design and fast loading time.

ADD BLACK BORDERS TO PHOTOS. Adobe GoLive and Macromedia Dreamweaver software both allow the easy creation of borders in choice of size and color.

KEEP CAPTIONS BRIEF. In most cases, the viewer controls which size to choose to display HTML typography. Although you can try to use "cascading style sheets" to dictate font attributes, older browsers do not read them.

CREATE EASY-TO-UNDERSTAND NAVIGATIONAL TOOLS. Make navigational tools in Photoshop or Elements and save in GIF format. Place consistently on each page. Navigational tools should be simple and functional, never competing with photos for attention.

TEST WHILE YOU WORK. Check your page design in progress by viewing Web pages in your Web browser. GoLive and Dreamweaver let you do this from within the program, without an Internet connection. Check links and make sure images read properly.

BE BROWSER-SAVVY. Change the title bar on every page so "Web crawlers" can list your pages by topic. Then, potential clients can find your work by doing a Web search. "Keyword tags" also allow search engines to find your portfolio.

ADD AN E-MAIL LINK. Allow clients to give you instant feedback on your work.

KEEP CAPTIONS BRIEF

For captions, you may type them directly into an easy-to-edit text box placed on the page. HTML type is not expressed in standard point sizes; standard HTML sizes are "2" or "3" for captions. By creating "cascading style sheets" you can attempt to force a viewer's browser to display type in your chosen font and size. However, all users have the choice of how to set their browser and at what size to display fonts. Therefore, you would be wise to keep captions brief; they will display differently on various clients' monitors. In most cases, stick with the default Arial or Times font choices. Some photographers make GIFs in Photoshop for a fancier but less flexible approach to captions. For type, GIF file sizes are relatively small and they load quickly.

CREATE EASY-TO-UNDERSTAND NAVIGATIONAL TOOLS

Keep your navigational tools simple and easy to understand. You may use words such as "Back," "Index," and "Forward" or use arrows or other logical icons. Make sure that the navigational tools stay in the same spot and do not jump around from page to page. Their design style should never detract from the impact of your pictures.

TEST WHILE YOU WORK

Both programs allow easy viewing in each browser, Internet Explorer and Netscape Communicator, without actually needing to be online. This helps you troubleshoot while you build the site to be sure that links work and items display properly. Each browser is unique and will show slight differences in displaying type and rendering pages. Even within the same browser, the Macintosh and Windows versions will show variations. For example, photographs appear darker on PCs. Check each if possible.

If your page opens with a blank box with an X in it instead of a photo or a type GIF, do not panic. Re-import the element and test again. Did you save the photos in JPG format? Remember that you must use JPG or GIF formats for the Web. ("PNG" is another acceptable, newer file type.) Do not put spaces in file names or some browsers will not read them. It is also possible to make an unintended error in importing a file. First, drag each into your software's proprietary site folder and then onto the page.

Dreamweaver and GoLive also have built-in "link checkers" that can help you make sure all links work properly. Test the links on every page to be sure.

BE BROWSER-SAVVY

As you build pages, change the title bar text at the top of each page. This text is what will display at the top of the viewer's Web page. "Web crawlers" automatically search the Internet and find pages according to subject and what is written in the title bar. Put pertinent information such as "Joe Smith Photography: Autos/1958 Chevrolet Corvette" in each title bar. Then search engines will find each unique page on your Web site, bringing in clients you never knew existed. By learning a bit about HTML coding, each program also lets you insert "meta tags" or "keyword tags" to help search engines find your portfolio.

The top photo shows the GoLive Layout view. Items can be aded and moved around the layout grid as desired. To check work in progress, the bottom photo shows how the software lets you open any page in Internet Explorer or Netscape Communicator—no need to actually be online.

Award-winning Web designer Joe Weiss creates sophisticated but easy to follow indexes. Your Web site should always start with an organizational plan and flowchart for the entire site.

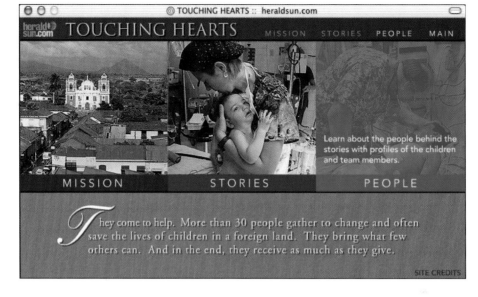

▶ back | ▶ home | ▶ next

A link can be made to change color as the cursor is moved over it. To make a "rollover," create two near identical GIF files, each of different color. Web authoring programs like Dreamweaver and GoLive are easily programmed to create the effect.

CREATE AN E-MAIL LINK

To generate repeat sales from your online portfolio, let your clients E-mail you directly from your Web site. The easiest way to do this is by simply creating a link. For an E-mail link, simply type in "mailto:youremailaddress.com."

Some advanced designers opt to create an E-mail template form where clients can request specific information with "checkboxes" and "radio buttons." Although such techniques do have their advantages, I recommend making it as easy as possible for a potential client to E-mail you right from your site.

ADVANCED TECHNIQUES

Add both practicality and panache to your site with easy-to-add advanced design techniques. Consult your software manual for the details.

MULTIMEDIA: Many photographers add multimedia elements as a marketing tool to create a strong impression. For example, Macromedia Flash software is popular to create animated "movies."

(*See Chapter 6 to learn more about the dos and don'ts of multimedia.*)

ROLLOVERS: Also called "mouseovers," a rollover is a link that changes color when the viewer's mouse moves over it. Make two same-size GIFs in different colors to create them. As the mouse rolls over, one GIF is replaced by the second, creating the illusion of a color changing.

STATUS WINDOWS: As you look at the very bottom of any Web page you will see the status window. This is the window that shows the progress as a Web page loads in your browser. When the cursor is placed over a designated link on your page, you can have the window change to a customized message to promote your work. For example, for a link called "Picture Story," the status bar can change to "See my pictures of the Alaskan wilderness."

THUMBNAILS: You have likely seen photographers' Web sites that show a group of small "thumbnail" photos on a page. The viewer clicks on the smaller version of a picture and actually

web design don'ts

DON'T LET YOUR DESIGN COMPETE WITH YOUR IMAGES. Your online design should ideally parallel the image that you create with printed materials such as letterhead or delivery memos.

DON'T USE TOO MUCH SPOT COLOR. We don't use pink slide mounts do we? Professional designers stick with a couple of tasteful, complementary color choices. Less is more.

DON'T USE GIMMICKY ANIMATION. Shareware such as "GIF Animator" is best used for more playful presentations. Selling your portfolio is what is important. Show off your photography, not your programming ability.

DON'T LOSE THE VIEWER IN LAYERS OF LINKS. From every page in the site, your client should be able to quickly return to the main index.

DON'T MAKE THE VIEWER SCROLL THROUGH PART OF A PICTURE OR CAPTION. Design your Web site in standard 800x600 pixel format so all viewers can see your portfolio without difficulty. Scrolling should be reserved for long blocks of text, such as your resume.

AVOID USING BLACK BACKGROUNDS. They look sexy but impede readability and can cause eye-strain. If you just can't resist, make your captions larger for legibility.

DON'T USE ITALIC TYPE FOR BODY COPY. The low resolution of the Web makes italic type nearly impossible to read. Instead, try bold or other contrasting typography styles.

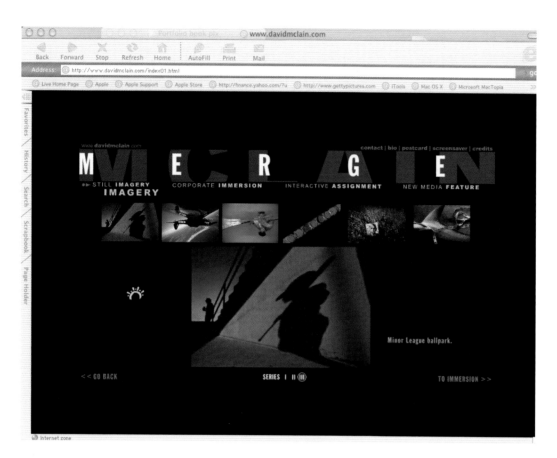

The bold index page for freelancer David McLain's site has links to corporate work, series, and even interactive multimedia assignments. It includes important links for E-mail and his online bio.

links to a new page containing a larger version. This can be a great technique but remember that tiny pictures don't communicate well alone, considering low screen resolution. Use thumbnails to facilitate user choice, but avoid making viewers return to the thumbnails page every time to see pictures at larger size. Always allow an option to click through full-sized pictures one by one.

WATERMARKING: If you have hesitated to put your work on the Web for fear that your images would be stolen, watermarking can put your worries at ease. In Photoshop, place a "digimarc" on each image by going to Filter/Digimarc/ Embed Watermark. The effect does not impede viewing. Remember, too, that 72 dpi images on the Web might be stolen for a school report, or another Web site, but are often too small to be used well in print. For Windows users, a free "JavaScript" program makes it more difficult for users to steal images by right clicking and dragging them to their computer's desktop. The script is available at www.billybear4kids.com/ clipart/riteclic.htm

HOW TO UPLOAD YOUR SITE TO THE WEB

Hopefully, after just a couple sleepless nights and a minimum of head scratching, you will be able to build a sensational Web site. I urge you to give

it a try. Only a photographer can best know how to display his or her work. There are several excellent Web design firms out there but they can be pricey. Also, even Web designers do not always understand the power of pictures.

After building your online portfolio and testing all links, you are ready to upload. After you choose your domain name and hosting company, your "host" will give you "FTP" instructions. FTP is a protocol for uploading your Web site to a server. You will need to copy and send all HTML page files along with each image file, including all photographs and typographic GIFs.

Dreamweaver and GoLive each include built-in FTP software. Simply open it up and type in the server address, your Web site address, directory folder (often left blank), and password. Select "connect" while your modem dials the host server. Select all files and drag into the appropriate folder, as instructed by your host provider. Since you are copying a multitude of files, be patient while they copy. A high-speed "broadband" connection saves time.

After dropping your files, your online portfolio is now on the Web and open for business.

CD portfolios
and multimedia >>

*Cheap to produce and easy to distribute, disks also have drawbacks. Here's
how to get your digital portfolio noticed, not buried in a pile of paperwork.*

6

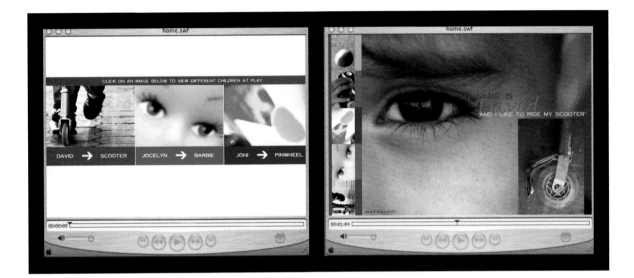

Although Web sites have become the most important way to view a photographer's portfolio via the computer, you should consider producing copies of your portfolio on disk as well. Why? No busy editor or curator wants to wait to see your work. Depending on whether the person evaluating your work has a high-speed Internet connection, or if a server is jammed at peak times of the day, photographs (and particularly multimedia presentations) can be slow to load online.

"The Internet is the big gorilla of image presentation, but it has skinny little legs," says Ohio University professor Terry Eiler. "Until broadband connections are absolutely common, you've got a delivery problem—the speed and quality of the image."

Done right, a portfolio on disk is viewed easily and quickly. A disk also has the advantage of being a concrete reminder to the viewer that your portfolio deserves a response. As I mentioned, an online portfolio exists only in cyberspace while a disk commands attention. Much like a music CD, the box containing your disk should have an eye-catching cover and support-

Created with Macromedia Flash software, David Mclain's disk lets the viewer click on an index of three stories to launch a multimedia show. The presentation plays on Macs or PCs with the Flash plug-in, which comes pre-installed with newer Web browsers. If users don't have Flash, the program opens in free Apple QuickTime software or RealNetworks RealPlayer.

ing materials that compel your client to open it.

When zip disks became popular in the 1990s and few CD or DVD burners yet existed, zips became the first industry standard for viewing digital portfolios. Now, CD burners are standard on even entry-level computers and DVDs are replacing CDs because of their greater storage capacity for multimedia. It used to be a bargain to make a portfolio copy for ten dollars on a zip. Today, CDs can be produced for just pennies.

Although I encourage you to distribute as many copies of your work on disk as possible, you will need to be creative in assuring that

WEB SITE AT RIGHT | Just like any good Web site, Mark Adams has easy to follow navigation and engaging content throughout his disk portfolio.

back

Joshua Tree National Park, California

next

menu

end

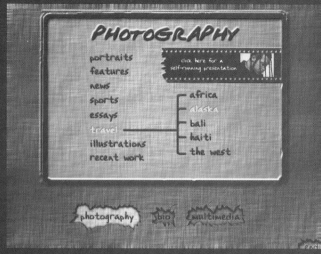

PHOTOGRAPHY

portraits
features
news
sports
essays
travel —
illustrations
recent work

click here for a self-running presentation

- africa
- alaska
- bali
- haiti
- the west

photography bio multimedia

end

BIO

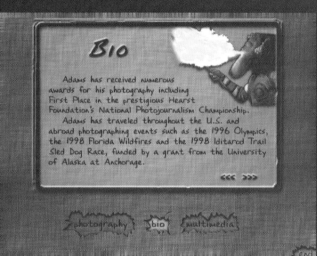

Adams has received numerous awards for his photography including First Place in the prestigious Hearst Foundation's National Photojournalism Championship.

Adams has traveled throughout the U.S. and abroad photographing events such as the 1996 Olympics, the 1998 Florida Wildfires and the 1998 Iditarod Trail Sled Dog Race, funded by a grant from the University of Alaska at Anchorage.

<<< >>>

photography bio multimedia

end

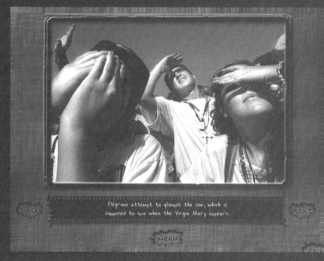

back

Pilgrims attempt to glimpse the sun, which is supposed to spin when the Virgin Mary appears.

next

menu

end

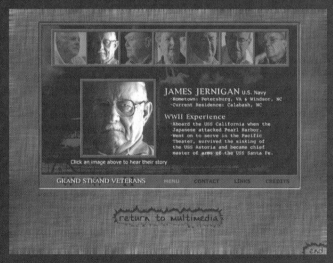

JAMES JERNIGAN U.S. Navy
- Hometown: Petersburg, VA & Windsor, NC
- Current Residence: Calabash, NC

WWII Experience
- Aboard the USS California when the Japanese attacked Pearl Harbor.
- Went on to serve in the Pacific Theater, survived the sinking of the USS Astoria and became chief master of arms of the USS Santa Fe.

Click an image above to hear their story

GRAND STRAND VETERANS MENU CONTACT LINKS CREDITS

return to multimedia

end

back

Jessie Wilson, Jr.'s hand rests on his Hammond B3 organ.

next

menu

end

David McLain's Flash presentations for the Classroom Connect program utilize sound, animation, and of course great photography. One smart feature: the viewer can turn off the sound at any point in the show.

Software programs such as Roxio's Toast for the Mac and Easy CD Creator for the PC (www.roxio.com) help ensure that you can burn a "cross-platform" disk.

Your next challenge will be what software to choose. Stick with something basic unless you plan to incorporate complex multimedia elements. For the Mac, QuickShow LT shareware software by Dave Howell was an effective standard for photographers to share their work on disk for nearly a decade. This easy-to-use software is simply dropped into any folder containing RGB image files. While not fancy, the program creates a nice slide show of JPG files.

QuickShow still works, but only in the Mac "classic mode," not with operating systems X and later. Unfortunately, it has not been updated in years. Without a consistent upgrade path it is likely that this program will fade in popularity in years to come. You can download it free by doing a Web search. Interestingly, there is another image-viewing product named "Quickshow" for Windows but it is a different program entirely and "buggy" to use in my experience.

Operating systems are in constant flux. Recent versions of both Mac and Windows systems include basic image viewing software. On the Mac, "iPhoto" is inexpensive but you can never be sure if it is installed on a particular computer. In addition to its ability to organize digital picture files, it can create a simple slideshow.

If all of this talk of compatibility issues seems like a headache, that's because, in all honesty, it really is. You do not want to risk losing a big job by not knowing if your disk is compatible. Hopefully, in years to come, a new standard will emerge with the ease of use of QuickShow that allows hassle-free viewing of a portfolio on disk. Check out my Web site (www.johnkaplan.com) for updates on this book as technology and photographic industry norms continue to evolve. For detailed information on how technology is changing the imaging world, take a look at Rob Galbraith's site for digital photographers (www.robgalbraith.com).

those who view your work will be able to see your disk without compatibility problems or inconvenience.

As with the Web, prepare all of your image files at 72 dpi. Use Photoshop's Unsharp Masking feature to make images appear appreciably sharper onscreen.

It is not enough to fill a folder with JPG image files and burn it onto a disk. No editor or curator is going to look at your work if forced to manually open each file in a program like Photoshop. Your challenge is to find a way to allow your images to be viewed quickly while at the same time leaving navigational control and viewing options in the hands of the person evaluating your portfolio. You will also need to decide whether you wish to incorporate other multimedia elements such as sound, animation, or even video.

YOUR BIGGEST MISTAKE

"Don't assume that every computer works like your own. People could question your competence if they can't read your disk."

JOE WEISS
Editor, Multimedia Producer

HOW TO AVOID COMPATIBILITY NIGHTMARES

If someone has a problem opening up your disk, you might never know. With a large pile of portfolios to evaluate, an editor or curator may simply move on to the next, forgetting about yours. This is one reason why disks are often used as supplements to print or slide portfolios. After a print portfolio is returned to the photographer, the disk can stay behind as a reminder and reference.

In most genres of photography, the Macintosh operating system is more popular among pros, but you can never be certain that your disk can even be opened on any given computer unless you have a personal relationship with the person checking out your portfolio.

MAKE AN HTML PORTFOLIO ON DISK

To avoid a steady stream of compatibility hassles, my suggestion is to create your disk portfolio

ask the multimedia experts

With so many software choices for building a digital portfolio on disk, I asked these leading experts to share their advice. With a sensible and not overly technical approach, the process of adding multimedia such as Macromedia Flash movies to a disk or to a Web site can be nearly one in the same.

THE PANELISTS:

PROFESSOR TERRY EILER: A former photographer for *National Geographic*, Ohio University's Professor Eiler has taught and trained top young multimedia creators.

MARK ADAMS: A freelance multimedia designer and former national Hearst championship winner, Adams is also highly sought after as a freelancer for his new media design work.

JOE WEISS: The winner of several Pictures of the Year awards for his Web design incorporating pictures and sound, Weiss is a frequent workshop leader. He is multimedia editor at MSNBC.

DAVID MCLAIN: A member of the Aurora & Quanta Productions picture agency. McLain's multimedia photographic expeditions across the globe are shared live with more than 250,000 school children participating in the Classroom Connect program on the Internet.

How can a photographer avoid being intimidated by technology?

MCLAIN: "Don't get too caught up in technology. It's just another tool. Ask, 'Who is my audience? What am I trying to communicate? What is the best tool to convey that message?'

"I'm not a programmer. You don't have to do the multimedia yourself. Collaborate with an expert. Barter for services if you need to."

ADAMS: "Multimedia is like taking pictures. When shooting, you can get bogged down in the technical. So what if you are great technically if the pictures aren't creative? In multimedia, find a way to present your pictures in an engaging way without getting bogged down in programming and scripting."

EILER: "You shouldn't buy into the fact that you need to know a particular software program to put your portfolio together. What's important is that the person puts your disk into their machine and that it's guaranteed it plays.

"It's all about content and image impact. If you can't do that, you are wasting your time building a disk or an HTML page. A weak portfolio is a weak portfolio. No amount of programming expertise will save you."

WEISS: "Make sure that nothing gets in the way of your photographs. It is a truism that you cannot trust any particular kind of technology. Be skeptical about relying on any one type. When working with software, double-check everything and assume nothing."

With so many software choices, how can a photographer choose what to use without a big programming hassle?

EILER: "The industry is changing programs about as often as most of us are changing socks. You need a program that runs on everybody's machine without difficulty. We're really at a crossroads. There is no de facto standard.

"We're using Apple's iMovie and iDVD. They build easily and are not dependent on a platform. The person looking at it just needs a DVD player. It has a built in slide show and has drag and drop sound. Remarkably simple."

ADAMS: "My philosophy is to keep things simple, yet elegant. Navigation has to be easy and intuitive. If they get lost and don't know how to get to your home page, you're going to lose 'em.

"Macromedia Flash has a learning curve. You have to commit yourself. It can be frustrating to learn but you don't have to become a full-out computer geek. With Flash, you can create two separate files, one for each platform, Mac and Windows. The drawback to Macromedia Director is that to create files to work on both platforms you have to buy both the PC and Mac versions."

WEISS: "I think people would be wise to learn Flash rather than Director. Flash lets video be inserted easily. Director is great for CDs but not for the Web but Flash is great for each."

MCLAIN: "Flash is the standard in the commercial magazine world."

Can you share any other advice for building a digital portfolio, whether for the Web or on disk?

WEISS: "I would recommend building a Web site and also distributing a version of it on disk. This is the best solution for cross-platform viewing. It offers so many advantages. When a disk is inserted into a computer, it can even have a link directly to a photographer's Web site and E-mail. It's a constant link to the photographer. This is a way to show new work since the CD was distributed. There is no reason why a CD you passed out three years ago can't link via the Internet to new work or an updated client list."

EILER: "You should still have a print portfolio for one-on-one meetings. When putting together your digital package, remember that it has to be used easily with the least amount of hassle."

ADAMS: "The convenience of having a Web portfolio is important. You can always port a Web portfolio to a CD. Especially for a freelancer, a CD is great for actively recruiting clients and marketing."

MCLAIN: "Remember to think about ease of use and the non-gratuitous use of technology. Photographers have a tendency to think they can do everything. But I can't spend my life learning every detail of software. I've stepped away from that. I let others do the programming. You've got to know your strengths."

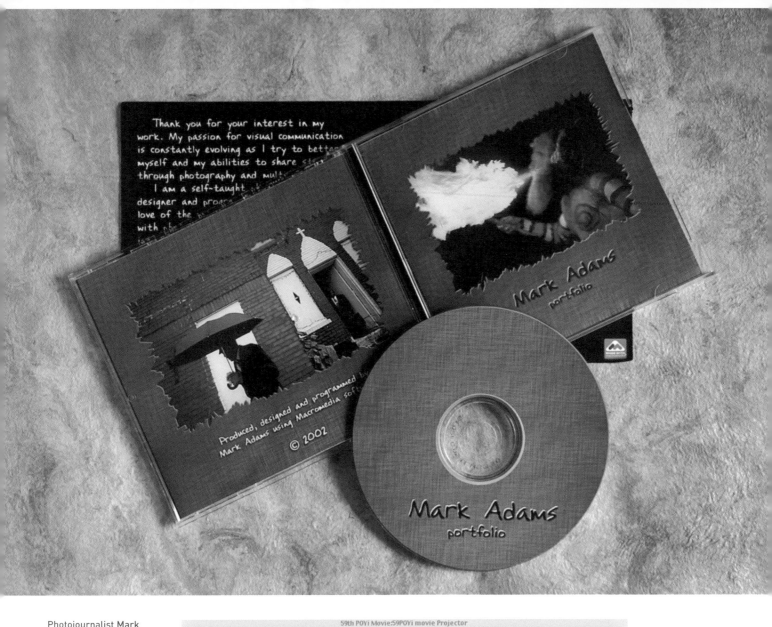

Photojournalist Mark Adams creates a strong and credible "branding" with consistent design throughout his package.

The Pictures of the Year awards disk showcases winners in a well-crafted Flash presentation. At the bottom of the screen, notice the viewer-friendly timeline created with red boxes.

using HTML page files, the same type used to build a Web site. If you have already read Chapter 5, Online Portfolios, you know that you can use Web design software such as Adobe GoLive or Macromedia Dreamweaver to easily place your portfolio on the Web. A basic Web site consists of a folder containing a group of HTML pages and image files.

When a site is uploaded, your folder of pages and files is copied to a server where it can be accessed on the Web. Instead of uploading to the Internet, it's just as easy to copy your folder onto a disk, where it can be viewed on either major browser, Internet Explorer or Netscape Communicator.

With this approach to creating a digital portfolio, you are in essence placing a Web site on disk. As each new page opens via a link from a previous page, it calls up the image files in your portfolio. No Internet connection is needed for viewing, just a browser. As long as your disk-burning software is compatible with both Macs and PCs, any version of popular browsers will read your files without problems. Your images and any multimedia elements will load and display rapidly.

Since not everyone is aware that they can open Web pages without actually being online, you will also need to include easy-to-understand instructions for viewing on popular Web browsers. For example, in Explorer, go to File/Open File. You will then see a dialog box to locate the first page on the site. Using Communicator, go to File/Open/Page in Navigator. It is as simple as that. (If the user just clicks on an HTML file, some operating systems automatically open their default browser but others will not. This is why I recommend including printed foolproof instructions.)

(Chapter 5, Online Portfolios, provides HTML page design tips that are also effective for designing a portfolio on disk.)

THE VIEWING PROCESS

Like a Web site, a disk can allow non-linear viewing. This means that the viewer can choose which images to look at and in what order. If you provide a main index page, you can break your portfolio into logical sections, allowing the viewer to choose which to look at first. As with traditional portfolio types, keep your edit as tight as possible for maximum impact. Be sure that each

distinct section starts and ends powerfully since the viewer may control the order. If you include a thumbnail page that allows selection of individual images, keep in mind that most people will still follow the logical order you provide.

Some photographers make the mistake of creating a completely self-running disk. The viewer is forced to watch a show of an indeterminate length with pictures appearing and dissolving at speeds that are often far too slow. By doing this, you run the risk of boring a potential client, or frustrating a viewer who wants to return to a particularly compelling photograph. If you decide to use advanced software to create such a show, be sure to follow the "three one rule." Each picture in a portfolio should appear for no more than three seconds and dissolve for no longer than one.

THE PROS AND CONS OF MULTIMEDIA

Self-running shows can be dazzling with the right mix of sound and image editing. However, unless you seek work as a multimedia programmer, always let your pictures do the talking and not your technique. Your images will always get you the job, not the show itself. Therefore, give the viewer a choice of stepping through your portfo-

Benjamin Rusnak puts the finishing touch on his disk portfolio with Memorex CD LabelMaker. The inexpensive software and labeling package has design templates for Photoshop, QuarkXPress, or Microsoft Word.

multimedia software choices

With so many software choices available, be sure your portfolio can be opened and played easily on both Mac and Windows machines. Platform compatibility and programming difficulty can be a hassle. Look for software that runs on its own without the need for users to download additional "plug-ins." Before sending out your disk, test compatibility on both platforms.

CROSS-PLATFORM / AVAILABLE FOR MAC OR WINDOWS:

FLASH (www.macromedia.com)

Popular Flash "movies" can dazzle the eye. One caveat though: Many editors and buyers strongly dislike Flash portfolios.

ADVANTAGES | A multimedia standard that can incorporate animation and sound. Impressive when used effectively. Files can be saved in both Mac or Windows formats. Can be used on disk or for the Web.

DISADVANTAGES | A difficult learning curve. Expensive. If programmed poorly, takes navigational control away from viewer. Disliked by reviewers who prefer a simple presentation. Newer versions don't work with older Web browsers.

KAI'S POWER SHOW (www.scansoft.com)

A great cross-platform program currently marketed by ScanSoft.

ADVANTAGES | Inexpensive. Cross-platform. Can incorporate sound. Easy to use. Comes with an integrated player so anyone can view. Imports PowerPoint slides.

DISADVANTAGES | Non-standard Windows interface. Not well supported.

DIRECTOR (www.macromedia.com)

Not as popular as it once was among multimedia pros, Director has been supplanted by Flash because it creates larger file sizes, a disadvantage for the Web.

ADVANTAGES | Versatile. Can incorporate sound, animation, and a variety of multimedia elements.

DISADVANTAGES | Difficult learning curve. Expensive. Both Mac and PC versions need to be purchased to create cross-platform disks. Requires Shockwave plug-in for Internet use.

LIVESLIDESHOW (www.totallyhip.com)

A low-cost program that plays on both platforms, but only on Apple QuickTime software.

ADVANTAGES | Versions available for Mac and Windows. Inexpensive. Can incorporate sound and transition effects. Can be used on disk or for the Web.

DISADVANTAGES | Needs QuickTime software to play, requiring a download for most Windows users.

POWERPOINT (www.microsoft.com)

Often used for meeting presentations, PowerPoint portfolios are problematic when distributed on disk.

ADVANTAGES | Easy to use. Lets viewer control navigation.

DISADVANTAGES | Requires viewer to own PowerPoint, preventing its practical use.

MAC ONLY:

QUICKSHOW LT (DO A WEB SEARCH TO DOWNLOAD)

A standard for nearly a decade, it has not been upgraded for years and does not work with newer Mac operating systems.

ADVANTAGES | Easy to use. An industry standard among Mac owners.

DISADVANTAGES | Mac only. No sound or animation possible.

FINAL CUT (www.apple.com)

A standard for professional video editing, Final Cut can program multimedia, too.

ADVANTAGES | Versatile. Incorporates video easily. Can produce content-rich DVDs with companion program, DVD Studio Pro.

DISADVANTAGES | Expensive in Pro version. Steep learning curve. Mac only.

iPHOTO (www.apple.com)

Useful as a simple slide show viewer, iPhoto is best known as a simple editing and organizing system.

ADVANTAGES | Simple. Easy to use. Inexpensive—sometimes bundled free. Can utilize sound. Can be exported to more versatile LiveSlideShow software.

DISADVANTAGES | Must play within Mac only iPhoto software unless exported to QuickTime format.

iMOVIE (www.apple.com)

As part of the Mac OS X operating system, this video editing software allows the creation of simple slide shows, too.

ADVANTAGES | Has built-in slide show. Incorporates stills and video. Can be viewed on screen or transfered easily to videotape. Can play on any DVD player.

DISADVANTAGES | Must be programmed on Mac platform but can play on Macs or PCs if QuickTime is installed. Not full-featured enough for multimedia pros, who favor Final Cut.

iDVD (www.apple.com)

Developed for the Mac OS X operating system, this software allows the creation of DVD multimedia disks.

ADVANTAGES | Inexpensive or free on some systems. Can play on any DVD player. Has built-in slide show. Simple drag and drop interface. Has ability to incorporate sound and video. Integrates with Apple iMovie software.

DISADVANTAGES | Must be programmed on Mac platform but can play on DVD-equipped Macs or PCs if QuickTime software is installed. Not enough features for multimedia pros.

iVIEW MEDIA PRO (www.iview-multimedia.com)
Similar to iPhoto but with a more intuitive interface, iView is a great slide show viewer that also works in Mac classic mode.

ADVANTAGES | Inexpensive. Easy to use. Can automatically generate Web pages with full-size images, thumbnails, and captions. Good for editing and organizing files.

DISADVANTAGES | Mac only. User must own software to view.

PC ONLY:

COMPUPIC (www.photodex.com)
Used primarily to edit and view photos, this low cost program also produces a simple .exe auto run show.

ADVANTAGES | Inexpensive. Can incorporate sound and transition effects. Can automatically generate Web pages. Self-running; no need for downloads or plug-ins.

DISADVANTAGES | PC only. Pro version needed to create CDs.

MY PHOTO SLIDE SHOW (www.copseystrain.com)
A simple, no-cost program that works well on Windows machines.

ADVANTAGES | Basic version is free. Easy to use. Slide shows can also be E-mailed. Runs as a Windows .exe file. No need for downloads or plug-ins.

DISADVANTAGES | PC only.

lio manually or letting it run automatically.

Some still photographers are now shooting video, too. Both formats can be included effectively on disk. Wedding photographers are rapidly learning multimedia presentation techniques since a wedding is also effectively captured with video and sound. Photojournalists and artists are also using sound to help tell a story or convey an aesthetic message. As with Web sites, multimedia disks have the ability to showcase your photographs with enhanced impact.

Several software packages ease the creation of multimedia portfolios. If you show your disk in person on your own laptop computer, you will not have to worry about compatibility issues. Since you will not always have this luxury, look for a program that allows your show to run on its own on any computer without the need for more software. For example, don't make the mistake of assuming that everyone has PowerPoint installed. Although it is ubiquitous as part of Microsoft's Office package, not everyone uses PowerPoint.

Along with its popularity for the Web, Macromedia Flash presentations can be viewed on disk as well. "Make it your first choice because 96 percent of modern computers have the Flash plug-in automatically installed," says multimedia producer Joe Weiss. Flash works well for CDs and the Web. "You should have a Web site anyway, so why do double the work?" he asks.

For many years, Macromedia's Director software was the standard for programming multimedia CDs but its popularity is declining because its Web-exporting capabilities are not as strong as those of Flash. For the Web, it requires the Shockwave plug-in, which not all computers have, while Flash is standard on most machines. For more complex presentations, Flash movies can be imported into Director, which has the advantage of incorporating a greater variety of media types.

Lost Luggage makes customized cases that get your video portfolio noticed.

The learning curve with multimedia programs can be steep, so arm yourself with good guidebooks such as the Visual QuickStart Guides offered by Peachpit Press (www.peachpit.com). Also try the free tutorials offered by manufacturers on their Web sites.

VIDEO PORTFOLIOS

No matter whether you keep your programming as simple as possible or jazz up your disk with animation and sexy sound, you may find yourself keeping your fingers crossed that it runs without a problem. Famed photojournalist PF Bentley suggests one way around such worries. Bentley is one of the premier photojournalists to build his reputation shooting video as well as stills. His video stories have appeared regularly on ABC's *Nightline* program and is also known for his *Time* and *Newsweek* magazine coverage and book, *Clinton: Portrait of Victory.*

As part of a new vanguard of "platypus" photographers, Bentley suggests skipping the disk and sending clients a videotape portfolio instead. "After all, any idiot has a VCR," he says. As DVD players continue to replace the video cassette, DVD portfolios will likely grow in popularity as well. A Macintosh iMovie portfolio can run on any home DVD player.

YOUR BEST MOVE

"Stay focused."

HORACIO VILLALOBOS
Director of Photography, *Diario Popular*

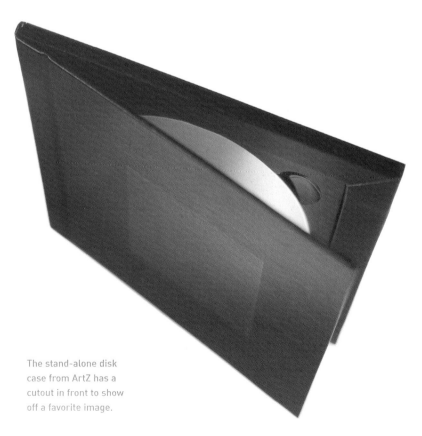

The stand-alone disk case from ArtZ has a cutout in front to show off a favorite image.

WHAT NOT TO DO

Don't assume that your client will eagerly download sound or video viewing software to see your disk. Quite the opposite is true. Invitations to download software are met with suspicion by those fearing viruses and compatibility problems, as well as being a hassle. If you have to send a disk rather than present your portfolio in person, choose software that is universal and compatible with virtually all computers. HTML Web-based presentations hold the most promise for the future. As Web browsers continue to become more sophisticated and high-speed connections become universal, multimedia presentations will be viewed easily online and on disk.

Never E-mail your portfolio unless you are sending just one or two images to whet a client's appetite. Also, don't forget to include an easy-to-follow instruction sheet for portfolio viewing.

OTHER DISK TIPS

When preparing your disk, always include an electronic version of your bio or resume with your complete contact information. You can make a PDF version using Adobe Acrobat software. These days, most computers come with Acrobat Reader software pre-installed to read PDF files but you will still need to pick up the full version to write them. It is also easy to create an HTML resume with Web-authoring software or even within Microsoft Word.

As with a Web portfolio, when deciding how to program your disk, keep it simple and easy to follow for any novice computer user. By first designing a flow chart with a foolproof navigational plan, you will be assured that viewers can find their way around your disk without confusion. The most famous picture editors are sometimes the least technically savvy. Let your pictures do the singing and avoid an overabundance of potentially annoying sound. To complete your professional presentation, avoid cluttered typography and gimmicks such as "cute" animation.

PRESENTATION STYLES

If you intend to present your work in a "jewel box" much like a music CD package, design a cover with software such as QuarkXPress or Adobe InDesign, Pagemaker, or even Photoshop. A strong cover should display your name prominently along with one of your most dynamic pictures. Several small pictures will look more like postage stamps and fail to intrigue the viewer to peek inside. The back cover is a great spot to include another photo, your E-mail, Web site,

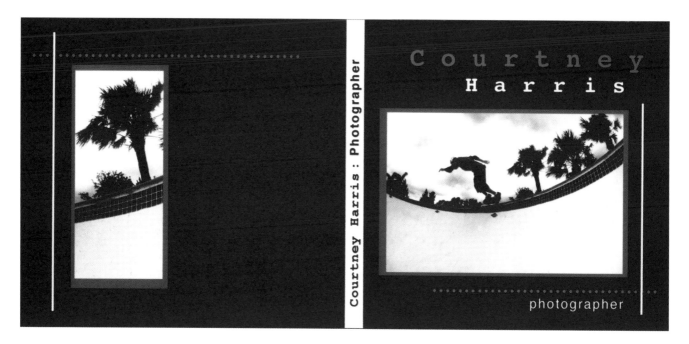

address, phone, and other contact information.

For design ideas, take a look at your CD collection at home. The best covers are memorable and cleanly designed. Labeling packages available in office and computer stores allow you to make a professional-looking label incorporating graphics to be pasted onto the disk itself.

Unlike other portfolio types, you may have to hunt around for interesting disk portfolio cases for CD and DVD portfolios. Some photographers include their disk inside a folio presentation folder that can also incorporate written materials such as a cover letter, caption sheet, or printed resume. In such a folder, the disk can be placed in a paper pocket and then glued in a conspicuous spot inside. I like the "Hot Pocket"

offered by Light Impressions (www. lightimpressionsdirect.com). The pocket is a Tyvek CD envelope available in bright colors sure to catch the eye.

For a ring-bound notebook presentation, several companies now offer pages that hold a CD or DVD in a binder. Light Impressions offers a transparent acetate page that holds a disk securely inside.

For a unique presentation, high-end portfolio companies such as Brewer-Cantelmo (www.brewer-cantelmo.com), Advertiser's Display Binder (www.adbportfolios.com) and Lost Luggage (www.lost-luggage.com) all make customized CD cases.

While a student at the University of Florida, sports shooter Courtney Harris created an eye-catching disk cover in QuarkXPress that is easily customized for new clients. Contact info and disk contents can be dropped in the black area next to the tree photo on the back cover.

The Hot Pocket by Light Impressions can be glued in a conspicuous spot inside any portfolio case to hold your disk. After a face-to-face review of your print portfolio, try leaving a disk and promo card behind.

slide portfolios >>

Slides are still a standard, especially in the fine art world or for stock sales. They are relatively inexpensive to duplicate and easy to distribute.

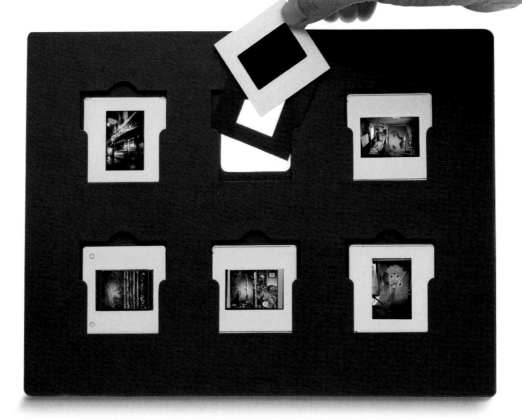

Slides are still used by exhibition curators, magazines, newspapers, and stock agencies. Although more expensive to produce than CD or DVD portfolios, slides are often desirable because of their superior image resolution and clarity. They are also a breeze to edit. Some will always prefer to look at slides over a light table than to browse through digital files on a computer.

Since technology is rapidly changing how pictures are viewed and edited, it is best to check in advance with potential clients to see if they still insist on seeing copy slides. For example, newspapers that hire photojournalists used to routinely require slide portfolios. Now, many embrace CDs or even online versions for hiring.

Slides are no longer a standard in advertis-

Black cardboard mats, such as those made by Light Impressions, remain popular for showing various format slide portfolios. Each image is isolated for impact.

ing. Print portfolios are always expected. "People don't even have the time to search for a light table anymore," says photographer's rep Gregg Lhotsky. "I haven't seen a chrome portfolio in years."

Magazines are not as quick to change as new technologies emerge; some editors still prefer slides. In the art world, curators insist on them. Wedding photographers still need transparencies for competitions. If potential clients ask for slides, be ready with several sets so you can target more than one client at once.

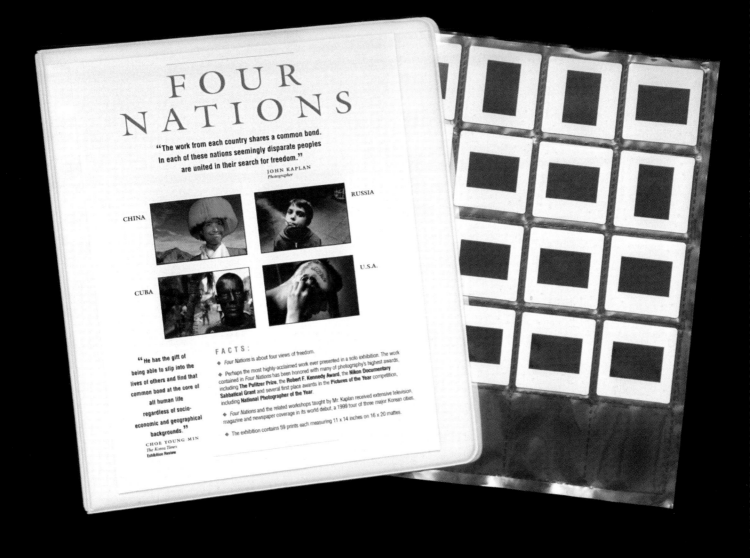

SWEAT THE DETAILS FOR SLIDES

Just as it is important that each of your pictures be presented consistently in a print portfolio, the same applies for slides. If you present slides with varying mount types or cropping styles, others may doubt your professionalism and work habits.

For a portfolio presentation, each slide should be labeled on back. Some photographers have a stamp or embosser made with their name and copyright logo. Others choose easy-to-make labels produced with software such as Avery Label Pro. Labels can be edited quickly on your computer; many word processing programs such as Microsoft Word now include built-in templates. The Avery label size for 35mm slides is "5267"; third-party companies also use the same format, allowing eighty labels per sheet. Apply labels carefully. Rub them after pressing down if your slides may be projected; the heat of the projector can cause peeling if you are not careful.

Note that for stock sales, most agencies require images to be labeled on the front of the transparency. Check in advance to be sure.

To add meaningful information to supplement your presentation, create caption sheets that correspond with titles or numbers on the back of your slide mounts. Some photographers like to include thumbnail pictures on a caption sheet for quick image recognition.

Consistent image quality is a must. Be sure that all of your copy slides show uniform exposure. If copying from prints, fill the frame with the picture unless it is a different shape from your film format. If your cropping differs, copy your print under glass against a piece of black velvet or mask the emulsion side with thin masking tape. Black velvet may be purchased at any fabric store and specialty slide masking tape is available at camera stores. If your slides are being made digitally with a film recorder, your lab should mask the sides of an image with a black background automatically.

When planning a new exhibition, I put together media kits using one-inch binders with clear acetate covers. An inkjet printer is used to print the cover. Inside are slides, an artist statement, exhibition list, reviews, and a bio.

When applied to the emulsion (back) side of a slide, Light Impressions polyester masking tape crops images. For a portfolio, it's best to avoid having the metallic side show in front.

If your slides were processed at different labs over the years, you may now have several types of mounts. To avoid a sloppy presentation, remount them yourself by carefully opening the back of each slide. Take your time and wear white cotton gloves available at camera stores when handling film. Remember that the dull or "emulsion" side goes toward the back.

The type of mount is your choice. I like unmarked, thicker plastic mounts because they do not shift when placed in "Vue-All" type pages as much as thinner ones do. Try to choose a mount that shows the entire film frame; many crop off a significant portion of the image. Paper mounts are convenient for your lab but a pain to take apart; some have rounded corners that also crop the image slightly.

HOW TO MAKE DUPES FROM ANY TYPE OF ORIGINAL

SLIDES FROM SLIDES: If you are starting with original slides, you will need to have dupes made. If your dupes are damaged or lost, it's no big deal.

But never trust that originals will be returned unless you have a signed delivery memo or sales agreement listing the value of each slide. Each original slide is generally valued at a minimum of fifteen hundred dollars. Groups such as the American Society of Media Photographers (www.asmp.org) or Editorial Photographers (www.editorialphotographers.com) help to establish fair guidelines. Rather than fight a legal battle now, be sure to have plenty of top-quality dupes on hand.

The problem with traditional slide dupes is that for some reason, even labs with good reputations often manage to get them slightly out of focus. Photographic dupes are made at commercial labs on a machine that works much like a traditional darkroom enlarger. The slide is placed in a film holder as light is projected through it. A new picture of the original is then taken on slide film.

Test more than one professional lab in your area. You might be surprised how much results can vary. Take a test image out of its mount to test duping quality. A good lab should not crop any of the picture and color fidelity and contrast should be true to the original. The only way to test for sharpness is to look at the dupe closely with a loupe of at least 8x. Projecting might be a good idea as well.

Whether you copy or have a lab do it, be sure that all copies are made on the same batch of slide film. Since labs replenish chemistry daily, it is best to try to have all of your film processed in the same batch. Although this is not critical for color copying, black and white images copied on color film can show a color shift if you do not have all rolls of film processed together.

The Peak 8X loupe is a tack-sharp standard at a reasonable price. It's available either with or without a separate viewer that allows viewing of uncut film strips.

slide tips

Sweat the details for a polished look.

DON'T OVEREXPOSE. Overexposed copy slides are portfolio killers. Always start with a test and check the results on a good quality light table. Look for clean whites and rich black tones in each frame.

USE THE SAME TYPE OF MOUNT THROUGHOUT. Whether you choose plastic or cardboard mounts, don't mix up the type or color throughout your portfolio. Instead, remount all with the same kind. When mailing work, never use glass mounts.

FILL THE FRAME. 35 mm slides are small to begin with. Be sure that your image fills the frame when possible. If using a shape different from the mount, mask carefully using a black background.

COPY YOUR IMAGES AT THE SAME TIME. You may copy the traditional way with a copy stand or choose to make digital slides made with a "film recorder." Either way, try to use the same batch of film and developing chemistry to avoid color shifts. Although rarely noticeable in color work, it's crucial with black and white.

LABEL EACH SLIDE. On the reverse "emulsion side," be sure to label with your name and copyright. (Stock images should be labeled on front.) Use a number or brief title to correspond to your caption sheet. Avoid writing on the slide mount by hand. Instead, make labels on your computer.

BRING YOUR LOUPE. When presenting in person, always bring along your own loupe so no one has to squint.

Avoid having a dupe made from another dupe. Always try to start with an original, whether it is a slide or digital file.

SLIDES FROM PRINTS: Until recently, the only option to make slides from prints was to use a copy stand or similar set-up. This tried-and-true method involves taking a picture of a picture. The photographer places a print on a copy stand or attaches it to a wall. Two daylight balanced strobes or tungsten "hot lights" are each placed at a 45 degree angle to the print and slide film is used to copy the image. In a pinch, a print may be taped against a wall to be copied outside on a cloudy day.

If a copy stand is not available, a tripod should be used to ensure that your print is parallel to the film plane. Copying behind a piece of glass is best but watch out for annoying reflections. Consider wearing a black shirt and shield reflections caused by your camera. Try cutting a hole the width of the lens in the middle of an 11×14-inch piece of black cardboard. Slip the cardboard over the edge of the lens while you shoot to hide reflections.

Exposure is so critical that it is always necessary to first shoot a test roll with "bracketed" exposures. The bracketing process involves shooting one copy of each picture at the exposure recommending by your camera meter and other identical shots slightly overexposed and slightly underexposed.

The bracketing of copy slides is often done in half f-stop increments (e.g. one at f8, one at f5.6/f8 and another at f8/f11) but I have found that even one-third f-stop increments show a meaningful exposure difference. Many cameras have a bracketing control. If yours does not, just shoot on manual and move your f-stop lens ring to change the rate of under or overexposure. Take careful notes for your test roll.

DIGITAL DUPES: A BETTER CHOICE FOR ALL

Most traditional darkroom work is giving way to digital technologies. Scanners have virtually replaced enlargers, if not for quality, then certainly for convenience. Even if you are a traditionalist making the finest of selenium-toned prints in the darkroom, your pictures will later be digitally scanned if your photography is reproduced or printed elsewhere.

Film recorders convert digital files to photographic slides, offering several advantages to the traditional method of duping. The first is convenience, no hot lights or copy stand are required, only a good quality digital scan or file. Dupes made with film recorders can also save hours of hand masking; the film recording machine should do this automatically, preserving your choice of cropping.

A second advantage is consistency. Once you have tested for exposure and color balance, you can easily have as many dupes made as desired. Subsequent orders will likely match your earlier batch fairly well. (Since black and white images are usually copied on color film, color

YOUR BIGGEST MISTAKE

"The biggest mistake is thinking that the aesthetic alone is worthy of space. Pictures have to compete for space in your portfolio just as they do in a publication."

CHUCK SCOTT
Photographer, Educator

shifting can be noticeable if you do not run a new test first, however.)

Check around to find a lab in your area that specializes in digital imaging using a film recorder. I use an Atlanta lab, Imagers (www.imagers.com), which is popular with pros. Although I live several hours from Atlanta, I E-mail my files to Imagers and have slides in hand two days later.

As with traditional duping, it is a good idea to bracket your exposures. By working in Levels in Photoshop, I adjust the midtone slider triangle, making one version of my file as is, one version slightly overexposed, and another just a bit underexposed. Typically, I leave the midtone slider at 1.00 for the "as is" test, type in 1.20 for the lighter version, and .80 for the underexposed version. This means I have bracketed once at an "exposure" 20 percent lighter and once at 20 percent darker.

Your lab will have its own formatting instructions. For example, some ask that files be converted to "targa" format in Photoshop (TGA file extension name) and that an image be no more than 20 megabytes in size. To use the TGA format, save first as an RGB even if your original is grayscale.

Images smaller than 2,000 pixels on their longest side may look "pixilated" with a case of the "jaggies," so check your image resolution in Photoshop's Image Size settings. Adobe Elements, the less expensive version of Photoshop, also lets you adjust image sizes. If your image is too small in terms of resolution, try "upsampling" with LizardTech's Genuine Fractals software. It is absolutely terrific as long as you do not increase the image size more than about 200 percent.

If you E-mail files for digital output, as I do, you will also need to use compression software such as Aladdin Stuffit, which has versions for both Macintosh and Windows platforms. The company has a trial version of its industry-standard software online (www.alladinsys.com).

Since film recorders do such a great job, why go to the trouble of hand copying prints onto slide film or having a lab make dupes? Don't bother unless cost is a concern, which it often is. Having a lab output your copy slides on a film recorder is quite a bit more expensive, but it is also fast and reliable, as long as your lab produces consistent results. If money is tight, you can get great results using the traditional methods used for decades. Content counts; the viewer will never know what method you used to make copy slides.

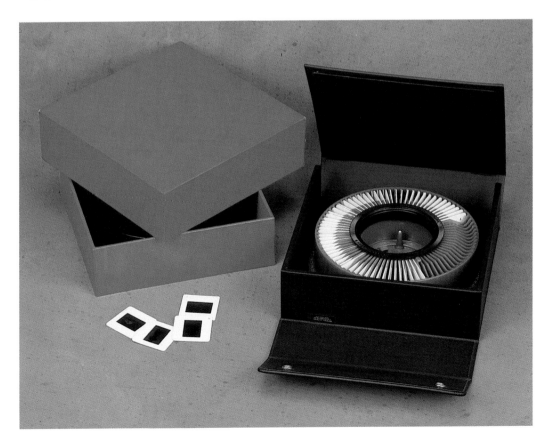

Although you may not get a chance to show a full tray these days, you have options to help make a first rate impression. The Carousel Box from Brewer-Cantelmo is sturdier than its cardboard brethren.

SLIDES FROM DIGITAL FILES: For an image file taken on a digital camera or scanned from film, making dupes with a film recorder is the logical way to go. However, if cost is a concern, you can first make a print using an inkjet printer or have one made at your lab. Then, copy the print as previously described.

Whatever your choice of duping type, if a commercial lab does your mounting, be sure to ask them to turn off their automatic numbering system. Try to keep the front of each mount simple and unadorned with logos, numbers, or other, printed material.

A SECRET EDITING TIP

Slide portfolios need their own unique editing approach. When you show 35mm or $2\frac{1}{4}$ slides you will likely place them in plastic slide pages or black cardboard mats. Here is a tip that can help separate your portfolio from the rest of the pack:

The human eye naturally gravitates to images placed in the corners. Therefore, each corner of your page needs to have one of your very best images placed there. First, place your slides in linear order in your pages. Then, do a modest re-edit to help make your portfolio really stand out. Of course, it is best to do this before going to the trouble of labeling slides and numbering caption sheets.

OTHER EDITING CONSIDERATIONS

After re-editing your slides, take a quick glimpse at your final selects. Do the images jump off the page, calling the viewer to take a closer look? If not, ask yourself if your portfolio shows enough diversity and varied approaches to your subject matter. Having a mixture of tight and wide shots will add visual interest, too.

If your portfolio has distinct sections, skip a blank space on your sheet before a new "chapter" begins. As we discussed with your print portfolio, do not assume that others will understand where groupings begin and end. The caption sheet will only be looked at if the viewer is interested in a particular photo.

If you have a fine art portfolio with distinct bodies of work, a space between them will define each. Similarly, photojournalists should skip a space before the beginning of each of their picture stories. Commercial shooters who display sub-specialties within

editing and presenting your slides

Slide portfolios are viewed distinctly from other types. Here's how to make yours stand apart from the crowd:

PLACE YOUR STRONGEST IMAGES IN THE CORNERS. The human eye naturally looks at the corners of presentation pages first. Place your absolute best pictures in these key spots.

SKIP A SPACE BETWEEN EACH "CHAPTER." If your portfolio contains distinct groupings, never assume that the viewer will know where each begins and ends. A blank space between each will guide the eye to each section.

ADD TITLE SLIDES. If displaying distinct sections, a brief title slide, such as "Automobiles," will help communicate your specialties. Simplicity and legibility are important; avoid being wordy. For impact, try white type against a black background.

LABEL EVERY SLIDE PAGE. Make sure that images are not lost while doing tasteful self-promotion at the same time. Add your name, address, phone number and E-mail to the front of each slide page. Small type is best; be sure that typography does not compete with photos.

the same portfolio should try this technique as well. You may even consider making title slides for each grouping in Photoshop or a layout program such as QuarkXPress. For added impact, make title slides with white type against a black background.

Slides are often lost. They can slip out of pages and be easily misplaced. This is why labeling each is essential. To further protect yourself and do some careful self-promotion at the same time, be sure that the front of each page is labeled with your name,

Although Gepe offers it's attractive mounts with or without glass, curators advise not to ship glass versions in the mail.

Easy-to-use Cradoc CaptionWriter software is available in Windows and Mac versions. It's available through Light Impressions.

Here's a striking solution for showing off your transparencies: Brewer-Cantelmo's Slide Portfolio is a foldout wallet case that holds up to 80 slides.

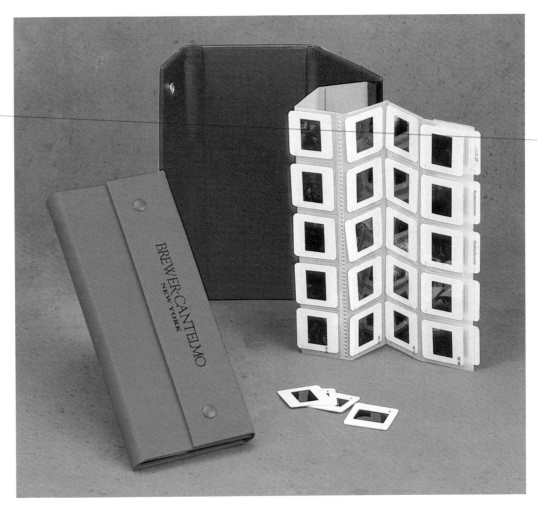

phone number, address and E-mail. Look for a way to do this simply and unobtrusively so your name stands out while not competing with the pictures.

One idea I use is to make a title slide with my contact information for each sheet of slides. This idea works well in the lower-right hand corner of twenty-image "Vue-All" pages. For black cardboard mats that display only four to twelve images, depending on film format, this technique may call too much attention to itself. If you prefer black mats, try simple, reversed type in a long, vertical strip along the left side of the page.

PRESENTATION STYLES

The choices of how to present your slide portfolio are not as varied as with print styles. Still, it is not difficult to make a distinctive presentation once you have chosen how to display your work.

"Vue-All" style slide pages are functional but not fancy. They may be placed inside a thin, ring-bound notebook for a polished presentation.

Check out your local office or art supply store to find some dynamic, new notebook styles. For a clean look, choose a notebook with a clear plastic pocket on the cover; this allows you to create a customized cover showing off your logo and an image or two. Ring-bound notebooks are also a good way to organize supplemental materials such as cover letters and caption sheets. I use $\frac{1}{2}$-inch wide notebooks to present exhibition portfolio proposals, complete with cover, slides, artist statement, and media reviews.

One thing to keep in mind with flexible slide pages: Slides can and do fall out, especially when mailed. Some load from the top and others from the sides. Try each style to see which you prefer.

A fancier approach is to place your slides in black cardboard mats. For 35mm, pages come in different size choices, allowing six to twelve windows each. An $8\frac{1}{2} \times 11$-inch page holds six, nine or twelve images, so you will need several.

Large format photographers often place each image in its own "quick mount" black mat. Your client can pick up each image by its cardboard mat to easily view your work. Commercial shooters often copy and reduce tearsheets onto

slide portfolio types

Choose a style that makes it easy for the client to view your presentation.

See the resource guide at the back of the book for companies that provide popular and unique styles.

"VUE-ALL" OR "PRINT FILE" PAGES

Thin and flexible, they hold twenty 35mm slides per sheet.

ADVANTAGES | Inexpensive, easily organized when placed inside your choice of ring-bound notebook or folio.

DISADVANTAGES | Utilitarian. Slides in thin mounts can fall out. Some are flimsy.

BLACK CARDBOARD MATS

Once unique, black mats are now an industry standard, especially for commercial photographers. Mats can be slipped inside a case for a winning presentation.

ADVANTAGES | Striking. Each image is isolated for ease of viewing. Thick, durable cardboard.

DISADVANTAGES | Several sheets required to display full portfolio. Larger sizes difficult to ship. For verticals, part of label on reverse is hidden by mount. Some sizes don't fit inside standard cases.

FOLIO BOOKS AND FOLDERS

A presentation style that stores standard slide pages and supplemental materials in a self-contained folder or narrow box.

ADVANTAGES | Keeps all materials together. Can be customized. Easy to ship.

DISADVANTAGES | Not for larger portfolios, no rings for Vue-All pages. Some not wide enough to hold standard pages.

FOLDOUT SLIDE PORTFOLIO

A folding slide portfolio with a leather or leatherette cover.

ADVANTAGES | Unique, can be imprinted, embossed, and customized with choice of materials.

DISADVANTAGES | Expensive. Limited to eighty slides. Hard to find.

CAROUSEL BOX

Rather than advertise the maker of the carousel tray, having your own customized box makes sense if your clients project the portfolio.

ADVANTAGES | An attractive alternative to the standard box.

DISADVANTAGES | Slides are rarely projected anymore. Hard to find.

4×5 film and present them this way.

Black mats are available at many camera stores and can be mail-ordered easily. Light Impressions (www.lightimpressionsdirect.com) carries a wide selection.

An outstanding slide portfolio solution is offered by Brewer-Cantelmo (www.brewer-cantelmo.com). Their foldout wallet has a cover that can be embossed or imprinted with your logo. It holds up to eighty slides.

If you are invited to show a carousel tray of your work, pick up a carousel box in choice of color. Brewer-Cantelmo offers two customizable styles.

Portfolios of large format transparencies are best presented in black mats with clear envelopes to protect the image. They come in a variety of formats.

photojournalism >>

Photojournalists capture the essence and emotion of people and community. Create a dynamic portfolio that will land coveted newspaper and magazine assignments.

Unlike many other photographic specialties, most photojournalists are generalists. The portfolio of a successful photojournalist needs to demonstrate versatility and craftsmanship. It should include a variety of picture types along with at least one strong picture story, too.

Many famous photographers recognized as the best in their genres started as photojournalists and later developed another niche. For example, two highly sought-after photographers in the fine art world, Sebastio Salgado and the late W. Eugene Smith, have been working photojournalists although their prints are highly collectible as well. Similarly, Annie Lebovitz got her start as a photojournalist in the 1960s, was

Franka Bruns well-seen feature of a young pianist was a first place winner in the Pictorial category of the Pictures of the Year competition. A great photojournalism portfolio always includes the unexpected.

recognized for her *Rolling Stone* magazine portraiture, and later became one of the best-known commercial freelancers in the world. She still does editorial assignments for magazines such as *Vanity Fair*. Leading nature shooter Jim Brandenburg worked as a photographer at Minnesota's *Worthington Daily Globe* before freelancing for *National Geographic*.

Full-time magazine staff photographer jobs have all but disappeared, even at "the *Geographic*." Instead, magazines hire free-

"A policeman's torment" was taken 15 seconds after officer Vincent Balsamico fatally shot a gunman in a Pittsburgh office building. That day I learned the importance of being told to always carry a police radio to lunch. The photo was published across the globe and was a World Press and Pictures of the Year winner.

Look beyond just the expected sporting events for great portfolio additions. Bruce Bennett's dazzling water skiing shot ran across two pages in *Sports Illustrated*.

lancers who specialize in the type of photojournalism that they publish, whether it is highly stylized portraiture or spontaneous storytelling. Today, unlike a daily newspaper photographer, the typical magazine photojournalist is one type of freelance photographer who specializes in editorial work. Many do portraiture or corporate annual reports to pay the bills or subsidize a passion for documentary photojournalism projects.

In photojournalism, the staff jobs with paid benefits and a steady paycheck are at newspapers. Students often make the mistake of believing that they will "cut their teeth" at a paper for a couple of years before moving on to the "photopia" of the magazine world. This may have been true during the heyday of *Life Magazine*

and European picture magazines such as *Stern*, *Paris Match*, and the *London Times Sunday Magazine*, when news photographers dreamed of coveted long-term assignments.

Today, magazines are highly specialized. Magazine photojournalism portfolios are targeted toward freelance assignment work. Most published pictures are illustrative in nature; many editorial photographers are more like commercial photo illustrators than traditional photojournalists. Long-standing magazines that use pictures prominently include *Sports Illustrated*, *Rolling Stone*, *Mother Jones*, *Vanity Fair*, *Smithsonian*, and *National Geographic*. At times, news magazines such as *Time* and *Newsweek* give dynamic picture play to a big

story. A new generation of magazines such as *ESPN* and *Details* target a young market with dramatic visual imagery.

(*Magazine photojournalists are also described as editorial photographers. For tips on putting together a freelance editorial portfolio, see Chapter 9.*)

Many of the best opportunities for photojournalists are at newspapers. Still doing well with a traditional medium in a digital world, many papers large and small have dedicated picture editors who evangelize the importance of photojournalism. At the best, photographers are given time and space to do the job right, whether in the backyards and baseball fields of Concord, New Hampshire, or on assignment for a big inter-

national story in the Middle East. Many newspapers routinely open up special sections for in-depth picture stories. Even the *New York Times*, once known as "The Great Gray Lady," is, at last, winning Pulitzer Prizes for photography and displaying pictures well.

LEARN THE LEVEL

The best thing for any emerging photojournalist is to build a portfolio that will serve as a stepping-stone to a publication that uses pictures well and respects the vision and storytelling ability of each photographer.

While in college, students "in the know" try to land as many paid internships as possible to help refine their portfolios. In the U.S., the best large newspapers for photography have included the *San Jose Mercury News, Hartford Courant, St. Petersburg Times,* and *Seattle Times,* among others. Mid-sized dailies with an impressive track record year after year have included the *Spokane* (Washington) *Spokesman-Review, Palm Beach Post,* and *Norfolk* (Virginia) *Virginian-Pilot.* Good small markets for photography have included the *Concord* (New Hampshire) *Monitor, Jasper* (Indiana) *Herald,* and the *Naples* (Florida) *Daily News.*

As picture editors come and go, good picture papers can become great ones or sometimes lose their visual magic. Join the National Press Photographers Association (www.nppa.org) to receive the annual *Best of Photojournalism* book and a great monthly magazine, *News Photographer,* which showcases leading papers.

Even while in high school, a photojournalist should build a portfolio to help get admitted at one of the strongest universities for undergraduate photojournalism. Some of the best known include Ohio University, Western Kentucky University, the University of Florida, the University of North Carolina, the University of Missouri, the University of Montana, Syracuse University, Ball State University, San Francisco State, and San Jose State. There are other good programs, too, in the U.S. and worldwide. Many also offer graduate degrees.

Students can continue to improve by working for the school paper or at their local daily. Savvy ones work their way toward the best newspapers through hard work, networking, and a passion for narrative storytelling. Students can also build their reputations and boost their "hirability" by entering contests such as the

YOUR BIGGEST MISTAKE

"A loose edit of your work."

DAB HABIB
Photographer, Picture Editor

Editors look for strong moments of interaction. Franka Burns captured a portfolio-worthy moment between family members as part of a picture story on a single mom.

Hearst Photojournalism Awards Program (www.hearstfdn.org), or the College Photographer of the Year competition (www.cpoy.org).

AVOIDING THE PORTFOLIO "CATCH 22"

When I was an undergraduate at Ohio University, it was normal for students to do two, three, or even four paid internships. Since everyone around me was so dedicated to building a portfolio worthy of an internship, I was encouraged to do so, too. By the time I graduated, I had interned at the *Palm Beach Post*, *Charleston* (West Virginia) *Gazette*, *Gainesville* (Florida) *Sun*, and *San Jose Mercury News*. The job market was tight but I was lucky. Because my portfolio had developed through my internships and work at the school paper, *The Post*, I was able to start my career at a good paper that later became one of the best, the *Spokane*

Spokesman-Review. I then worked my way to the once proud *Pittsburgh Press* and magazine assignments at *Life*.

Each place where I worked respected the power of photography and allowed me to continue to learn to convey stories with passion. While working for daily newspapers, I would tell myself, "Even if the assignments begin to repeat themselves, the people rarely do." Once I stopped trying so hard to produce a portfolio picture every time I picked up the camera, I relaxed with my craft and the communication with my subjects gelled. As I developed a specialty in documentary picture stories, I freelanced, became a photography and design consultant, and eventually returned to grad school to become a professor.

At each point in my career, I have been fortunate to shoot for organizations that helped me grow and mature, readying me for each new

challenge. Much of my professional success is directly linked to working toward building a good portfolio while in school. (On the other hand, Sebastio Salgado got his start at age thirty-five, so whatever your present situation, time is on your side!)

I knew another promising young photographer who took a job at a small daily after school. Unfortunately, his newspaper had no strong advocate for photography in the newsroom. Its editors had little understanding of the power of photojournalism. My friend, "Larry," was given five or even six assignments a day, rather than the usual two or three. He never had enough time to do the job right and the quality of his pictures suffered.

In time, Larry became resentful. He was interested in doing picture stories but the newspaper did not want to publish them. Larry believed he should not do any work he was not getting paid for and became disenchanted. Naturally, he looked for work elsewhere. But, to his surprise, he could not find it. His portfolio just was not strong enough. He was stuck.

YOUR PORTFOLIO AS "VISUAL CURRENCY"
What happened to Larry was not directly his fault. Editors always want to see strong recent work but his newspaper did not clear an easy path for him to produce it. Larry was smart and talented but he made a crucial career mistake. Any photographer should be willing to work on his or her own time if necessary, to do whatever it takes, to tell visual stories with depth and meaning. This is how to work beyond a not-so-hot job to a better one, and an even better one after that.

Most publications respect photographers as true equals in the newsroom and pay them pretty well, on company time of course. However, no one wants to hire a photographer who rationalizes why his work is not as good as it should be. Busy editors are not interested in sob stories of "what ifs" or "could have beens." What they seek is a positive attitude paired with imaginative pictures and good ideas. What you actually hold in your hand, the portfolio, is the key to the best assignments, internships, or jobs. Think of your portfolio as a form of visual currency to help place yourself on a truly rewarding career path.

ESSENTIAL ELEMENTS IN A PHOTOJOURNALISM PORTFOLIO
As I mentioned, a strong photojournalism portfolio needs to demonstrate versatility. For newspa-

building a portfolio for the long term

Seasoned photojournalists learn the mechanics of making good photographs early in their careers. The ones who succeed over the long term possess three traits.

• They like people.
• They have a curiosity about the world.
• They are committed to telling stories with integrity and honesty.

per work, this means a command of news, sports, features, and picture stories. Magazine photojournalism portfolios may instead be highly specialized, but those first breaking into the business almost always get their start at a paper.

The best portfolios are also intimate and filled with emotion. They have a point of view and a fresh vision that goes beyond a merely literal interpretation of a scene. However, to fall back on another cliché, "Do not put the cart before the horse." Look first to tell any story well through photography, with technically solid pictures that can be understood and appreciated by any reader. Quit trying so hard to be deep or subtle, or to impart secondary meaning in your work. First, always be sure that your pictures communicate on a primary, visceral level. Let your style and strengths evolve naturally rather than forcing yourself into a formula.

You can still be a highly effective and successful photojournalist if you do not particularly care for certain aspects of the craft such as spot news coverage or sports action. (However, strive to improve in your weak areas.) If you are like me and sports action was never your strength, develop your ability to do well with sports features pictures away from the ball. When I won the Photographer of the Year award, I had one decent sports action photo in my portfolio. It was just okay, but the judges instead remembered the emotion and intimacy of my sports features. (A great resource to see the top pictures of the year for newspapers and magazines is at the Pictures of the Year Web site, www.poy.org).

WHAT EDITORS ARE LOOKING FOR
Consistently ranked as one of the finest small newspapers in the nation, the *Concord* (New

YOUR BEST MOVE

"Put in pictures with real, meaningful content, not just pretty pictures. They ought to say something important."

CHUCK SCOTT
Photographer, Educator

Hampshire) *Monitor* is able to hire many bright young photojournalists. It does not pay as well as larger papers but photographers clamor to work or intern there because it uses pictures superbly and can be a stepping-stone to other opportunities. Its director of photography, Dan Habib, started at a newspaper and later became an award-winning freelancer doing assignments for *People*, *Time*, and *Fortune*. Habib returned to the newspaper because "I missed having some control over my work and how it gets published. I also like having a close connection with a community," he adds.

Known for his thoughtful feedback, Habib sends a letter to each job or intern candidate that gets at the crux of what most editors want to see. Here's an excerpt:

> "Those who reached the final round had a few things in common. They had at least one strong photo story, which showed an ability to obtain access to intimate and difficult situations. Original ideas are a big bonus. Stories are often the best forum for a photographer to convey a sensibility for subtle moments and strong journalistic instincts.

Stories were complimented by diverse singles, showing a range of sports, spot news, general news and features. They demonstrated technical proficiency, as well as the use of flash. The top contenders had unusual, complex compositions as well as tight, high-impact moments. All of the photographs were thoughtfully composed and cropped, and led the viewer's eye through the frame."

In terms of editing and packaging, Habib likes to see one picture story and eight to twelve singles for an internship application. For an experienced photographer seeking a job, he expects two strong stories and ten to fifteen singles. What hurts the package are badly duped or poorly printed images, he says. "Most editors agree that if a photographer can't make excellent dupes (or have them made) they may not make technically excellent photos every day."

The stacks of portfolios that Habib receives are usually submitted on CDs. Some are contained in three ring binders, others placed inside two-pocket folders. Whatever the packaging, "what really sets a portfolio apart is good emotion with socially relevant subject matter. Photographers can get so caught up in their

vision but forget that editors want to see sports, too, particularly shot with long lenses," he adds.

Photojournalists would also be wise not to ignore the importance of caption writing. Along with the portfolio, "I have to have the captions to understand how the photographer thinks and puts a sentence together. I value accuracy," says Sue Morrow, *St. Petersburg Times* assistant managing editor for visuals.

THE PICTURE STORY

Talented photographers sometimes make the mistake of hurting their portfolio by honing their ability to shoot great singles while ignoring the responsibility to develop relevant picture stories. Great stories take time. Many editors and most contest judges believe stories are the most

For *Sports Illustrated* coverage of the Sydney Olympics, Bill Frakes and Dave Callow constructed a "strip camera" using a Hasselblad chassis. Rather than panning the camera itself, a motor was used to move the film across the film plane at the speed of the runner. The result was their spectacular shot of Marion Jones winning the 100 meter gold medal.

[NEWSPAPER PHOTOGRAPHER OF THE YEAR BRIAN PLONKA]

The international Pictures of the Year competition is among the most celebrated in photojournalism, along with the Pulitzer Prize and World Press Awards. Photojournalists dream of winning POY's top honor, Photographer of the Year. After being named Regional Photographer of the Year several times and a third-place portfolio winner in POY, Brian Plonka of the *Spokane* (Washington) *Spokesman Review* reveals how he took his portfolio to the top.

Whether to win a contest or to compete for a job, why is one portfolio noticed while others are ignored?

PLONKA: "A portfolio has to have a message with continuity and feeling. It has to have a point of view. Never try to reinvent the wheel. As you go through highs and lows in your career, don't rush things. A portfolio should be a true representation of who you are at any point in your career development."

Brian, you are the National Photographer of the Year. Was it just your portfolio that got you there?

PLONKA: "Yes and no. The field of photojournalism has been formulated for a long time. We can incorporate more art into the newspaper genre. I have been on a different learning curve lately. It has to do with vision but also with being happy where I am living and working."

You look at many portfolios at workshops and judge contests, too, such as the College Photographer of the Year competition. Which portfolios stand out?

PLONKA: "The ones that impress me are the ones where a photographer has a unique vision that carries through the entire portfolio. It's about style but it has to have content, too. You can't just shoot pictures in weird light and say 'Hey, it's my vision.' It has to have content and care for people."

What are the most important elements in a photojournalism portfolio?

PLONKA: "First is content and the photographer's ability to get inside a situation. I see a lot of photographers who see the world from outside. It's very evident.

"For a newspaper portfolio, you have to demonstrate a level with pictures that would be used in the paper. But people are starting to appreciate a different take on things, too.

"A lot of people think a magazine portfolio's style differs from a newspaper one, but I don't think it has to be. In New York, editors are looking for a documentary sense and that you are not wasting your time as a photographer. To be a magazine photographer you have to have a refined technical style. Editors want to know if you can use color and light at any time."

Why did your portfolio win POY?

PLONKA: "It is a challenge to cover the community every day and show the readers their own world they don't ordinarily see. I think the judges saw the love I have for shooting and that I was trying to push the level of newspaper photography—trying different things."

What's your best portfolio advice for others at any point in their careers?

PLONKA: "Don't get too analytical or do too much thinking. I've met a lot of students who think too much. They were really intellectual, really good talkers but they couldn't put it on film. Take pictures because you love to do it."

As part of a picture story on environmental contamination in Libby, Montana, Brian Plonka anticipated a chilling and surreal moment. In terms of access, great photojournalism is made from the inside looking out, rather than the outside looking in. Plonka's story was part of his Newspaper Photographer of the Year portfolio.

Palm Beach Post photographer David Spencer transformed a routine assignment of a gospel concert into a work of art. Everyday assignments should always be treated as an opportunity.

important part of a portfolio because they demonstrate the true journalistic insights of the photographer.

Concentrate on subjects with relatively easy access and the potential for strong emotion and interaction. Early in your career, your chances of success will be greatest by focusing on one person or relationship rather than an entire family or community. Rarely can a picture story be shot in a single afternoon! Several visits are required to complete a story that is portfolio worthy. Go back, go back, and go back again to build rapport with story subjects. When your subject is relaxed and not camera-aware, that's when the real moments start to happen.

The most common type, the narrative picture story, has a beginning, middle, and end. A literal chronology is usually not necessary. More important is an emotional chronology, with conflicts and resolutions much like a good novel. (An important difference is that photojournalism pictures, other than portraiture, should not be posed. Photojournalism is strictly non-fiction.)

A good story is best edited down to five to twelve images. An effective one can be shot in either color or black and white, but not both at the same time. It should have a mix of tight and wide shots, diverse compositions and plenty of thought-provoking interaction and emotion. In terms of editing, think of any story as a mini-portfolio. It must start strong, end strong, keep moving through the middle, and not have redundant images. A tight edit is key to producing a winner.

Documentary photographic essays are also a worthy approach. Traditionally best suited to magazine display or a gallery exhibition, more newspapers are taking chances and publishing them as well. However, keep in mind that the documentary style often represents a strong point of view, rather than the objectivity expected in newspaper work.

What can be redundant in a narrative story is often the strength of a documentary project. For example, a narrative story usually has no more than one portrait but a documentary essay might consist entirely of portraits. Most documentary essays are shot exclusively with wide-angle lenses, which might be seen as redundant in a traditional photojournalis-

Iconic photographs of historic events will always be remembered. More than a lucky moment captured in time, such pictures take forethought and often great courage. Although few shooters ever get the chance to truly be a part of history, Associated Press photographer Jeff Widener hid in a nearby apartment to document a moment of lone defiance at China's Tiananmen Square uprising.

tic approach. As long as the pictures are strong, a documentary photographic essay may have a broader edit, usually ranging from eight to twenty images.

PHOTOJOURNALISM WORKSHOPS

Workshops are terrific for hands-on portfolio critiques. Many of the best in photojournalism are sponsored by NPPA. These include one-day seminars such as the Flying Short Course and weekend long workshops including the Northern Short Course, Southern Short Course and Atlanta Seminar.

For learning how to shoot an effective story, the Mountain Workshop (www.mountainworkshop.com) sponsored by Western Kentucky University or the Missouri Workshop (www.mophotoworkshop.org) sponsored by the University of Missouri are both excellent. Students and professional attendees do not have to be affiliated with the schools that

CASE STUDY

It's difficult to find a weak image in this selection from photojournalist Brian Plonka's POY-winning portfolio. Still, one of these pictures is less appropriate for a photojournalism portfolio and weakens the impact of the group. Which would you cut? See page 156 for the answer.

1

2

3

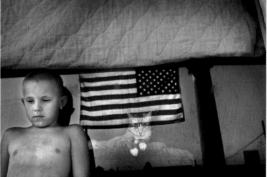

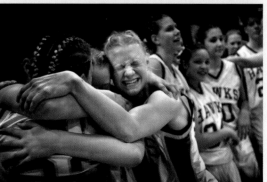

4

photojournalism portfolio categories

For a newspaper photographer, news, features, portraits, and sports are important. A portfolio doesn't have to include every category. To work at better publications and compete in photo contests, picture stories are absolutely essential, too. Here are the standards of the industry, as defined by the Atlanta Photojournalism Seminar (www.photojournalism.org):

SPOT NEWS: A single picture of an unscheduled event for which no advance planning was possible.

GENERAL NEWS: A picture of a scheduled or organized event for which advance planning was possible.

FEATURE: Usually a found situation with strong human interest; a fresh view of an everyday scene.

SPORTS ACTION: A single picture or sequence showing participation in a game or athletic event.

SPORTS FEATURE: A feature picture that is sports-related.

PORTRAIT/PERSONALITY: A picture that captures an aspect of the subject's character.

PICTORIAL: A picture that exploits the graphic aesthetic qualities of the subject with emphasis on composition.

PRODUCT ILLUSTRATION: A photograph that illustrates any product, including clothing and food.

ISSUE ILLUSTRATION: A photograph conceived to illustrate a particular idea or editorial concept.

NEWS PICTURE STORY: A collection of photos with a single theme that fits the description of the Spot News or General News category.

FEATURE PICTURE STORY/ESSAY: A collection of photos with a single theme that fits the description of the Feature category.

SPORTS PICTURE STORY: A collection of photos with a single theme that fits the description of the Sports Action or Sports Feature category.

The Atlanta Seminar rules are similar (but not identical) to other competitions such as POY, which has separate newspaper and magazine divisions. Each portfolio must include at least one entry from a multiple picture category, news, feature, or sports picture story.

To be competitive in most portfolio competitions, a minimum of two good stories is needed.

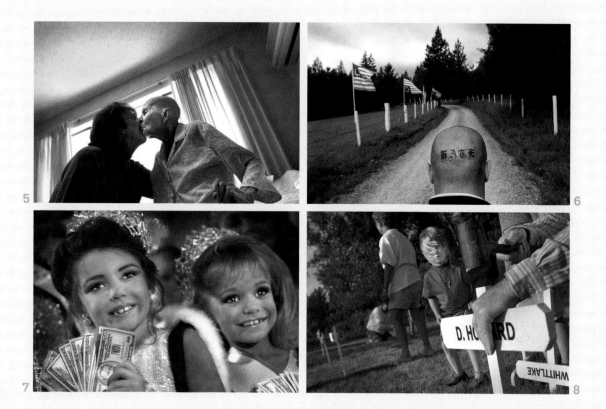

Kathy Plonka's picture story on a meth addict who eventually lost custody of her children has strong interaction, and a variety of compositional perspectives and story-telling situations. Its narrative approach embodies a powerful emotional chronology.

Concord Monitor Director of photography Dan Habib knows how to push for access before the crucial New Hampshire presidential primary. With an unrestricted day with the candidate, he was able to bring back an extraordinary photo of Bill Clinton weary from his first presidential campaign.

sponsor them. Young professionals and students learn about the freelance world from top shooters and New York picture editors at the Eddie Adams Workshop (www.eddieadams.com).

To make the jump to international photojournalism and editorial freelance photography, the Perpignan festival held each September in France is perhaps the most influential in the world (www.visapourlimage.com).

The portfolio of a photojournalist can be beefed up with examples of fashion, editorial illustration, and the use of light. Good workshops abound including the Maine Photographic Workshops (www.theworkshops.com) and the Palm Beach Photographic Workshops (www.workshop.org.) The Sports Photography Workshop (www.richclarkson.com) is great place to learn from *Sports Illustrated* shooters and Allsport photo agency editors.

Every photojournalism portfolio needs at least three compelling portraits. I found homeless eight-year-old Sergei Mayorov at the St. Petersburg, Russia airport. He spent his days stealing and begging in order to afford high-status Marlboro cigarettes.

freelance work >>

Commercial photographers understand the needs of agencies, buyers and editors. Here's how to package your work to land lucrative assignments selling products, ideas, or lifestyles.

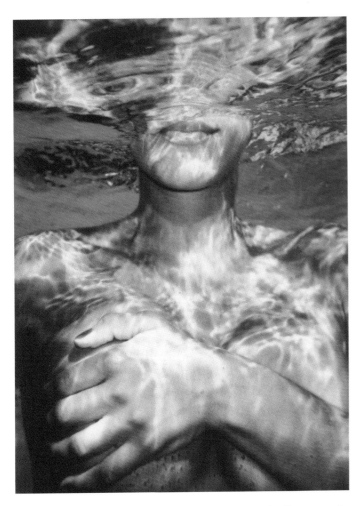

Fashion and entertainment photographer Yaro succeeds with a glamorous sense of the surreal. The Russian native shuttles between the L.A., Miami, and New York markets.

All types of freelance photography share one important trait: More photographers than ever compete for assignments and stock sales. How you position yourself in the market determines how you build your reputation over time. Your portfolio must convey a feeling of ease in craftsmanship as well as a distinct, memorable style. Knowledgeable photographers "brand" themselves without becoming pigeonholed in a stagnant niche.

Pure and simple, the right portfolio will induce confidence and net you far higher fees. Whether presented in person or online, your "book" must look and feel important. "Show the images of not what you are currently doing, but what you want to do," advises Ohio University professor Gary Kirksey.

A potential client must never be confused about how you position your strengths. "It's a representation of who you are and which type of vision you bring to the job. In New York City, you may never get to meet the buyer in person, so your portfolio must speak for you," Kirksey says.

SATISFACTION IN YOUR VISION

Freelancers decide not only where their natural talents lie but also where the sweet spots will be in the market for the foreseeable future. Find a shooting niche with ongoing demand as well as personal fulfillment. For a continued sense of job satisfaction, the two must work hand in hand.

Enthusiasm is another intangible that should come through in your work. If you like what you do, it will no doubt be reflected in your portfolio, making you that much more hirable. "If you just make images that you think your clients want to see, you won't be satisfied," says Connecticut-based freelancer Jake Wyman. His corporate clients have included Texaco and Pitney Bowes and he has also done assignments for editorial clients like *Fortune* and *Business Week*. Wyman suggests shooting for yourself first, working in

Too much TV? J. Kyle Keener's photo is simple but entertaining—a keeper.

Rather than work in Photoshop, Yaro prefers the challenge of composing elaborate concepts in camera. He hired a crane to suspend a piano for an Arthur Hanlon album cover shoot. For an otherworldly technique, he often "cross processes" transparency film in negative color chemistry.

areas that interest you, while making sure that there is also a market for them.

"When I first got out of school, I was working as an assistant in Hoboken, New Jersey. I would go down to the docks and climb through a hole in the fence because I was drawn to those huge container ships. I put together a portfolio of them and approached Maersk, one of the biggest shipping companies in the world. I ended up shooting assignments for them for twelve years," Wyman says.

Today, Wyman pursues his interest in corporate photography by doing annual reports for companies such as Bank of America. When he learns what a specific client seeks, he puts

together customized online travel, lifestyles, or stock portfolios by theme. Although each portfolio presentation is tightly focused, Wyman enjoys a variety of assignment types and self-generated topics for stock sales.

"I sometimes wonder if I should be focusing more directly on travel, corporate, or stock. But, when one is slow, I can focus on the other. It spreads the risk," he says.

Yaro, a Los Angeles-based fashion and music photographer, builds his reputation by carefully taking on conceptual assignments that do not quash his creativity. Although advertising jobs can pay, on average, several times what editorial jobs do, he tries to avoid assignments that are

too tightly controlled by art directors and clients. "I'd rather have my work to be famous than to eat," he jokes.

By splitting time between L.A., Miami, and New York, he builds his contacts in the entertainment and fashion and beauty worlds. "That's my Bermuda triangle in America," says the Russian native. His clients have included record companies Sony and Epic and magazines such as *Elle*, *Cosmo*, and *Maxim*. But it is *Loft*, a small and trendy magazine based in Miami that allows the creative control he craves.

"It's hard because I see myself as an art director, too. There's more control in some editorial work—the photographer has more input," he says. Like many up-and-coming shooters, he balances idealism with the realities of the marketplace.

"When I was younger, I was rebellious and turned down jobs. When you are young, you want to change the world. When you get older, you want to change the young," he says. "Some things you do for money. You've got to walk the steps, but it all furthers your portfolio."

HOW MUCH TO SPECIALIZE

In a city like New York, you can so heavily specialize that you could even differentiate yourself as the best "Window Blinds" photographer in the world or excel at conceptual advertising work in "Motion" or "Smoke and Fire." For your portfolio not to go up in flames, understand the market, where you live and work. Be astute not only to the evolution of the craft of photography but also to the economic marketplace.

"Your physical, geographic market determines how specific you need to be. Depending on where you are, your style also needs to be defined, such as how you approach lighting—natural versus heavy color gels, for example," says Kirksey.

In smaller cities, photographers may handle a wider range of jobs to build a successful freelance business. "In New York, food photographers only show food. The bottom line is to know your market and what you want to do. Your book should reflect that," he says.

"Remember that photography is a commodity," says agent Gregg Lhotsky of Bernstein &

Every portfolio should surprise and captivate the viewer. Detroit's J. Kyle Keener took first place in issue illustration in the Pictures of the Year competition with his rendition of "Gray man." Keener built the set and covered everything with gray latex paint.

Andriulli (www.ba-reps.com). "It's not a precious temple of grandeur. Get your portfolio in front of a lot of people so they can hire you." Lhotksy's firm reps in-demand photographers like Gregory Heisler, Daniela Stallinger, and Stephen Wilkes.

Always keep the buyer focused. "Art buyers" are at ad agencies while "photo buyers" work in editorial. Even for established photographers who tightly specialize, break your portfolio into distinct sections by topical theme. If your chosen themes are not complementary, such as corporate portraiture and horse racing, create separate portfolios. To really know if your specialties fit together well in the same portfolio, ask yourself if a particular client would be interested in every picture in your book. If not, customize your presentation.

Just as photojournalists should package their portfolios with at least one picture story, advertising shooters may want to include at least one series focusing on a specific campaign. For inspiration, look at annuals such as *Communication Arts* or the *PDN Photo Annual*.

Many freelancers, especially on their way up, combine advertising and editorial work. Why bother with editorial photography, when rates are lower and photographers are often asked to give away rights to their work? "The editorial contracts for photographers are not so hot these days. They are asking for everything and paying nothing," Wyman says.

"But editorial is a major selling tool for your reputation. Your name is out there in front of a lot of people. That's advertising you can't buy," he points out.

NETWORK YOUR PORTFOLIO

A strong portfolio should always be combined with a diligent networking effort, both within the photographic community and in the corporate world. Even though most photographers compete with each other, they also help all freelancers by working to establish fair professional standards and rates. And, if one photographer is booked on any given day, she is likely to suggest that an art director take a look at the portfolio of a colleague.

Most such referrals are from fellow members of professional groups and trade associations. To understand how the corporate, advertising, and editorial worlds interrelate, successful pros actively participate in organizations like the Professional Photographers of America (www.ppa.com), the American Society of Media Photographers (www.asmp.org), and Editorial Photographers (www.editorialphotographers.com).

Advertising photographers get involved in Advertising Photographers of America (www.apanational.org) and also join groups that their clients belong to. The APA Web site has a great resources list with links to organizations such as the American Institute of Graphic Arts (www.aiga.com) or the American Association of Advertising Agencies (www.aaaa.org). In a large city, groups like the Art Directors Club of New York (www.adcny.org) can wield considerable influence on photographic trends.

KEEP YOUR PORTFOLIO FRESH AND YOUR VISION STRONG

To move beyond what you are doing now and toward what you deserve to shoot, invest some personal time to self-assign "spec" pictures to test in your portfolio. For example, since no editor will assign a fashion assignment if you have none to show, try trading prints for the time of an aspiring model who also wants to strengthen her portfolio.

Many have said that any photographer is only as good as his or her last job. The need for self-promotion is constant, even for so called "famous photographers." Remember that as you

Many commercial photographers have no interest in moving to a large market. Rather than heavily specialize, freelancers in small markets are often asked to shoot a variety of assignments. Allen Cheuvront, of Gainesville, Florida, does industrial advertising work like this shot for an automotive cable company, as well as corporate, editorial and even wedding jobs. His broad-based portfolio is segmented by category.

Excellence in Automotive Wire & Cable Products

Creative Automotive, Inc.

land new clients, somebody else may be losing them. To avoid losing yours, a commercial portfolio should move with the times. Let it evolve naturally with new work that you are proud of as you discover new topics and innovative approaches.

"Step out of your comfort zone. Take that risk," says Tom Kennedy, the former director of photography at *National Geographic*.

"The famous are told over and over again how great they are. They tend to internalize that their greatness will always pull them through. They expect that, just because of who they are, people will fall in love with their work. Eventually, they die creatively. My wish for anybody is that when they are eighty years old, they are still going forward and growing every day." Kennedy says.

At *National Geographic*, and later at *CameraWorks* (www.cameraworks.com), Kennedy has assigned and edited the work of many of the top shooters in the world. With fewer magazines publishing traditional reportage these days, most magazine photographers are self-employed as editorial photographers, rather than strict photojournalists.

"Editorial photography clearly encompasses more than photojournalism," he says. "The environmental portrait, or celebrity portrait, has grown up as a genre. As a matter of economics, the photographer is asked to create a reality rather than be an observer of the human condition. Working hand in hand, there is a direct collusion between the subject and photographer."

As publicists and art directors also shape this "new" view of reality, a photographer runs the risk of forgetting how to capture images spontaneously. By creating artificial realities in highly paid commercial work, the photographer should also be sure that it does not bleed away authenticity, Kennedy says.

"I want to see who you really are. Work out of a wellspring of personal commitment."

Many who aspire to do time-honored magazine photojournalism also do advertising work and annual reports to generate superior income to finance impassioned social documentary projects. "You have to find challenges that build you financially and creatively, too," Kennedy advises.

TECHNOLOGY CAN'T REPLACE SKILL AND SIMPLICITY

Like fame, technology should never be used as a crutch. Although imaging software like Photoshop is a powerful tool in the world of

advertising, a conceptual picture should be conceived and executed through creative collaboration, not gimmickry. Great photographs are rarely invented "after the fact" on the computer screen of a photographer or art director.

"There has been a loss of craftsmanship, especially in studio work," says photo illustrator extraordinaire, J. Kyle Keener, known for his ability to build elaborate sets.

"Many young photographers have too rigid a personal vision. Sometimes a personal vision does not communicate to the rest of the world, or it sometimes might not be appropriate for any given job. They are suddenly lost when they need to be straightforward. Have a strong vision but do not be so overbearing that your portfolio does not show enough diversity for you to do a multitude of different jobs," he advises.

College students often make the mistake of believing that concept is key and the ability to control light is not highly regarded anymore. But the ability to use multiple lights for food, fashion,

Former newspaper shooter Stuart Tannehill found a new career direction doing conceptual photo illustrations that are in high demand by editorial clients. This example is for a piece on Obsessive Compulsive Disorder.

and portraiture is critical, Keener says.

"Lighting is most important, whether it is simple or complex," says Yaro, who is largely self-taught. "But usually it's simple. I don't know my physics of lighting but I do know what I want. When it gets complex, I hire assistants.

"A portfolio has to have a feeling. It has to bring out the magic. But it doesn't have to shock," he says.

PACKAGING YOUR PORTFOLIO

As photographers face a tougher time getting their foot in the door to show portfolios in person, they lose the ability to make an important contact. "Even if they say to drop it off, I try any ploy I can to actually look 'em in the eye and shake hands," says Steven Shames, a New York social issues photographer whose credits include *People*, *Newsweek*, and *The New York Times Sunday Magazine*. "Without getting cute, package it to get noticed. Put it in a red box if you have to."

Fashion photography rep Julian Meijer says clients look at the online portfolios of his photographers but always call to see their print book. His photographers show extensive tearsheets and Meijer recommends custom-made portfolio books by companies such as Brewer-Cantelmo. For now, slides are out.

"Clients use the Internet to help in research.

But the (print) portfolio shows the quality. It has to be clean and extremely beautifully done. The problem is that it is just too easy to copy others."

In their efforts to be original, many photographers show books that are poorly organized or tacky, he says. "It's all about the pictures. You don't have to put your dog's picture at the end. It's the signature style that's important."

YOUR ONLINE PORTFOLIO

Although no online portfolio can have the impact of a successful face-to-face meeting, the Internet has revolutionized how freelancers share their work. As clients get ever busier, they are less likely to pick up stock books or root through stacks of promo cards. The Web has become the first choice for locating photographers. Some freelancers now show online portfolios exclusively.

Not only is an online portfolio essential, post it in more than one place for maximum exposure. Wyman posts different versions of his in four places. Although Photonica (www.photonica.com) is his primary agent for sales of existing stock photos, he prefers to find his own new clients. If they find him directly, he does not have to share a commission.

If an art buyer already knows Wyman by name and reputation, they can find his online portfolio (www.jakewyman.com). He has a portfolio posted at AGPix (www.agpix.com), and another at the famous Black Book (www.blackbook.com), where his work is instantly updateable. The Workbook is another popular site where photographers post their portfolios (www.workbook.com).

"It isn't always necessary to advertise in print anymore. I can send a client an E-mail that includes thumbnails and a link to my Black Book portfolio. It's so spontaneous and fast. It's immediate," he says.

When Wyman learns about a client's interests, he can call up his Black Book portfolio from any computer, enter his password and instantly upload new pictures for a customized presentation. Thumbnails are generated automatically. He can E-mail a Black Book page directly or send a personalized message with links to a list of other agencies that show his work.

"You can update it all the time. The photographer controls what goes up. Since I don't live in New York, it's essential for me," he says.

DO YOU NEED AN AGENCY?

I was fortunate but naive. When I won a Pulitzer Prize in 1992, I had decided to "go freelance"

developing "vision"

As leading photographers, art directors, and editors discuss what makes a great portfolio, one word is almost unanimously repeated: vision. By merely copying trends in annuals, you may lose sight of why you became a photographer in the first place. Being savvy about your market does not mean losing touch with personal passions.

Tom Kennedy has mentored many of the most famous photographers and reviewed portfolios of many of the most promising. The former director of photography at *National Geographic* has turned his attentions toward the Internet and multimedia as tools for communicating. Named by *American Photo* as one of the most important people in the industry, the director of photography for *Washington Post Newsweek Interactive* shares advice pertinent to all shooters.

Three steps toward a visionary portfolio:

A COMMAND OF CRAFT. Control from a technical standpoint and a sense of aesthetics.

A MASTERY OF SUBJECT. Going beyond knowledge and research. When photographing people, the ability to become intimate with the subject.

THE ART OF CREATING NARRATIVE. A vision and interpretation of what the photographer is seeing rather than just a literal recording. A point of view.

just the month before. Although I visited influential New York agencies such as Magnum (www.magnumphotos.com) and Black Star (www.blackstar.com), I decided to go it alone. Winning a Pulitzer might not get you an assignment on its own, but it always opens doors to show your portfolio.

Early on in my days as a freelancer, magazines such as *Life* and *Fortune* were calling me. I thought, "Why deal with agency commissions when I can deal directly with magazines and art buyers?" As I became busier, I was constantly on the road. Not home to service the needs of

clients on deadline, I lost business. Looking back, I now realize that an agent would have been a big help. For my recent projects, Jose Azel and his Aurora Photos agency (www.auroraphotos. com) have been invaluable in getting them to the right people.

Today, freelancers work both sides of the street, so to speak. They troll for business directly with their own online portfolios, face-to-face meetings, and promotional mailings. Agencies database their work for stock sales and take a cut of corporate or editorial assignments.

The ever-changing market for fashion and beauty always makes room for the portfolios of inventive photographers. Outlets include advertising, editorial, catalog and calendar work, stock sales and even retail product rack cards. Gary Kirksey's "Janelle" is glamour photography at its most beautiful.

Jake Wyman specializes in three areas: travel, corporate, and stock. This versatile stock shot at Chicago's O'Hare airport is part of a portfolio grouping he calls "Urban landscapes."

A SEPARATE STOCK PORTFOLIO WILL BOOST YOUR INCOME

For steady income over the long term, have an assignment portfolio as well as at least one type of stock portfolio, focused by specialty. As stock agencies continue to send out less traditional "hard" stock books, art buyers and editors instead have instant access to thousands of photographers' portfolios online. They search for a particular topic by keyword.

After paying a listing fee, photographers who are savvy marketers of their own work can check traffic reports on sites such as the Black Book. By regularly checking which keyword topics are searched most frequently, and which Web pages are most popular with clients, photographers can contact sources or update their portfolios with relevant images.

Ann Guilfoyle founded the influential *Guilfoyle Report*. Now transformed as *AGPix*

(www.agpix.com), the popular site is free to any buyer of photography. Photographers pay an annual listing fee to showcase their work but pay no commissions like they would to a traditional agent. In return, they get a report of "Daily Picture Wants" and an online portfolio including their stock list. For clients who prefer a printed resource, the company still sends out the *AGPix Stock Directory* listing travel, location, and nature and wildlife photographers.

"Economics is driving photo buyers to the Web," says Guilfoyle. "They are under so much deadline pressure and they are looking at our site even late into the evening. Also, they no longer have to worry about losing slides."

Just as bad slide dupes used to hurt the professionalism of a portfolio, "don't kid yourself with poor scans," Guilfoyle says. With your work online, people expect variety and change, your newest coverage," she urges. Like Black Book,

interview

[PHOTOGRAPHERS REP GEORGE WATSON]

A good representative more than earns his 25 – 35 percent commission but it is crucial to find the right talent/rep relationship. As a partner in Watson & Spierman Productions, George Watson represents some top New York photographers including Kan and Joseph Ilan. As president of the Society of Photographers and Artists Representatives, he offers advice on how to make it in the ever-competitive commercial photography industry.

What helps to sell a commercial portfolio?
WATSON: "It boils down to consistency and making people confident that you can deliver and turn their idea into something magical. You have to be technically good and the lighting and composition have to be there. But a portfolio with true vision is different from one where the photographer is copying another photographer's style in an effort to make money. If the work is really coming from your soul, it shows."

Is it necessary to always include a series to show capability in shooting an extended campaign?
WATSON: "It depends on what you shoot. If you shoot lifestyles or editorial fashion, it's advantageous. If you shoot portraits or celebrities, it's more about showing that you can bring out their character. Most still-life photography is not about campaigns.

These days the people who make the final decisions are unfortunately most often the clients, not the creative team. There is less need to show a series. It's more about showing a portfolio that conveys a confidence that you can produce the shots they need in the way they envision them."

How does a photographer break into the New York market?
WATSON: "In New York City, it boils down to timing. It's best to specialize with something unique at the right time for current trends. Here it's about what's going to knock someone's socks off. Be willing to send portfolios and promos without seeing the art buyer or art director in person, unless they know someone who knows you. Contacts are extremely important to get in the door."

Should photographers always start as assistants?
WATSON: "It's a good thing to do. You learn how to deal with clients as well as technical things, too. But it's not necessary for everyone."

What gets a promo card or mailer noticed?
WATSON: "One thing that's important today is that they shouldn't have to open it. Make it a postcard or an envelope with an acetate window. The outside has to make them want to keep it right away. It could be a foldout or a self-mailer booklet. Whatever it is, it's all about the images."
(See Chapter 13 for advice and examples on creating effective promos.)

With so many reps out there, how does a photographer find the right one?
WATSON: "The first thing is to look at the other people this person represents. Decide if you hope to be associated with that group. The personality of the rep is very important. Call up references. If a rep has a good reputation, they can confidentially say, 'Call anybody.' SPAR's Web site lists all members and links to their artists' portfolios (www.spar.org)."

Workplace portraiture is always in demand for both the advertising and editorial markets. Corporate jobs pay, on average, several times more than editorial assignments. Financial services company Allianz assigned Jake Wyman to do this corporate shot of a technology mutual fund manager.

AGPix allows photographers to change their online portfolios at will.

Seattle's Natalie Fobes markets her nature and wildlife specialty in the agency's stock directory but reaches corporate clients through her Web site (www.fobesphoto.com). Like Wyman, she wants clients to book her for assignments directly but markets her stock list at the AGPix Web site. Fobes has been featured on *CBS Sunday Morning* and has worked for clients as diverse as Microsoft and *National Geographic*.

Although some photographers post their own full stock portfolios, remember that it is hard to drive traffic to any Web site, even with considerable advertising promotion. If you are well known, a prospective client should be able to find your work through a search engine such as Google (www.google.com). However, they first must know that they want to find you.

Getty (www.gettyimages.com) and Corbis (www.corbis.com) now dominate the stock and assignment markets, having bought up many influential agencies such as Stone and the Image Bank. For all but the biggest names in photography, it is hard to go it alone without the help of image marketers. Powerful agencies such as Art + Commerce represent big names like Stephen Meisel and William Eggleston, bridging the fine art, commercial, fashion, and editorial worlds.

To sell your stock portfolio, the *Photo District News* online stock photography guide (www.pdnonline.com) is a great place to begin researching which agencies might best represent you. The *Photographers Market* book also has thorough listings and contact information for each agency. Since the needs of clients are always changing, be sure that you have an up-to-date version.

ARE YOUR READY FOR A REP?

Repping agencies promote the assignment portfolios of a select group of photographers, often within focused specialties such as fashion, celebrities, advertising, or still lifes. Julian Meijer (www.julianmeijer.com) represents fashion and entertainment photographers such as Anton Corbijn and Herve Haddad. To capitalize on the growing European fashion market, he recently relocated his agency to Paris from New York.

In fashion, you really have to be in the top cities—New York, Milan, Paris, and London, he says. For advertising, Chicago is also important. For entertainment, it's Los Angeles.

Unlike an agency like Art + Commerce, he'll take a chance on a top-level new photographer, he says. "I take risks on young photographers. I like a photographer to show me what they like to do, not what they can do—what they have to say that's different. What I want is a unique language," Meijer implores.

"It takes two years to build a solid photographer so he's on the market getting advertising and editorial. There are too many fish in the same tank in fashion. We're like the big brother, the nanny, and the hospital," he jokes.

George Watson, a partner at New York's Watson & Spierman (www.watsonspierman.com), represents big names in advertising including Kan, Joseph Ilan, and Adam Brown. For an aspiring photographer to find an influential rep, he advises that a portfolio has to be current. "It starts with a portfolio that is appropriate for the ever-changing market," he says.

"To get there, you have to be a king at marketing, but also the portfolio needs to have a story. Not, 'I can do this and that, and studio, too.' The right focus in commercial photography is how you mix up the ingredients like models, hair, and makeup," Meijer says.

Most advertising photography involves a collaborative effort. "It's not just how good you are, but also how good you are with other people,"

Fashion and entertainment photographer Yaro has a unique vision. He utilizes vivid imagery for his dramatic advertising and editorial assignments. Although all of these photos are successfully and artfully composed, which one really doesn't belong? See page 156 for the answer.

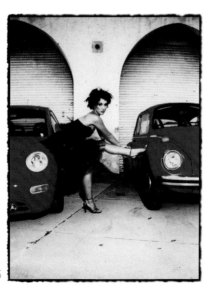

1

2

3

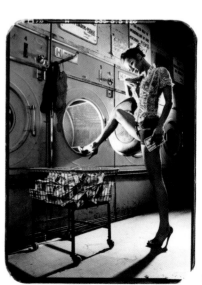

4

5

6

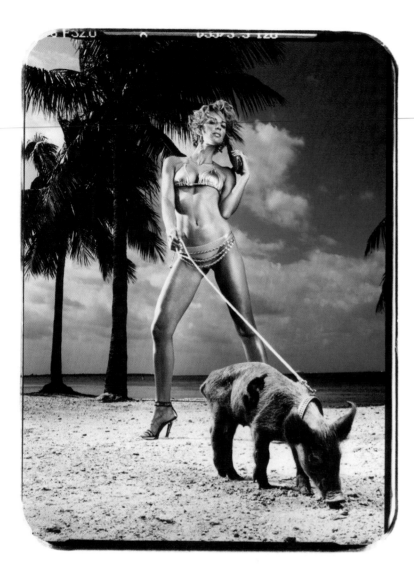

For a *Loft* magazine Miami Beach editorial assignment, Yaro brought in both beauty and beast for a story describing women as gold-diggers and men as money-grubbing pigs.

YOUR BIGGEST MISTAKE

"Don't show something in your portfolio that you can't do consistently."

J. KYLE KEENER
Photographer

Meijer says. Hair stylists, makeup artists, and set stylists are so important that agencies such as Art + Commerce and Bernstein & Andriulli represent them as well.

Up-and-coming photographers can boost the sophistication of their portfolios by offering to trade prints to promising stylists in exchange for their services. "The photographer doesn't see the little things much of the time," says Lisi McClure, a still-life and fashion specialist who works on sets in Miami and New York. She does the styling on shoots for designers such as Ike Behar and companies such as Breyers.

Stylists like McClure are experts at color, placement, and unity. "In composition, it's all about balance. Show what is necessary. Get right to the point," she says. "The photographer is worried about lighting, the client, and the art director. The stylist is a problem solver; it's like having a magnifying glass on the set."

The Web site of *PDN* has a terrific business services link that includes an excellent guide to repping (www.pdnonline.com/business resources). If you believe you are ready, learn more from the Society of Photographers and Artists Representatives (www.spar.org). If you have a lead on a good rep, the Workbook Directory (www.workbook.com) lets you search by name and view the portfolios of photographers they currently represent. Many agencies list their portfolio review policies on their Web sites.

To find listings of stylists, prop companies, or just about anything else related to photography, browse the Resource Advantage Web site (www.rasource.com).

KEEP GROWING

Workshops are offered in virtually all freelance photographic specialties. Membership in ASMP (www.asmp.org) and EP (www.editorial photographers.com) will keep you up to date on business practices and photographers' rights at group seminars. In addition to offering workshops, the Professional Photographers of America (PPA) has an online university (www.ppa.org).

Each October in New York, *PDN* offers the PhotoPlus Expo (www.photoplusexpo.com), which is filled with seminars on changing markets and technology as well as innovative promotional strategies.

General workshops include the Brooks Institute Weekend Workshops (workshops. brooks.edu) and Anderson Ranch Arts Center Workshops (www.andersonranch.org).

It is difficult to recommend specific schools for the study of commercial photography. There are terrific ones of every type. Some great photographers are trained at leading technical schools such as the Rochester Institute of Photography (RIT) or the Brooks Institute of Photography. Others attend four-year state schools such as Ohio University or the University of California at Berkeley. Private schools known for solid photographic training include Syracuse University and New York University (NYU).

Highly respected two-year programs are offered in virtually every state. For example, in Georgia, take a look at the Creative Circus and the Portfolio Center. In Florida, check out the Fort Lauderdale Art Institute. In North Carolina, Randolph Community College has one of the most impressive studio facilities found anywhere.

Many advertising and fashion photographers come from grounding in fine arts programs offered by schools including the Art Center College of Design, Rhode Island School of Design (RISD), Parsons School of Design, the School of Visual Arts (SVA), School of the Arts Institute of Chicago, and the San Francisco Art Institute. Schools in Europe and Asia also turn out sophisticated shooters who work in the U.S.

FURTHER READING

"If you are going to be in this business, *Photo District News* (*PDN*) is a required read," says professor Kirksey. The monthly magazine is supplemented by a free Web site (www. pdnonline.com) loaded with news, resources and practical advice. Pros scan the Editorial Photographers Web site daily (www.editorial photographers.com) to participate in forums or check pricing guidelines.

Web sites with high-quality commercial stock include Solus (www.solus.com), the Workbook (www.workbook.com), and Black Book (www.blackbook.com).

The industry's finest printed creative directory annuals include the juried *Communication Arts* (*CA*) *Photography Annual*, *Black Book Photography*, *Workbook Photography Portfolios*, and *Klik Showcase Photography*.

An indispensable business book is the *ASMP Professional Business Practices in Photography*. Rohn Engh's *Sellphotos.com* explains how the Internet is changing photo marketing. For a creative approach to sales, take a look at *Selling the Invisible: A Field Guide to Modern Marketing* by Harry Beckwith.

Every photographer has favorite coffee table books that serve as inspiration. Spend a lazy Sunday afternoon at your favorite bookstore to add to your collection. Online sources for photography books include Photo Eye (www.photo-eye.com). Out-of-print monographs can be located at Alder Yarrow (www.alderyarrow.com) and an eclectic range of international titles is found at Kowasa (www.kowasa.com).

DESIGN: JANE HEFT

Freelancer Jake Wyman knows how to blanket the Web with more than one type of online portfolio. At top is Wyman's own site where he promotes his assignment work. AGPix and Black Book each promote his stock sales.

wedding photography >>

Wedding photographers build reputations through word of mouth and the satisfaction of former clients. A strong portfolio and sample albums are a must.

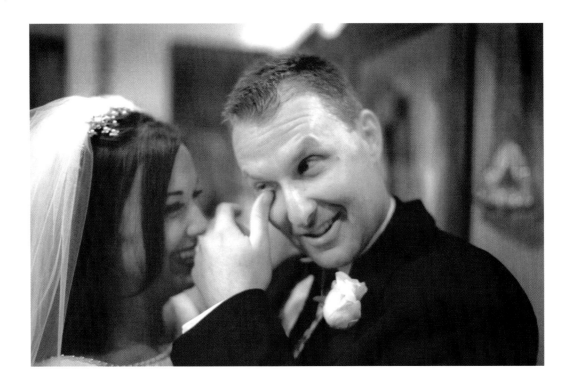

Wedding portfolio psychology is unique. In virtually any other genre of photography, the photographer eagerly clamors for any opportunity "to be allowed" to visit a potential client. Whether you line up at a conference for a review with a famous photographer or practically beg your way into the office of a powerful editor, the client always controls the pace. Showing a wedding portfolio is entirely its own animal. In most cases, the wedding photographer does not go to the client; the client comes to you.

Think about this: With other types of portfolio reviews, the client looks to hire the photographer to shoot someone or something else. For a wedding, the client is also the subject, setting up an entirely different dynamic for viewing the work. In other face-to-face reviews, experienced photographers know to be quiet when showing

Look for both tight and wide shots when editing your portfolio. It's not hard to capture strong bridal emotion but Ian Martin makes sure to keep a close eye on the groom as well.

their work, waiting to be asked pertinent questions. For weddings, the photographer is usually hired directly by the bride and must know how to carefully, gingerly, lead the review.

Consider, first, the concept of vanity. As a potential client looks at your work, her first concern is not, "Does the photography look good?" More likely, it will be, "Will I look good on my wedding day?" If the groom happens to come along, he also wants a low-stress planning process. With all the details couples face to plan a near-perfect wedding, successful pros know they are likely to get the job if they can serve to reduce anxiety rather than create it.

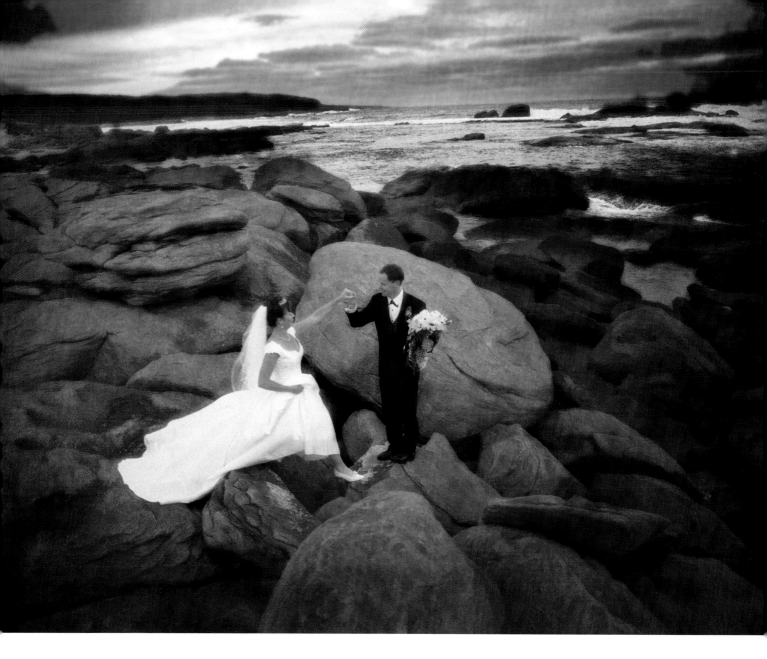

RELAX WHEN SHOWING YOUR WORK

Do not make the mistake of whipping out your portfolio as soon as you meet a potential client. Of course they need to like your work. Far more important is that they like YOU. "When you meet them, they want to know that you are not going to show up at their wedding and embarrass them," says California photographer Ian Martin.

"They want a connection with you," says Tom McCall, who works up and down the East Coast. "You won't get the job if you are fake; they'll sniff out a phony. Talk for a while. Allow clients to express their enthusiasm about what they are doing. Once you've connected, then you show 'em the book."

With more than twenty years experience, Northern Florida's Stewart Powers is one of the most celebrated wedding photographers in the nation. He knows it's essential to set the right viewing mood. Along with his partner and wife,

Susan, he redesigned his studio's viewing room with warm colors and soft edges.

"It needs to be warm and inviting, particularly to women. It has to be comfortable and relaxing.

"The first thing is not to put an album in the bride's hands right away. If you do, rather than look at your pictures as a story, she will think about all of the upcoming details of her own wedding, what colors to choose, etc. Everything other than what you care about: the photography."

Powers asks questions such as how the couple first met and talks for as long as the bride wants to. "I ask, 'Tell me how you see your wedding?' That's how we learn about preferences. If the client has any fears or baggage about bad photography they've heard from their friends' weddings, we let them unload it. I ask what they like and what they don't."

"Next, we show them a three minute Kai's

Many savvy photographers add depth and variety to their portfolios with scene-setting images taken in dramatic surroundings. The rocks along Western Australia's Margaret River made a superb backdrop for Perth's Peter Edwards.

Power Show (inexpensive multimedia software from www.scansoft.com) with 180 images. I make a joke and ask if they see any they like. We choose music that is upbeat and romantic.

Even the language that Powers uses with potential clients is carefully chosen to help set the mood for the anticipated big day. "We never use an aggressive word like 'shoot.' Instead, we are likely to say, 'capture,' or 'photograph.' "

PORTFOLIO MECHANICS

How many photographs to show is dependent on your personal style. Many photographers first show a "greatest hits" book with roughly twenty images culled from a variety of weddings. Also presenting a tightly edited sample album from a single wedding can be a good idea to help create confidence in your abilities.

Since the bride is likely to visit several photographers, or look at their work online, it is best not to show every literal detail contained in a typical full wedding album during a first meeting, but rather an abbreviated version with highlights. Your chances of getting the job will increase by presenting a tightly edited sample album paired with a positive first impression.

Most pros suggest showing proof books only when asked. "It's boring to look at 100 photos of someone else's wedding," says Martin. "I show a portfolio book with nine or ten photos from each of three weddings. Online, I show four weddings and a handful of informal portraits."

Once a client has booked you, then you can carefully roll out your "marketing munitions." Since more prints purchased represent increased profits, consider showing a larger sample album with the types of images you plan to capture. This usually includes formal portraits of the bride and groom and families as well as a range of photos showing the story of their day. Let the client decide which situations most appeal.

To increase sales, consider presenting a full-size final album as well as smaller-scale versions targeting the parents of each couple. For example, a typical bride and groom album might be 12×12 inches, while parents' albums are available in formats such as 5-inch or 8-inch.

Powers has increased his business and won Professional Photographers Association awards by creating albums that utilize a chronological "picture story" approach. He also offers specialty albums such as engagement recreations or honeymoon albums. "Most photographers underestimate what clients will invest in photography," he says.

Tom McCall specializes in high-end weddings that spare no expense. Particularly well-heeled clients occasionally bring in two or even three photographers, he says. "Sometimes, I'm just the black and white guy."

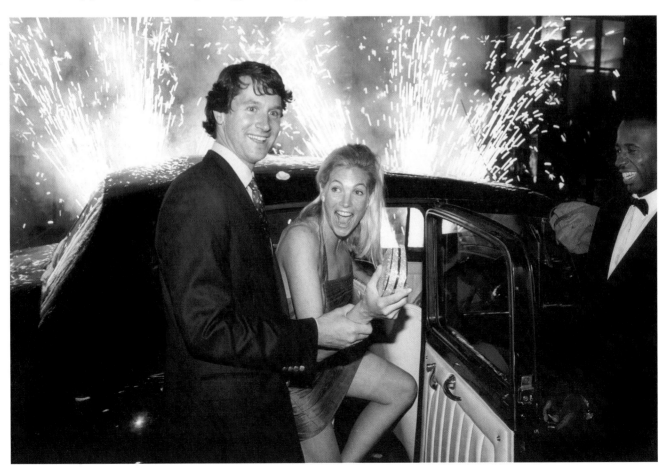

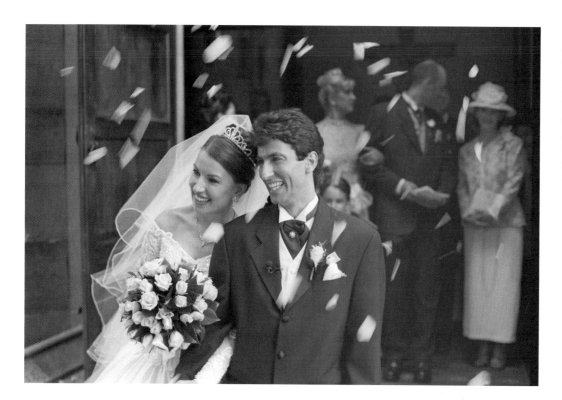

The first-rate work of Australia's Peter Edwards shows why traditional and photojournalistic approaches can work hand-in-hand. A great wedding portfolio is strengthened with examples of well-lit portraiture as well as spontaneity.

THE TREND TOWARD SPONTANEITY

The wedding industry is undergoing a sea change, both in terms of technology used and evolving shooting styles. Gone are the days of completely posed and orchestrated weddings. Capturing spontaneous moments in what is termed the "photojournalism" style is hot. A photographer interested in building a business would be wise to understand the strengths of both traditional and photojournalistic approaches.

Since referrals are key to long-term success, be sure to be in touch with trends that clients discover at bridal fairs and in magazines. Develop your talents in capturing spontaneity and romance. However, remember that most clients still desire well-lit posed portraits, too, as long as they do not feel stiff and cold.

In years to come, the bride and groom will remember their wedding day through the good feelings captured in your work. An effective portfolio blends mood and emotion with glamour and class. It must show people at their most attractive while, at the same time, not intimidating future brides.

The photojournalistic approach first became popular in the 1990s as shooters such as Dennis Reggie tossed out the old conventions of strict poses in favor of natural moments and edgier compositions. When Reggie was hired in 1996 to cover the wedding of the late John F. Kennedy, Jr. to Carolyn Bessette, he became a superstar in the industry. His fees have climbed beyond

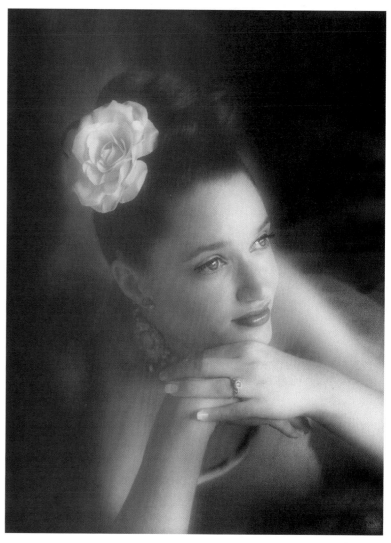

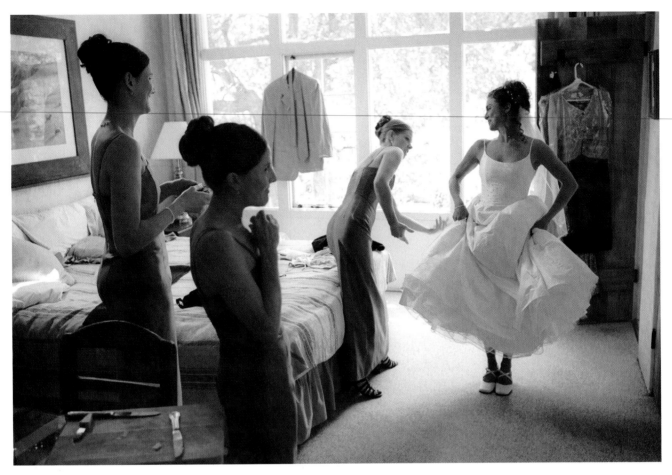

A photojournalistic style portfolio always benefits from behind the scenes shots. Like any good photographer, Ian Martin arrives early.

twenty thousand dollars.

Naturally, other photographers jumped on the bandwagon and the marketplace is now filled with "wedding photojournalists." Some are former newspaper photographers able to more than double their salaries using similar skills. Others are traditional portraitists and studio owners who recognize a paradigm shift in the industry.

FIND THE APPROACH THAT WORKS FOR YOU

Whatever your natural style and strengths, don't make the mistake of throwing it away just to follow a trend. Always shoot to your strengths while not ignoring the forces that shape the market. Your portfolio will land you work only if it communicates your comfort level and the unique strengths you bring to the wedding.

If portraiture and elegant, posed "moments" show your style at its best, by all means, let that be reflected in your portfolio. If lighting and posing is not your strength but you are great at the "fly on the wall" approach, show peak situations of joy and emotion. As with any type of freelance photography, have confidence in your own style and vision. Be willing to take

YOUR BEST MOVE

"You've got to be comfortable getting close to emotion."

TOM McCALL
Photographer

workshops and seminars that can help strengthen weaknesses and teach marketing skills.

"In 1997, we recognized the trend," Powers says. Rather than put his own reputation on the line experimenting with a new style on an unsuspecting client, he asked a fellow photographer friend in another state if he could build samples by capturing pictures behind the scenes at an upcoming wedding. Armed with images in a successful new portfolio style to show, he began to integrate the photojournalistic approach.

"We don't use the term 'photojournalism' because of course we do affect the moment," he says. While many photojournalists pose nothing other than a few family portraits, Powers also places couples in situations that possess the potential for good moments. He then asks his subjects to ignore him and react to each other.

"We call it editorial style. I'm trying to tell the best story like a photojournalist but my clients hire me to have an opinion and vision. When we need to, we do pose them so they look their best. If the strict photojournalist is only an observer, he's not doing anything to benefit the client and thus improve the day."

Clearly, in most regions, the marketplace has room for photographers with complementary

visions and varying approaches. Tom McCall targets high-end weddings, particularly in New York and Connecticut. "I love black and white. When I got out of grad school in 1998, I didn't see many ways to make a living with it."

His love of documentary-style photography was fortuitous at a time when the trend in weddings gravitated toward his natural shooting strengths. His wife and business partner, Samantha, took a workshop from Dennis Reggie. It helped the couple realize that the emerging photojournalism wedding market still had room in the Northeast for a specialized approach that targets only the most affluent. Years later, the McCalls have built a lucrative business doing only hand-printed black and white photography (other than proofs). Eighty percent of their business is through referrals from former clients. McCall blends photojournalism "reportage" shot on 35mm with portraiture of the wedding parties and their families shot in $2\frac{1}{4}$ format on Hasselblad. "For us, it was just dumb luck. We hit upon a trend at the right time.

"For high-end weddings, they don't want to hire a stranger. To get this type of client, the people in the portfolio have to look like they are of the same class, not the folks down at the fire hall. The advice we got was, 'Don't go after the big fish if you are swimming with the minnows.'

"It's hard to get that first big job. When looking at your own portfolio, ask yourself, 'Is this glamorous? Is this beautiful?' To get the client you have to have exciting images. Your prints can't skimp on quality. I like the 'greatest hits' portfolio approach to show breadth of work," McCall says. He also shows albums upon request.

"It's a little misleading to only show your best pictures," says Michael Schwarz, who directs the Wedding Bureau agency (www. weddingbureau.com), along with partner, Alan Weiner. "We ask a photographer to show their best along with an album from a wedding so a client can see what they might expect from their own wedding." The agency contracts working photojournalists, including Pulitzer Prize winners, who shoot weddings on the side. The pho-

As a newspaper photographer, Chris Record is used to thinking on his feet and recording spontaneity. Doing weddings is a lucrative option for photojournalists who seek a supplemental income. Some eventually make the jump to full-time wedding photography, which can easily pay double that of a newspaper salary.

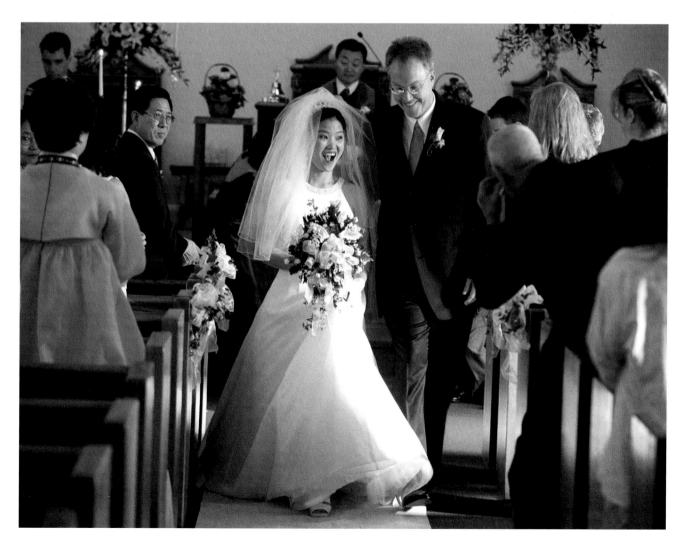

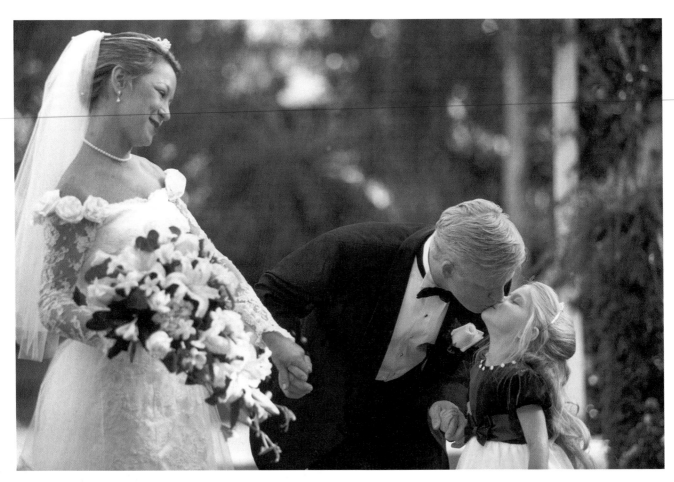

Long lens compositions are great for isolating special moments that couples will long cherish. Strong wedding portfolios mix up lens choice, angle and perspective to create a winning mix for Taylor Smith of Powers Photography.

tographer works for a set day rate and the agency handles the details, making its profits from album and reprint packages.

Amateurish attempts by untrained photographers to shoot in the photojournalistic style have disappointed some clients who are later surprised to have been portrayed in a "too honest" and unflattering light. "I think the next thing will be a nexus of fashion and reportage. It feels real and yet it's really about beauty," says McCall. Such an approach blends advertising glamour and editorial spontaneity. The style is captured in the work of photographers such as John Dolan, Terry deRoy Gruber, and Bruce Plotkin.

DON'T OVERREACH

"You do not want to raise unrealistic expectations," says Martin, a former newspaper shooter who increased his salary by more than fifty percent the first two years after turning to weddings. "Be sure that your portfolio entices but also is indicative of the quality that the client should expect to receive.

"Ask yourself if the portfolio reflects a level of quality you can attain on an everyday basis. Shoot a

YOUR BIGGEST MISTAKE

"Don't talk badly about other photographers. It's not professional"

STEWART POWERS
Photographer

lot of weddings, even for practice with friends." Martin says.

PROFESSIONAL GROWTH

Not every style is right for any given market. Join professional organizations and attend meetings and seminars, even if you are still a student. Pros who build their reputations over the long haul follow their instincts but don't ignore important trends. For wedding photographers, finding a mentor in your hometown is not always easy. Wary of ever-increasing competition, pros in your area might not be willing to share their secrets.

At seminars and workshops, it is often much easier to find a receptive audience. Each February, PPA (www.ppa.com) holds the annual Wedding Photographers Conference. More than twenty schools throughout the U.S. affiliated with PPA's Continuing Education System offer workshops. *Professional Photographer* magazine lists upcoming schedules in each issue. The group also hosts state and regional meetings on a variety of pertinent subjects.

While PPA targets professionals of all types, Wedding and Portrait Photographers International (WPPI) is exclusively for those within the genre (www.wppi-online.com).

interview

[WEDDING PHOTOGRAPHER STEWART POWERS]

Master photographer Stewart Powers is the only Wedding Album of the Year three-time winner, the top prize given by Wedding and Portrait Photographers International (WPPI). Powers shares his insights.

> >

With so much competition in wedding and portrait photography, how can a photographer find a mentor?
POWERS: "Ask to assist at a wedding far from your home or in another state, where you are not going to be in competition. Then you'll be greeted with an open door."

When you look at other portfolios, what are the qualities that set the best apart?
POWERS: "The photographer understands light. Know several techniques for getting light into the eyes to avoid "raccoon eyes." I look for a sense of fun and playfulness. Let the people be themselves. Also, an understanding of romance, what it really looks like. Avoid being contrived and cheesy."

What are the qualities that help a wedding photographer win top awards for their albums?
POWERS: "For us, it is just story-telling. There's nothing to detract. We include chapters with segues. We plan our locations ahead of time and think of how we'll link them together. We expand the concept and might include something like a proposal reenactment. Avoid the use of painted backdrops, which may give a generic look."

Even though photographers build their reputations by winning awards, how does that help when showing album samples to a prospective client?
POWERS: "We don't stress the awards because we're trying to appeal to the right-brain—how things feel. Not the left-brain, such as awards we've won. It's not the information in the picture that's important, it's the feeling that it gives you."

What are most of your clients looking for in an album?
POWERS: "They want fun and elegance. The pictures should reflect that. They want their story to be a complete tap-

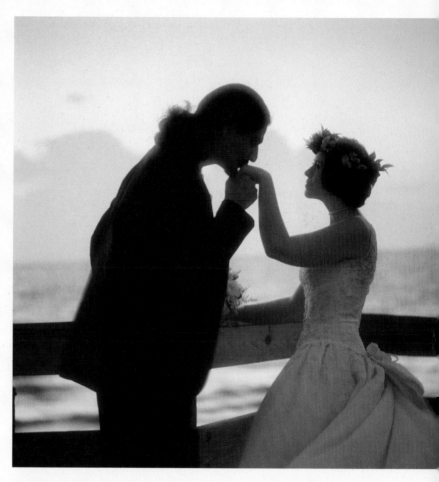

Three-time Wedding Album of the Year winner Stewart Powers understands that the traditional approach still yields keepsake photographs that his clients adore. Beginning in 1997, he also began working in the photojournalism style along with partner, wife Susan.

estry of the day from hair and makeup to even being carried across the threshold of the honeymoon suite."

With all of the changes in the industry, can you recommend reading that keeps a photographer up to date on technical matters?
POWERS: "I read *Photoshop User* magazine and the online technical forums at fredmiranda.com and dpreview.com. Keep your mind open to everything aesthetic. My former professor, Evon Streetman, says, "If you want to be a great photographer, study everything but photography.""

Some photographers ask for higher fees to turn over their film rather than the traditional approach of putting together an album. Is this a good idea?
POWERS: "So many photographers are just giving them the film and not doing the book. Ask yourself if you are going to benefit the client or are you simply recording the event? We're in a small town and 70 percent of our business is referrals. We benefit the client all the way to building the album. In this market, it's important to be service-oriented so they come back and continue with us as clients."

Compositions of simplicity and grace can say it all, as Central Illinois photographer Jeffrey Woods found.

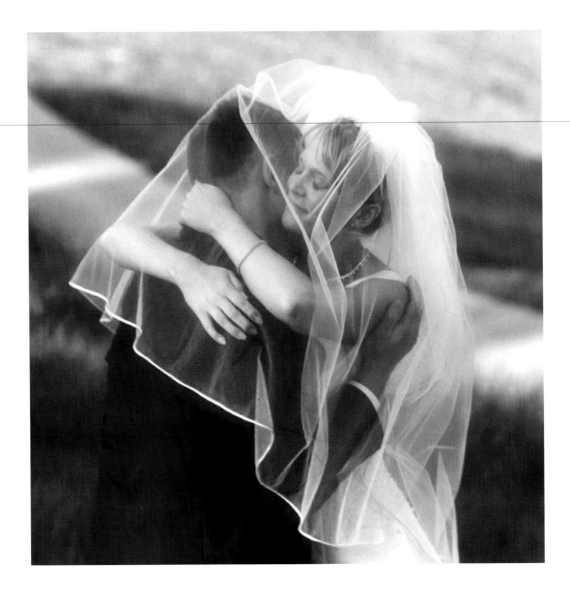

Members receive the *WPPI Monthly Photography* newsletter and are listed at the group's wedding referrals Web site, www. eventphotographers.com.

Both organizations sponsor album and print competitions. Get a close-up feel of the quality of albums that are deemed industry best at PPA

national, regional, and state conventions. At the national convention, a multimedia presentation shows the top ten winning albums from the PPA international exhibition.

Magazines of interest to wedding and portrait photographers include *Professional Photographer* from PPA, *Rangefinder* from WPPI, as well as *Studio and Design*. Do not ignore what your clients read including *Brides*, *Modern Bride*, *In Style*, and *Bridal Guide*. You will also find regional magazines at local bridal shops and florists.

Scan the Web for online forums devoted exclusively to wedding photography. You'll find them as part of Web sites such as www.zuga.net and www.pro4um.com.

ONLINE PORTFOLIOS

While brides and grooms still prefer to visit prospective photographers in person, today they are likely to have first scanned several sites on

adjectives for an active portfolio

The Web site of Stewart Powers, the only three-time Kodak Gallery Elite grand prize winner, incorporates the words below. They embody the energetic approach that he brings to his craft.

A successful portfolio communicates with emotion and vigor. Do your pictures bring to mind any of these feelings?

- Fun
- Romantic
- Unobtrusive
- Timeless
- Sexy
- Spontaneous
- Happy
- Graceful
- Lush

the Internet. Even though this increases competition, it also opens up new markets for photographers, such as destination weddings. Having a Web site helps any photographer work more efficiently by weeding out prospective clients who seek a different shooting style or fee structure.

An effective online portfolio must go beyond competence. It should clearly reflect your shooting style and create a feeling of confidence. The Web site design should subtly parallel the impression that you hope to make in person.

"I want all my contact with the client to have the same visual thread all the way through," says Martin. "Everything should have the same design continuity whether it is advertisements, the contract, the proof book, or the Web site. It's a method of branding and distinguishing myself."

As with a print presentation, an online wedding portfolio should tease right up front with the photographer's best work.

A native of Carmel, California, a popular spot for destination weddings, Martin's long distance marketing efforts are accomplished through listings at www.theknot.com and www.weddingchannel.com. Couples find Martin by typing in the location of the wedding and getting lists of vendors and photographers who serve his area. He finds the listing fees to be well worth it.

"To seriously compete nowadays, it's essential. I frequently have clients book me three thousand miles away without ever having met me," Martin says.

"These days they'll live in Boston and get married in Atlanta," says the Wedding Bureau's Schwarz. "Our photographers each have an online portfolio. Our clients shop online and decide to hire based on what is online."

Many photographers also post online proofs to increase sales to family and friends of the bride and groom. Photoshop's Actions control is a convenient way to automatically build HTML proof pages of thumbnails. One company, Pictage (www.pictage.com), has built a lucrative niche by posting online proofs. The photographer sends raw film or files and the company handles everything else. It scans and posts each photo at its Web site. As customers order prints, Pictage outputs them digitally and ships them. "It's driven up our reprint sales 25 percent," says Schwarz.

CD AND DVD PORTFOLIOS AND ALBUMS

Some photographers like to hand out self-running CDs in Windows format at bridal fairs. Software such as CompuPic (www.compupic.com) can be used for simple auto-run slide

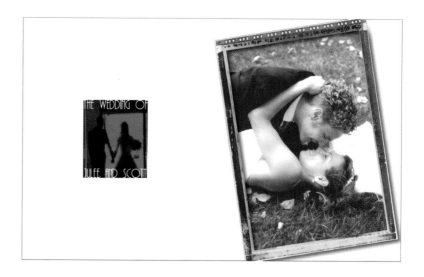

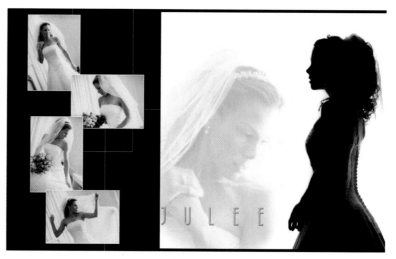

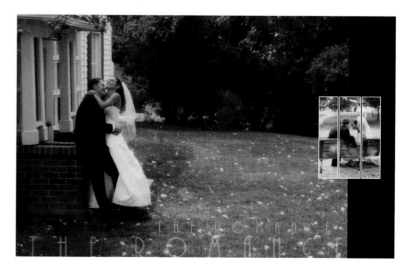

Digicraft helped pioneer digitally composited magazine-style albums. Their groundbreaking design and binding services produce stunning coffee-table books, helping clients win album awards, such as this one for Sue Halliburton. The company offers several levels of service to those who prefer to do the printing or design work themselves.

PETER EDWARDS

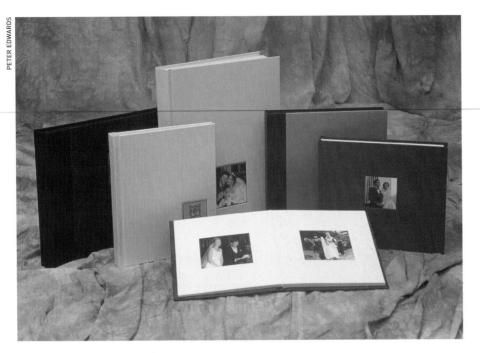

Jorgensen's Art Albums feature hard-covered cloth books with a clean look.

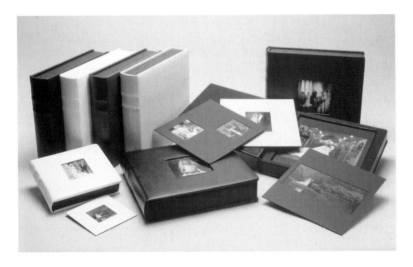

Art Leather is one of the premier sources for variety in high-end albums.

are being outputted digitally as well. While some use programs such as QuarkXPress, Powers sometimes does the design work himself directly within Photoshop or uses template software such as offered by Australia-based Martin Schembri (www.martinschembri. com.au). He then sends his digital layout files via CD or FTP to Burrell Professional Lab in Indiana. Burrell (www.burrellprolabs.com) specializes in wedding photography services including retouching, texturing and lacquering.

Digicraft (www.digicraft online.com) is a pioneer of meticulously crafted hand bound books that are digitally composited in Photoshop. Its cutting-edge designs have won many awards. White Glove also features digitally printed coffee table-style books (www.wgbooks.com).

ALBUM CHOICES

For large albums, library-bound leather books offer the advantage of thinness while exuding the highest quality. Leather Craftsmen (www.leathercraftsmen.com), Art Leather (www.artleather.com), Capri (www.caprialbum. com), and Zookbinders (www.zookbinders.com) all compete at the high end. Each makes custom books as well.

Other superb wedding album manufacturers include Jorgensen (www.jorgensen.com.au), as well as ArtZ (www.artzproducts.com) and Renaissance (www.renaissancealbums.com).

FURTHER READING

You will find an abundant choice of books on technique at your local bookstore. For a guide to wedding reportage, photojournalists recommend *Wedding Photojournalism: Techniques and Images in Black and White* by Andy Marcus. For a concise update on changing technology, take a look at *Professional Techniques for Digital Wedding Photography* by Jeff and Kathleen Hawkins. For creative inspiration, browse through *Innovative Techniques for Wedding Photography* by David Neil Arndt, or an excellent guide to trends, *The Art of Wedding Photography: Professional Techniques with Style* by Bambi Cantrell.

shows as well as cataloguing. If you have no interest in doing the programming yourself, Collages.net creates CDs for photographers to sell to clients and also offers an online portfolio listing service (www.collages.net).

Few photographers believe that disks are destined to eventually replace albums, though. "They like the convenience of the CD but they still want the book," Powers says. "They want a beautiful heirloom document to hold. But still, I'm intrigued by the idea of putting together DVDs with stills, sound, and motion."

DIGITAL ALBUM PRODUCTION

Many photographers make archival inkjet prints and place them in albums or let specialty album companies bind them. Multiple picture layouts

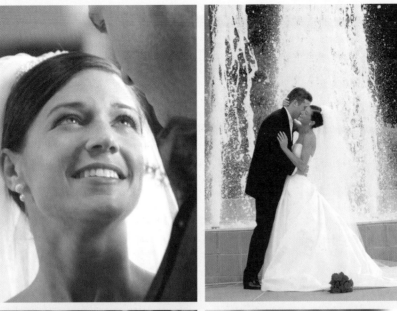

1

2

Here is a selection taken from one couple's wedding by celebrated photographer Stewart Powers and his partner Susan. When Powers puts together a competition album, it does not include all photos chosen by the bride and groom, only the best. Which could be cut? See page 156 for my thoughts.

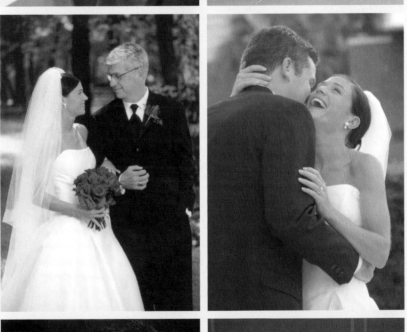

3

4

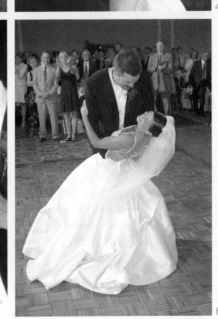

5

6

CASE STUDY

With many great images in circulation, you must build a portfolio that demonstrates diversity and a personal perspective.

While he was still a master's student at the University of Florida, the Smithsonian asked Carlton Ward to do a photographic book on bio diversity in the African nation of Gabon. While in the field, he created a portable studio to carry out the project.

'll never forget the day I took my first "great" nature photograph. After high school, I took a year off before college to backpack across the country and try my hand at shooting scenics in the great American West. As we rounded a bend in Yosemite National Park, I was suddenly faced with the most stunning photo opportunity I had ever encountered.

In front of me was Half Dome peak, surrounded by a rich azure sky and perfectly mirrored in the lake below. I quickly rushed to take out my gear and photographed the magnificent scene with every lens I had, burning up several rolls of slide film in the process. With the addition of my newly found polarizing filter to the lens, I just knew I had a keeper. It was a true natural high.

After the exhaustive shooting session, we stopped at a camp store to pick up supplies. It had an aisle with gift items and postcards so I decided to take a look. I'll never forget what I saw for sale—photographs of Half Dome, almost exactly as I had composed it, on posters, t-shirts, and even coffee cups! That day was an important lesson for me—shoot what you love but also find ways to bring back nature photos showing a unique and fresh perspective.

The best nature and wildlife portfolios do this. It's not difficult to locate stunning scenery and render it on film. The passion for documenting the great outdoors is shared by thousands of talented shooters, many of them amateurs whose

work can rival that of the finest professionals. The challenge is to captivate viewers through unique composition, light, and perspective.

WHAT'S YOUR NICHE?

Whether you shoot nature and wildlife as a serious hobby or as a freelancer doing editorial assignments and building stock, many pros suggest finding at least two complementary niches. The old definitions of what is and what is not a "proper" scenic, for example, have changed. Few successful freelancers refuse to capture landscapes devoid of figures or man-made influences, although that is certainly a valid approach for those who want to show the very reasons why nature's beauty should be preserved.

Even the late Galen Rowell's stunning photographs of the environment were at times supplemented by pictures of the people who inhabit it in his books and *National Geographic* essays.

Many come to their passion for nature photography through other photographic interests such as photojournalism or travel. Seattle's Natalie Fobes started as a generalist, a newspaper photographer. As a freelancer, she specializes

in the Pacific Rim and has earned a reputation as perhaps the world's premiere photographer of salmon. Her nature and conservation photo essays have appeared in *National Geographic* and she has published the book *Reaching Home: Pacific Salmon, Pacific People*. Her nature and wildlife work is complemented by her strength in shooting people. Fobes' other books are as diverse as a fine art series of Polaroid transfers of the Alaskan wilderness and the aftermath of the Exxon Valdez oil spill.

With so much good photography of wildlife in circulation, Fobes says that photographers can no longer make it by shooting only straightforward pictures of animals. "You need to look for behavior, good light, and composition—something that expresses emotion or tells you more."

Delaware's Pat Crowe worked for more than twenty years in newspapers and was a National Photographer of the Year before making a name for himself all over again as a wildlife shooter. "I came at it from a photographer's perspective, not that of a naturalist like some do," says Crowe, who has been featured in *Outdoor Photographer*. "I try to incorporate graphics,

John Moran entitled his well-planned photograph of the comet Hale-Bopp, "The World is a Miraculous Place."

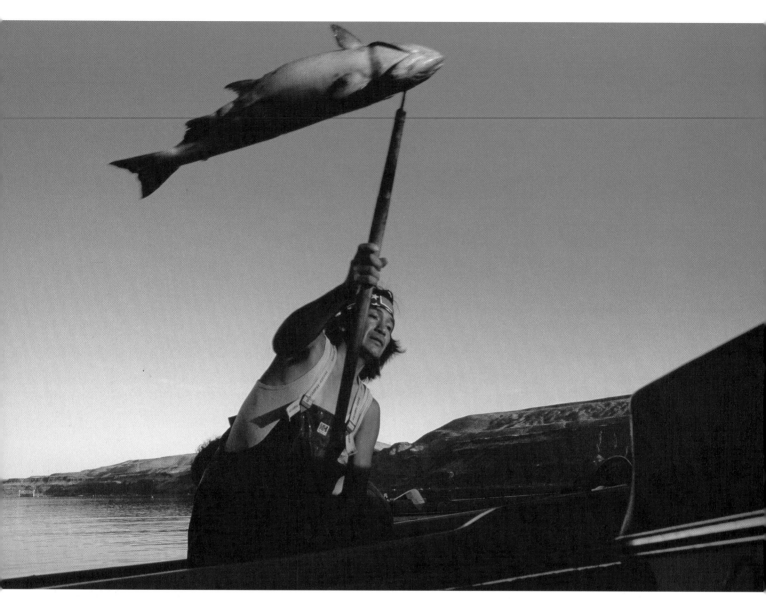

Depending on your niche, today's nature and wildlife portfolios often bring in the human element. Natalie Fobes found a Yakima Indian fishing for Chinook salmon on Washington's Columbia River.

something that makes a picture pop." He found a niche in simple, evocative black and white pictures that he has marketed through the Animals Animals wildlife agency (www.animalsanimals. com). Although he loves getting away from the rat race and out into nature, Crowe also specializes in scenics and portraits in Ireland and humanistic corporate work, too.

The portfolio of Utah's James Kay also shows more than one related specialty. Kay first became known as an adventure photographer capturing sports such as skiing and mountain climbing. He landed covers of many top magazines including *Outside*, *Sierra*, and *Outdoor Photographer*. When surrounded by incredible scenery in his assignment work for magazines, he also developed a body of work of scenics.

REACH OUT

For shooting inspiration, reach beyond nature itself and check out the national and regional forums sponsored by the North American Nature Photographers Association. Professionals, serious hobbyists, and students attend NANPA (www.nanpa.org) gatherings featuring talks by leaders in the field along with project development tips, field trips, and portfolio reviews. Although it is best to bring a tightly edited portfolio, paid portfolio evaluations at NANPA conferences allow you to bring up to a hundred images for feedback from established pros like Darrell Gulin and Chris Johns.

Check out the NANPA Web site to read a first-rate reference handbook of shooting tips and a schedule of upcoming events and workshops. Members receive the bi-monthly nature newsletter, *Currents*. The annual Members Showcase CD highlights captivating photography.

The Nature Photographers Network (NPN) posts an online magazine that helps sharpen shooting skills with articles such as how to anticipate animal behaviors and understand basic biology (www.naturephotographers.net). The site links to personalized portfolios of each member. Members can post their portfolios on the Web through a free one-year portfolio hosting service at Imageculture (www.imageculture.com).

PRINT PORTFOLIOS TARGET SPECIFIC CLIENTS

Although the Internet has become an essential showcase for an outdoor photographer's work, showing a print portfolio is still an effective way to solicit new assignments. The sale of stock transparencies or scans through an agency can also serve to build a steady revenue stream for freelancers.

Print and online portfolios can be customized to the needs of a specific client. Before the Web, it was always advantageous to send out portfolios of prints, says Kay. As he built his reputation, his print portfolio was strengthened through the addition of tearsheets of covers and a publications list, helping potential clients trust his abilities.

Dallas-based wildlife specialist Sean Fitzgerald suggests looking first at your target audience. He has three distinct wildlife print portfolios. His art portfolio is sent to corporate buyers and galleries. "They want to see color, shape, and form displayed through a nature and wildlife palette."

His photojournalism-oriented editorial portfolio targets editors at magazines such as *Audubon* and *Sierra* or even *Time* and *Newsweek*. Such magazines often look to document specific environmental issues such as deforestation or pollution. "For that I ask myself, 'What would an editor want to see?' Include images showing behavior, too."

Fitzgerald's third portfolio helps generate stock sales. "This has images that are simple, with a broader advertising theme, where the thematic possibilities jump out. For example, illustrating perseverance through adversity."

Even with the advantages of a print portfolio, the Internet has revolutionized the business of nature and wildlife specialists. "A client in Europe can look at it instantly online without a two-day lag time to mail it to them. We can be on the phone discussing it with them as they look at it," says Kay.

A captive situation at an alligator farm yielded a great stock shot for John Moran. NANPA's voluntary captioning guidelines ask that photographers always state where and how the image was made.

ONLINE PORTFOLIOS MAY SERVE MORE THAN ONE AUDIENCE

As I mentioned, some successful nature and wildlife shooters work in two or more distinct thematic areas of photography. If you shoot in more than one, like James Kay, separate your portfolio into distinct categories.

As with all freelancers, a Web-based portfolio has become the most valuable marketing tool for nature and wildlife shooters. A savvy Web site can appeal on more than one level. Logically, future clients are a key audience. Editors may look at an online nature portfolio wanting to assign editorial work or simply get a taste of a photographer's shooting style.

A tightly edited sample of stock offerings may also be included online. However, most photographers have found that when it comes to marketing, it is nearly impossible to go it alone. Most tease with their Web site and also distribute their work through stock agencies. Websites often include stock lists so interested clients may quickly understand a shooter's topical or geographic specialty.

A second potential audience for an online portfolio is buyers in the fine art print market. Nature and wildlife shooters can boost their income considerably (up to 25 percent, most say) through print sales. For instance, a reader might be captivated by a picture in a magazine and look up the photographer's Web site online. Also, commercial art reps scan the net seeking images suitable for corporate buyers.

Having an online print gallery is another link in the chain, says Kay. Great outdoors photos are used as corporate art to remind employees of concepts such as the need to excel. In addition, companies such as American Airlines and IBM have bought Kay's stock photos of climbing and adventure sports for ads demonstrating concepts such as accomplishment.

Many leading photographers advertise matted and framed prints online, trying to balance one foot in the nature and wildlife market and another in the world of fine art. Fitzgerald's online portfolio markets stunning Iris fine art prints on watercolor paper as well as his wildlife and environmental journalism shooting specialties by geographic region.

YOUR BEST MOVE

"The whole point is for them to remember you. Make the portfolio a personal statement of who you are as a photographer. You are selling your vision."

NATALIE FOBES
Photographer

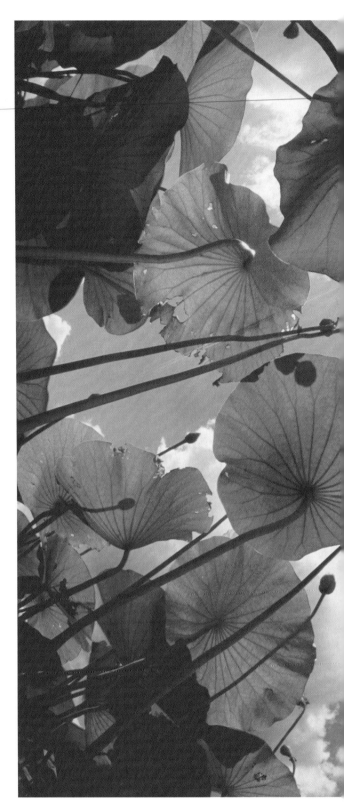

KEY PORTFOLIO ELEMENTS

A wide range of equally valid approaches is demonstrated in nature and wildlife portfolios. A serious amateur or professional interested only in the art market might put together an effective grouping of large-format landscapes, for example. Other photographers make their living spe-

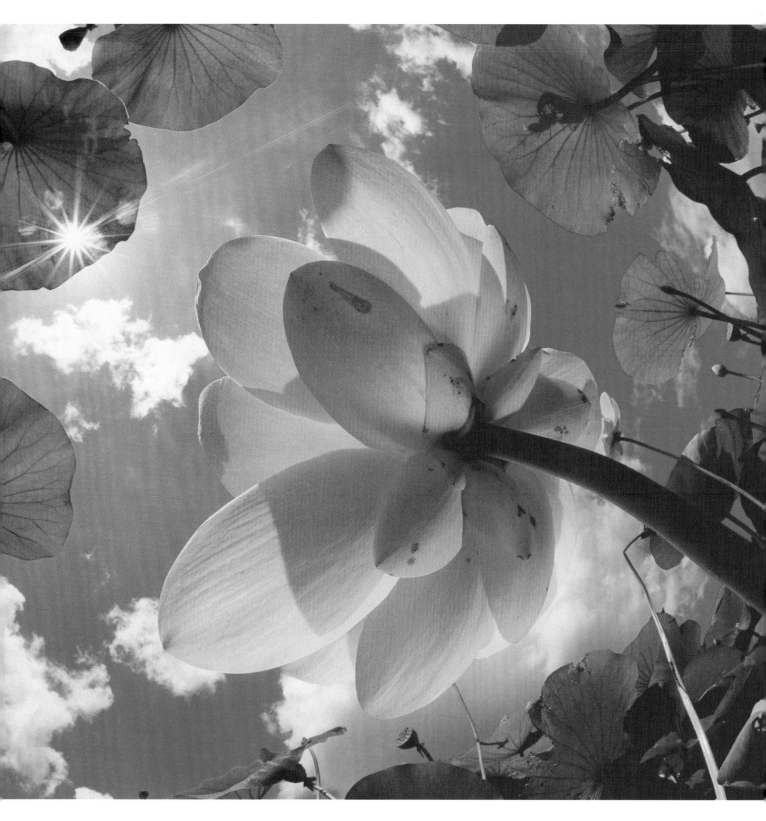

cializing solely in flora and fauna or primates. If you work in more than one subject area, as many do, separate each in your portfolio and look to show variety within a specialty.

Compelling composition comes alive with a mix of wide angle and telephoto lenses. Isolating an animal with a long lens can be effective, of course, but is more involving if the picture also incorporates interesting facial expression or movement. Wide lenses, particularly at small apertures for enhanced depth of field, are terrific for documenting perspective, context of habitat, or the drama of the land.

Florida nature photographer John Moran

When editing your portfolio, ask yourself if it shows a variety of perspectives. As the imaginative John Moran urges, "Get high, get low, get dirty and get wet."

says that like any genre of photography, memorable pictures are taken by "thinking outside the box." Moran has been published in *National Geographic*, *Outside*, *Smithsonian*, and on the cover of the *National Audubon Society Field Guide to Florida*. He urges the importance of perspective. "Get high, get low, get dirty, and get wet. What do nesting ospreys look like from inside the nest?" he asks. "What does a lotus in bloom look like from underneath, from the perspective of the critters that crawl beneath it?"

Engaging use of light, perhaps more than any other single technical factor, helps to add drama to your portfolio. Aesthetically, light can be crucial to selling a photo. Any seasoned nature and wildlife shooter knows to work during the first two hours in the morning, or during "sweet light" moments before sunset.

"Everything starts with light," says Fitzgerald. "If I'm looking at a portfolio, I want to know if they can work in all types of conditions.

There is no single rule to follow such as the light always coming over the shoulder. I want to see backlight, sidelight, or even cloudy conditions with a softer effect." As Jim Clark writes in the NANPA handbook, think of inclement weather as an asset, not a liability. However, when composing, avoid large areas of bland, overcast sky to avoid pulling the viewer's eye right out of the frame.

Fill flash can open up needed detail but "if somebody notices it in your photo, you've likely used too much. Develop a grasp of subtlety," says Fitzgerald.

Image sharpness is essential for salability. Image-stabilizing lenses often pay for themselves many times over because they help photographers overcome the technical hurdle of shooting movement of wildlife in fleeting light. "If it's not sharp you might as well forget about it—cut it from your portfolio," says Crowe.

After the director of the Animals Animals

It's no secret that sunset shots are often clichéd. However, this combination of inclement weather and the setting sun created an otherworldly winner for John Moran.

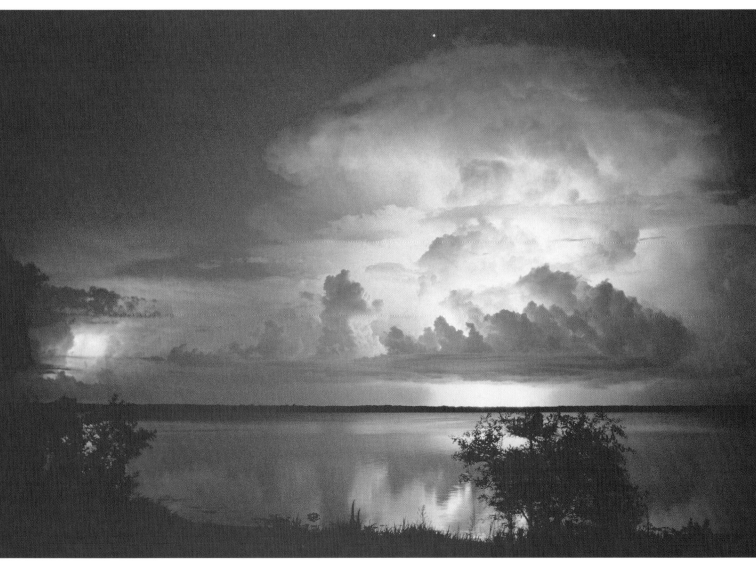

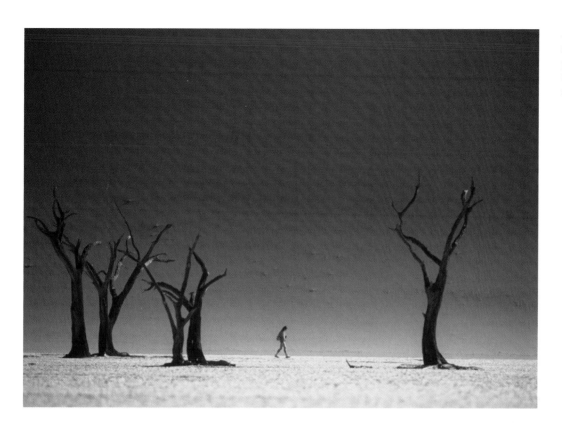

Jake Wyman's poetic scenic from Namibia was published in National Geographic's *Adventure* magazine.

agency rejected several of Crowe's photographs that were otherwise excellent compositionally, she suggested that he invest in an inexpensive Peak 10x loupe. Because of its far more modest magnification, "the Schneider 4X loupe makes you feel like you are a tremendous photographer," he jokes. "I also started making sure I was always using a tripod."

Knowledge of subject goes far beyond how to choose a lens, film, or other technical factors. Every successful nature and wildlife specialist that I speak to stresses the need to do research to understand behavior and habitat.

"Know your animals. If you don't know much about the behavior, at least be able to differentiate between a duck and a goose. Agencies want to know which specific species you've captured. It's the same with trees, bushes, anything. Go to a large bookstore and pick up an encyclopedia of animals. The Audubon field guides are good, too," says Crowe.

SHOOT FROM THE HEART

Your portfolio should convey inspiration, not information. To improve, be open to shooting from your heart, not just mastering technique, says Moran. Indeed, seemingly magical photos often come from photographers who may not possess the most outstanding technical skills, but instead a passion to share their joy of discovery.

As *Outdoor Photographer* columnist Dewitt

the ethics of captioning

Whether an image was taken in the wild or at an animal farm, the photographer has a responsibility to caption it accurately. It may not matter to advertising buyers where and how an image was captured but nature and conversation publications deserve to know the shooting circumstances. The NANPA voluntary captioning guidelines below assist in "the maintaining of integrity and trust among nature photographers, photo users, and the public."

SUGGESTED CATEGORIES:

WILD: As "Wild," this term, or no wording to indicate otherwise, would identify any creature having the freedom to go anywhere and to disregard artificially set boundaries, with the exception of tracts established to protect the creature for its own sake and where it lives in a natural state.

CAPTIVE: Abbreviated "Capt," this term applies to any living creature in a zoo, game farm, cage, net, trap, or in drugged or tethered conditions.

PHOTO ILLUSTRATION: Abbreviated "Phil," or in actual situations: "Dbl. Exp.," "Digital Retouch," "Composite," etc., this indicates assembly of an image from two or more images or parts, or removal of significant parts by computer, darkroom, or other means. It may include addition or subtraction of elements, duplicating elements within an image, sandwiching different images and removing obstructions. This definition does not include removing scratches or dust, repairing damage to images, or making slight alterations that have traditionally been made by filters or in the printing process.

[NATURE AND WILDLIFE PHOTOGRAPHER SEAN FITZGERALD]

After taking a workshop from photographer Art Wolfe, Sean Fitzgerald was inspired to change his career. The former lawyer junked his briefcase for a camera bag. He was later chosen by Wolfe to receive the coveted "Rising Star Award" at the FotoFusion photographic festival. Fitzgerald has been a contributor to *Outdoor Photographer* and the subject of a cover story in *Professional Photographer* magazine. He is a multiple winner of the Valley Land Fund Wildlife Photography Contest, one of the richest in the world.

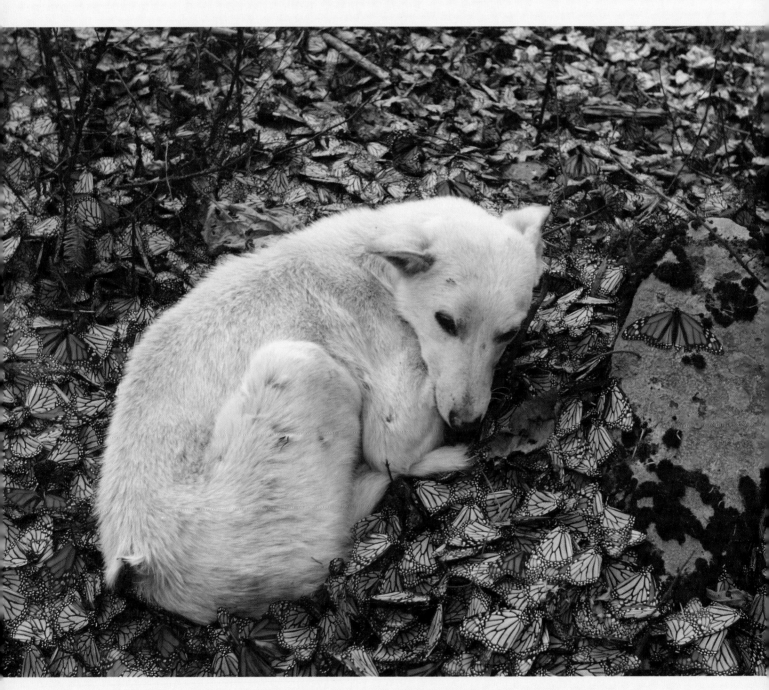

Former lawyer Sean Fitzgerald took a workshop from Art Wolfe that changed his life. He switched careers and became a successful wildlife shooter. While in Mexico, he found a remarkable contrast—a dog resting among a seemingly endless group of dead monarchs.

Sean, what's most important in a wildlife portfolio?

FITZGERALD: "I learned from being in front of a jury that your first and last impressions are what is critically important. The case is won or lost based on your opening statement. It's the same with photography."

Does a photographer have to show both nature and wildlife in a portfolio?

FITZGERALD: "No. Sometimes the twain does not meet. If you do wildlife well, you don't have to do landscapes. What's important is to try to grow as a photographer, not just by doing traditional work, but by trying to take the next step in communication."

What are your tips for taking a portfolio to the next level?

FITZGERALD: "Look for the power of simple images without a lot of clutter. Think of wildlife photography as an art, not just documenting animal behavior. Give it as much artistic impact as you can. Be conscious of colors, how they flow from one to another. Also ask yourself, 'What kind of emotional or cognitive impact do my pictures have?'"

What is that next step in the evolution of the nature and wildlife field?

FITZGERALD: "It's so easy to just be a craftsman. I think that the next great photographer will do images with power that will show the real plight of the earth, including the dark side like habitudinal issues, pollution, and population encroachment. If all the public sees is awesome photos in the wild, only the beautiful ones, they will be lulled into thinking all is fine. The images that rise above may not be as beautiful as they are disturbing."

Is it true that a photographer in the nature or wildlife genre will not be taken seriously if he include people in their photos?

FITZGERALD: "The traditional view is to photograph only where the hand of man is not present. Photographers can be drawn to nature and wildlife because they don't have to deal with people. No model releases, no hassles. My view is that in today's world with man having overlapped where the wild used to be, the two are inseparable. You have to be comfortable photographing man and nature and how the two affect each other. They environment is becoming a keystone issue for the general public."

Even though we know magazines and novices sometimes place too much emphasis on equipment, what's really needed?

FITZGERALD: "Sometimes you do need specialized and technical equipment. Super-wide lenses, a macro lens, and up to 600mm telephotos are needed to do serious wildlife photography. Image-stabilizer lenses are unbelievably good. To me, the ideal kit also has a carbon fiber tripod with an efficient ball head. For wildlife, you need two good bodies and a 2X teleconverter."

What kind of research is needed before choosing where to travel?

FITZGERALD: "Wildlife photographers tend to go to places where wildlife is fairly habituated. There is a better chance of success that way. You have to look at it from a business perspective. If you are going to shoot elk, you need to know that in September you'll find them near the road at the north part of Yellowstone Park."

Do you have tips on how to make a living?

FITZGERALD: "With so much good, timeless stock photography out there, today you have to be a master of all trades. Be crafty about how you blend everything together. I do stock, fine art, and environmental photojournalism. I don't have the luxury to only stick to one aspect.

"Go beyond the expected and think beyond the timeless beauty of a photograph. Does it tell a story or provoke an emotion? Find income wherever your heart takes you."

Jones says, "Before you focus your camera, you must first focus yourself." Confidence, curiosity, and a childlike sense of wonder are traits embodied by inspired photographers like John Shaw, Art Wolfe, or Frans Lanting.

"Technical excellence is less important than emotional impact. Too many people get bogged down in the rules of photography. It is art, not a rote formula with a checklist of right and wrong. That can take the life out of it," says Fitzgerald.

"When I'm at my best, it's not about the picture, it's about the experience of being out there in nature chasing the light, open to appreciating the gifts of the planet," says Moran.

CONSIDER THE ENVIRONMENT

Rather than to just document the environment, nature and wildlife shooters have an ethical responsibility to protect it. No portfolio picture is worth damaging what your photos seek to pro-

tect. As Bob Atkins points out in his online guide to nature photography (www.photo.net/nature), "There is only one rule. Do no harm. Harming covers a lot of ground from picking flowers to harassing wildlife."

"It is important to tread as lightly as possible. There is such fragility to the environment. Ask yourself if it is so important to get the photo to endanger the habitat of an animal," says Fitzgerald.

"It's not only about disturbing their habitat, it's also about causing their behavior to be adversely affected. In their world we are only visitors," says Fobes.

NATURE AND WILDLIFE WORKSHOPS

There are more nature and wildlife workshops offered than in any other genre of photography. With so many out there, how do you find a good one? Famous photographers sometimes make great teachers, but not always. Check the Web sites of photographers that you admire and see if the topics offered interest you. Don't be afraid to

CASE STUDY

Wildlife photographer Sean Fitzgerald travels the world in search of the perfect shot. This selection from his portfolio captures the drama of the wild combined with the patience needed for elegant composition and engaging light. Which should be cut to strengthen the impact of his portfolio? See page 156.

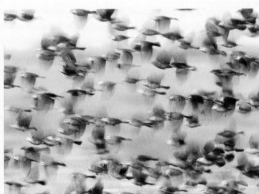

1

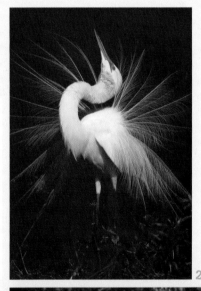

2

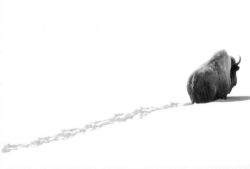

3

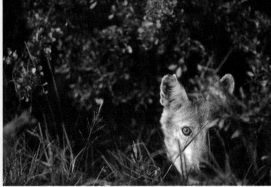

4

ask for references. With travel expenses and hefty tuition fees, you have every right to know if you are receiving fair value.

John Shaw, Freeman Patterson, Darrell Gulin, Art Wolfe, Frans Lanting, and George Lepp all have strong teaching reputations. The NANPA Web site is a reliable source for upcoming sponsored workshops. Joseph Van Os Photo Safaris (www.photosafaris.com) and Weldon Lee's Rocky Mountain Photo Adventures offer a range of topics (www.rockymountainphotoadventures.com). The Palm Beach Photographic Workshops (www.workshop.org) offers good underwater courses off the Florida coast.

General workshops with offerings by leading nature shooters include the Ansel Adams Gallery Workshops, (www.anseladams.com), Santa Fe Workshops (www.santafeworkshops.com) and the Maine Photographic Workshops (www.theworkshops.com).

FURTHER READING

With a multitude of nature and travel books being published each year, the best remain perennial favorites. John Shaw's *Nature Photography Field Guide* and any of the *National Geographic* Field Guides are a good place to start building a collection. Shaw's books, in particular, are in the "dog-eared" collections of even the most famous pros. Other recommendations from a long list include Freeman Patterson's *Photography and the Art of Seeing* and Martha Hill and Art Wolfe's *The Art of Photographing Nature*.

Popular magazines include, of course, *National Geographic*, *Audubon*, *Smithsonian*, *National Wildlife*, and *Outdoor Photographer*. Lesser-known publications include *Nature Photographer* and *The Natural Image*. An excellent CD reference to identify various species is *Thayer Birding Software* (www.thayerbirding.com).

exhibitions and fine art >>

Fine art photographers make their livelihoods through print sales and an active exhibition record. In the subjective world of art, here's how to maximize your chances to land exhibitions and reach buyers.

What are the standards for a fine art photography portfolio? That's almost like asking, "Which grain of sand on the beach is your favorite?" A great portfolio can take many forms but it is essential to share a distinct and memorable point of view. More than any other photographic genre, a fine art portfolio is defined by the strength of the photographer's vision and the success of communicating that point of view to others.

The art world is subjective and opinionated. There is no set right or wrong, but instead several truisms that guide the path for photographers who want to build their reputations and exhibition records. The first is that an art photography portfolio needs to be cohesive. Instead of sharing a few pictures from several bodies of work, it would be wise to highlight one or two projects in depth to give the viewer a strong sense of mission.

"Avoid a sampling without a point of view,"

New York photographer Jill Enfield used infrared film to capture "Crooked Forest," an astonishing vision of Fire Island. The hand colored image is included in her book, *Photo-Imaging: Complete Visual Guide to Alternative Techniques and Processes.*

says Arizona State professor Stephen Marc. "I look to see if the body of work is cohesive—with continuity, but not the same type of image over and over again."

Technical merit should also not be overlooked. Although most artists concentrate first on establishing a conceptual theme, every image should demonstrate consistent excellence in technique, just like any other type of photography.

Fine art needs to also convey a sense of the aesthetic. Good art does not have to be pleasing;

PHOTO AT RIGHT | Ruth Adams' erotic still lifes of organic objects are printed in large scale on inkjet watercolor paper.

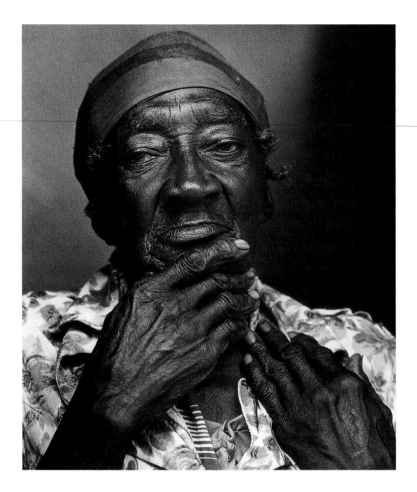

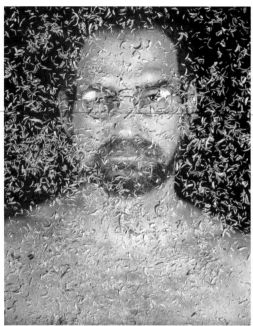

In his series "What do you do with yours?," George Blakely assembled a group of 20x24 Polaroid self-portraits on the artist's collection and consumption habits. Here, he is seemingly engulfed in fingernails.

In their efforts to be "deep," photographers too-often forget the power of simple, evocative portraiture. Heralded documentary photographer Ken Light included this one in his book, *Delta Time: Mississippi Photographs*. To learn more about the documentary approach, his book, *Witness in Our Time: Working Lives of Documentary Photographers*, is a good introduction.

at times its intent can even be to purposefully disturb. But a distinct body of work does need to hang together in terms of the types of processes used and the photographer's belief that the photography is important. In other words, with rare exceptions, it should not be just art for art's sake but instead formed with clear intent.

As Florida photographer Anna Tomczak points out, "There needs to be a thread throughout the work. One thing needs to relate to another." Marc uses the metaphor of the legs of a tripod when describing which portfolios impress him. "The work should be interesting aesthetically, technically, and conceptually. If any of these is weak, it falls over flat."

THE NEED FOR FEEDBACK

To call a picture "art", a photographer's only true responsibility is to communicate with himself. For most of us, this provides too little satisfaction, however. We want others to appreciate a unique point-of-view and what we hope to say about the world through our photography. It is one thing to believe in a valid, personal perspective and another for others to "get it." In truth, any point-of-view is valid in the art world but

that does not mean that others will agree or choose to show your pictures.

Go to workshops and seminars to share your portfolio. Seminars are also where much of the important networking happens that will help you find outlets for your work. As a potential student, you may meet a professor whom you wish to work with. There is no sense in choosing a school that does not encourage your growth and feed your creative instincts.

Just like any pro, an art photographer needs to systematically work to build a reputation. I make it a point to try to attend the annual Society for Professional Education conference held each spring. SPE's membership comprises students, teachers, photographers, gallery directors, and critics (www.spenational.org). Its national and regional conferences provide opportunities for one-on-one portfolio review sessions. Some reviewers seek solo and group exhibitions to schedule in coming years while professors critique portfolios in search of devoted students who wish to pursue a Master's of fine art degree in photography or digital art. Photographic magazine editors also come to SPE looking for projects to profile. During the last day of the convention, any photographer can fill a table with her prints as attendees walk around and discover work they like.

Ruth Adams is a professor at the University

of Kentucky who actively shows her work at gatherings like SPE. Her energies are paying off. Adams' thoughtful still lifes of organic objects have been accepted in a multitude of juried exhibitions and *Camera Arts* magazine has asked to profile her portfolio. Beginning as an undergrad at Syracuse University and then a master's student the University of Miami, she quickly realized that the people she meets at conferences are a big help in guiding her career path.

"What people look for with my work and what I seek in the portfolios of others is a consistency of vision. A person needs to be passionate and connected to their work—to care about what they are doing." She adds that it is also important to learn how to verbalize your photographic intent articulately without boring the viewer. "When I show my work, it has concept and reason. This also has to come through when you talk about it," Adams says.

Visual arts professionals including artists, museum directors, and gallery coordinators also attend the annual College Art Association conference (www.collegeart.org). Although photographers are just a part of the CAA membership, it is a great organization for portfolio feedback or for those seeking artist-in-residencies or full-time teaching jobs.

Workshops are always among the best venues for portfolio feedback. Some of the most influential include the Santa Fe Workshops (www.santafeworkshops.com), the Maine Photographic Workshops (www.theworkshops.com) and the Woodstock Photography Workshops (www.cpw.org). Held once every two years in Houston, FotoFest (www.fotofest.org) is heralded as one of the largest photographic arts gatherings in the world.

Tomczak suggests creating your own forum in the tradition of the French concept of the "Salon." "Invite people over once in a while and have a little reception. Like the 'F64' club in

YOUR BEST MOVE

"Keep your portfolio in circulation. Show it as much as you can."

ANNA TOMCZAK
Photographer

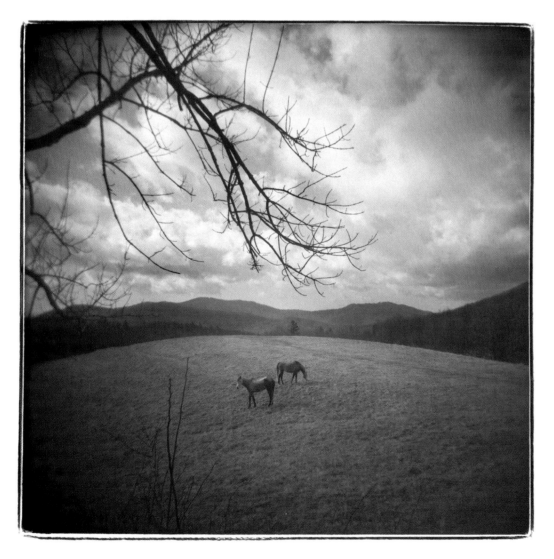

A Holga camera provides a creative release for Bruce Bennett's fine art work.

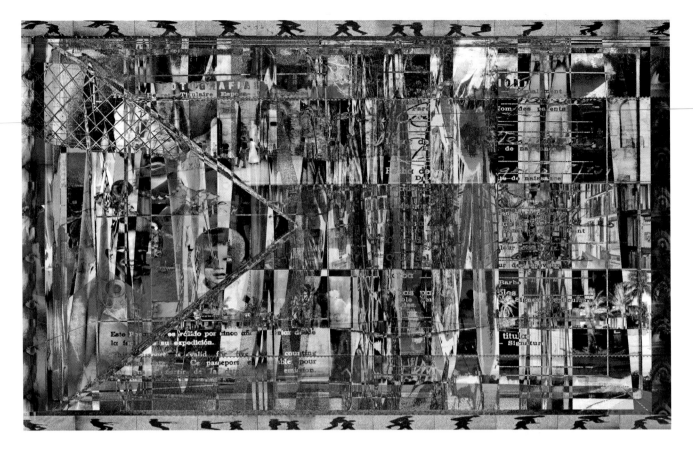

Digital imaging expert J. Thomas Lopez creates huge, iconic prints of his impressions of the world for "The Flag Series." Dozens of images comprise each flag.

California (which included Edward Weston, Ansel Adams, and Imogen Cunningham), get people together to look at work. Invite people with the ways and means to collect."

THE NEED FOR PATIENCE

As you begin to network at photo gatherings, remember that most great artists build their reputations over time. Few are as fortunate as famed photographer Jerry Uelsmann who was asked to do a solo exhibition at the Museum of Modern Art at age 27. Because exhibitions are planned two to three years in advance, professor George Blakely of Florida State University urges patience. "I'm a strong advocate of reviews. You take your portfolio and you lay it out. If it's any good, you should pick up exhibitions. It all steamrolls, but at a glacial speed."

Marc points out that any body of photographic work in progress should not be rushed. "Work on an idea over time. Ask yourself if you would still be excited about showing it in four or five years, not next year. Don't respond to trends that you see. Follow your own path that you are committed to," he says.

Taking the time to pursue a degree is often worth the personal commitment, especially if you find a teacher to mentor your artistic vision. Great schools for photography can be found in

any state. Some of the best known, for undergraduates, include the Rochester Institute of Technology (RIT), Brooks Institute of Photography, the Rhode Island School of Design (RISD), the University of New Mexico, the University of Arizona, San Francisco Art Institute, the University of the Arts, Columbia College, the California Institute of the Arts (CalArts), and the Savannah College of Art (SCAD). In an era of decreased public funding for the arts, many community colleges offer terrific two-year programs, too.

For graduates, leading photographers also recommend many of the above schools. Others from a long list of good places to consider include the Art Institute of Chicago, Yale University, the University of Florida, Arizona State University, the University of Miami, the Maryland Institute College of Art, Ohio University, the University of California-Los Angeles, the University of Illinois, and Florida State University.

No matter what school you choose, if you have great art inside you, it will emerge.

FINDING EXHIBITIONS AND SOLO SHOWS

Join state and regional arts groups to learn about exhibition opportunities. Several publications list upcoming calls for entries for curated shows by theme. *Art Calendar*, a business magazine for

[PHOTOGRAPHER ANNA TOMCZAK]

Specializing in 20x24-inch Polacolor transfer botanical assemblages and figurative portraiture, Anna Tomczak is in demand. Her work is in the permanent collections of the Brooklyn Museum of Art, Orlando Museum of Art, and Southeast Museum of Photography, as well as the corporate collections of Disney, IBM, Merck, Pfizer, and Polaroid. She has been profiled in *Digital Arts*, *Camera Arts*, and *View Camera* magazines. Tomczak dissuses how to sustain your artistic integrity in the fickle world of fine art.

> > *Anna, how would you describe your work?*
TOMCZAK: "It's always hard for me to explain it. It's subconscious. I like it when people read into my work, but I don't. I just create it. I don't really work in themes. With found objects, it's spontaneous. The photograph is about the object itself and its universal qualities."

What should be in an artist's portfolio?
TOMCZAK: "It depends on what kind of work it is. One thing needs to relate to another... Sometimes there is one familiar object in one piece that plays off something in the next. Even colors can tie them together.

With so many derivative styles out there, what makes a body of work truly one's own?
TOMCZAK: "The technique and craftsmanship is very important, whether silver prints, transfers, whatever. The fact that the photographer really knows how to handle the materials really makes you want to look at the print.

What are important elements in the artist's statement?
TOMCZAK: "It needs to explain your technique and the forces behind what's inspiring you to do it. It should be brief rather than extensive. Don't leave anything important about the work out.

How does one work her way up from group shows to solo exhibitions?
TOMCZAK: "It's always good to be in group shows. They build your reputation. A solo show comes from getting your work to a higher profile, by getting the right people to look at it. Show a body of work that really helps a curator focus on your intent. Go to places where people are actually looking for work such as FotoFest or SPE. There are many in Europe, too. Galleries also have regular monthly viewing times.

We all face creative peaks and valleys. Since our portfolios reflect us at our most creative, how does one move beyond a low point and on to the next project?
TOMCZAK: "Keep a focus on continuing to work. Don't get distracted. As Jerry Uelsmann says, 'You can't just wait around for inspiration. You have to just get in there and work.'"

Beyond an artistic vision, technique and craftsmanship are crucial elements to a fine art portfolio, says Anna Tomczak. "Fontleroi's Dream" and Tomczak's other 20x24 botanical assemblages are in more than thirty permanent collections.

visual artists, is one of the best sources for listings of national, regional, and international shows (www.artcalendar.com). It's also a terrific source for grants, fellowships, and awards.

Another opportunities database can be found at ArtBiz (www.theArtBiz.com). It lists juried shows, competitions and galleries seeking to review portfolios. Photographers can also search ArtBiz to apply to join visual artists slide registry services, take workshops, or apply for grants and fellowships.

Most calls for entries ask for copy slides. Dupe as many sets of your best work as possible to increase your chances of acceptance. When faced with rejection, have the fortitude and confidence in your talent to keep sending out your best photographs. "The problem with juried shows is that you have no idea what a particular juror will like," says Adams. "You have to have thick skin. Get your work out there. If it doesn't get in, you have to understand that with a different juror, it probably would have."

THE ARTIST STATEMENT

In most types of photography, a picture should stand alone without the need for words. But when it comes to fine art, the intent of the artist is paramount in understanding the photograph.

When showing your portfolio, it is best to include a tightly written abstract of your artist statement. One or two paragraphs should suffice.

If the reviewer shows an interest in one of your projects, leave a copy of your full artist statement, which should never be longer than a page. Avoid the fallacy of over-intellectualizing. As noted photographer J. Tomas Lopez of the University of Miami puts it, "You can't compensate with words for a lack of skill in imaging. The more you have to talk, the less your images work."

A good artist statement is an explanation to yourself and to others. It should introduce the idea behind the project and should never be so self-important that it alienates. Lastly, it should be clear. Emerging photographers occasionally confuse their grasp of intellectual concepts with the need for clarity, resulting in a negative impression of pretentiousness.

Here's a good example of a tightly written abstract by photographer Les Slesnick, whose photos won the $100,000 grand prize in the Moments of Intimacy, Laughter and Kinship (MILK) international competition (www.milk photos.com):

> The goal of *Private Spaces* is to document the values of a culture as it is represented in the home and other interior spaces.
>
> People tend to display in their homes what they value most in life, whether it's a gun collection or family photos and mementos. An enormous amount of information about the people occupying these spaces can be gleaned by studying its contents.
>
> The result is often what has been called a "peopleless portrait" — much is learned about an individual without actually seeing him. It's as if the person occupying the space just left the room, but left everything about himself behind, expecting to return momentarily.

Assuming that the advice in this chapter can help you land a dreamed-of solo show, you may be asked to provide a full statement for an exhibition catalog. A full page would be appropriate for a photographer like J. Tomas Lopez whose work is included in the permanent collections of the Smithsonian, the International Museum of Photography, and the French Biblioteque Nationale.

Les Slesnick's "Private Spaces" documents the values of Latin America as represented in the home and its mementos.

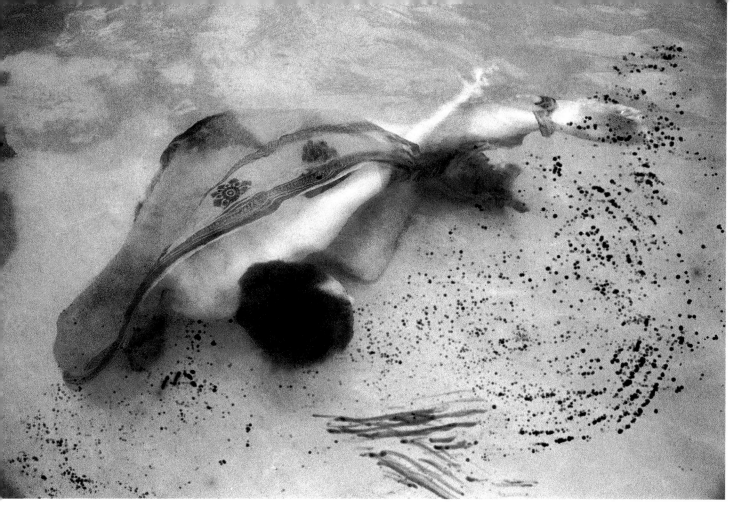

> For over twenty years I have been making images of the human figure underwater as a metaphor for being out of my element. In English, the phrase "out of my element" doesn't carry the same power as "a fuera de mi elemento." In Spanish, there is resignation–an acceptance of the inevitable, a submission–it is a concept also tinged with sadness.

The Water Series shows men, women, children and myself underwater, on the water, and breaking the surface of the water as visual metaphor. I depict, through the models, a sense of groping or floating... of purgatory... of another world where one doesn't quite belong—but a place where one must adapt.

The images are romantic and melodramatic; some are somber and quite dark, but I can't always hide behind a cool and intellectual persona. I make believe I am not afraid and yet I am always afraid.

Before I moved to Miami, I thought of water as a metaphor solely for being a stranger in a strange land, but moving here has left me more alienated than ever—I feel less Latino, certainly less Cuban. It's as if I'm Ishmael, both the biblical wanderer and the narrator in Moby Dick.

In this new work of computer generated inkjet prints, a decentralized unconscious has emerged. I feel a compulsion toward the postmodern, toward a place where I watch myself exist and act but detached from outcome. The quality of ink on watercolor paper transforms the images into a softer, more ethereal image than the silver gelatin prints I made for so many years.

The figures, for me, are still both sexual and religious—they are iconic bodies that are free, able to live and breathe in the water and capable of flight. But somehow they seem more comfortable, concentrated and in their own being than I am.

Finally, as I look at these photographs now after so many years of making them, what I feel is a sense of surrender. A yielding of my ego to the forces of the universe. There is a peace and sense of home that I long for in these figures and that is perhaps attained through these images.

Each body of work and the individual photographs comprising it should be titled. When titling, do not overreach, simply ask yourself what the picture means to you. Tomczak loves poetry and also looks to literature and music for inspiration when she names a piece.

In "The Water Series," J. Thomas Lopez uses underwater human figures as a metaphor for feeling out of his element in a world where one must adapt.

THE PROS AND CONS OF ARTS FESTIVALS

Not all successful art photographers choose to go the gallery and museum route. Arts festivals and street fairs are a viable outlet for any photographer who cares less about starving and more about reaching everyday buyers rather than museum curators. It is also true that not every serious photographer wants to pursue photographic art as a full-time profession.

"Search for your own niche. It's fine to make your living at arts festivals. Remember though that there is a danger in defining yourself by where you are exhibiting. But that's okay," says Blakely.

Should a photographer dream of going all the way to the top of the art world along the path of famed visionaries like Ansel Adams, Irving Penn, or Robert Mapplethorpe, most experts suggest shying away from festivals. "It's a gamble. If somebody is buying your work in a park on a Sunday afternoon, you pretty much kill your chances of making it to the stratospheric levels of A-level galleries and museums," says Lopez.

The top festivals, including Cherry Creek in Denver or Gasparilla in Tampa, attract many serious artists who take home prize money topping $15,000 and sales that can top $10,000 in a single weekend.

Slesnick is a consistent best of show award winner at festivals. For two decades he has been successfully showing at street fairs as well as exhibiting at museums including the London Salon of Photography and the Appleton Museum. He works as a pharmacist during the week and ponders the decision of whether to pursue his photography fulltime.

> ### YOUR BEST MOVE
> "Show the world through your eyes. It's as much about the real world out there as it is about your point of view."
>
> GERD LUDWIG
> Photographer

Arts festivals require portfolio submissions in slide form. To learn more about them, join the National Association of Independent Artists (www.naia-artists.org).

WHAT TO PRESENT

We already know that a fine art photography portfolio needs to demonstrate a point of view. Avoid the "hodgepodge" approach that is a sure giveaway to curators that you are dabbling in too many areas. That assignment to photograph eggs may have worked well in class but ask yourself if it serves to further your artistic mission.

For your portfolio, do not create the impression that you are exploring blindly in an area you know nothing about. Your intent must be clear.

"I want to get engaged in an artist's visual intellect," says High Museum of Art curator of photography Tom Southall. He suggests showing one group of tightly related images that urge the viewer to say, "Let me see more."

Avoid showing too many bodies of work. Many well-known imagemakers recommend showing no more than twenty images. That is a weighty number of matted prints to slip into a portfolio case and just enough to fill a slide page. You may wish to highlight a more evolved body of work with roughly a dozen images while also showing an excerpt of six to eight photos from a work in progress. Prints should always be archival and matted unless so large they would become unwieldy. Glass-mounted slides only serve to gather dust and annoy curators used to receiving shattered ones in the mail.

As professor Lopez says, consistency in your presentation demonstrates your commitment to a line of inquiry. "Prints of varying sizes show that you are struggling to find yourself. They become metaphors for not knowing how your work looks best."

FURTHER READING

For inspiration to take your work to the next level, pick up the book, *Art & Fear: Observations on the Perils (and Rewards) of Artmaking* by David Bayles and Ted Orland. "It addresses the issues of why we get stuck. I gave it to a student who was going to quit and she didn't," says professor Adams.

Besides the well-known *American Photo*, *Peterson's Photographic*, and *Popular Photography*, magazines and periodicals for art photography include *Aperture*, *Camera Arts*, *Double Take*, *Apogee Photo* (free and online), *Blind Spot*, *View Camera*, and *Afterimage*.

are you truly serious about your work?

According to University of Miami professor J. Tomas Lopez, three traits are essential to sustain an artistic vision over time, leading to a meaningful body of work.

[1] **PASSION.** Show passion for what you shoot. Believe in it.

[2] **ACCESSIBILITY.** Is your idea doable? There is no point in trying to pursue a great project in Bora Bora if you can't find a way to get there.

[3] **UNDERSTANDING.** You have to be knowledgeable about your subject. Do research. Bring something personal to the exploration that others don't have. Live the life of what you choose to document.

Fine art photographer Anna Tomczak creates elaborate assemblages and captures them with a rare 20x24-inch Polaroid camera. Her highly collectable photographs are ethereal and leave much to the viewer's imagination. Which image should be cut to reinforce Tomczak's unique style? See page 156 for the answer.

self promotion and future growth >>

Having great work is essential, but so is the art of salesmanship. Whatever type of photography you specialize in, here are key strategies for clinching the sale and continuing to get hired time and time again.

After seeing a listing in *Photographer's Market*, Pat Crowe gathered a portfolio of his distinctive black and white pictures and sent them off to the Animals Animals agency. Besides generating steady stock sales, his work was featured in *Outdoor Photographer*. Crowe's wildlife photos are perennial sellers; he does corporate and Ireland work as well.

Congratulations. By making it to the final chapter of the book, you are either raring to go build a sensational portfolio or ready to send it out the door. Your portfolio will do most of the talking for you but photography is not the only factor needed to induce confidence in your abilities.

Interpersonal skills and the psychology of salesmanship are also important. Although each genre of photography is unique, there are universal truths in getting your work to the right people and building your reputation over time.

AVOID THE DREADED PORTFOLIO DROP

The lives of picture editors and buyers are not as glamorous as they may seem to photographers dreaming to be allowed to enter their hallowed offices. Some are so busy with deadlines and upcoming projects that they can only wish they actually had time to talk to prospective photographers. As new talent busily swarms and buzzes around them, many have had to resort to weekly portfolio drops.

If you are asked to drop a portfolio, don't take it personally. Imagine needing just twenty minutes of a client's time multiplied by thirty other photographers weekly. That equals ten hours just not available to an already swamped person.

If you are forced to drop a portfolio, and you may have to, it will likely get a two-minute cursory glance unless it proves to be a true showstopper. Make sure you have a tight, impactful edit. Who is truly doing the reviewing is a big unknown. You may address your cover letter to the director of photography, but it's just as likely that a third-level researcher will be doing the reviewing. The advice in previous chapters will no doubt help your portfolio get noticed. You want to be sure to get it in the right hands, though.

"I know that it is hard to get in to see someone," says *People* magazine picture editor Beth

PHOTO AT RIGHT | When shooting, it's worth remembering the important magazine cover format. Sean Fitzgerald's photo of South African kokerboom trees was the perfect fit on the cover of a *Professional Photographer* story on his work.

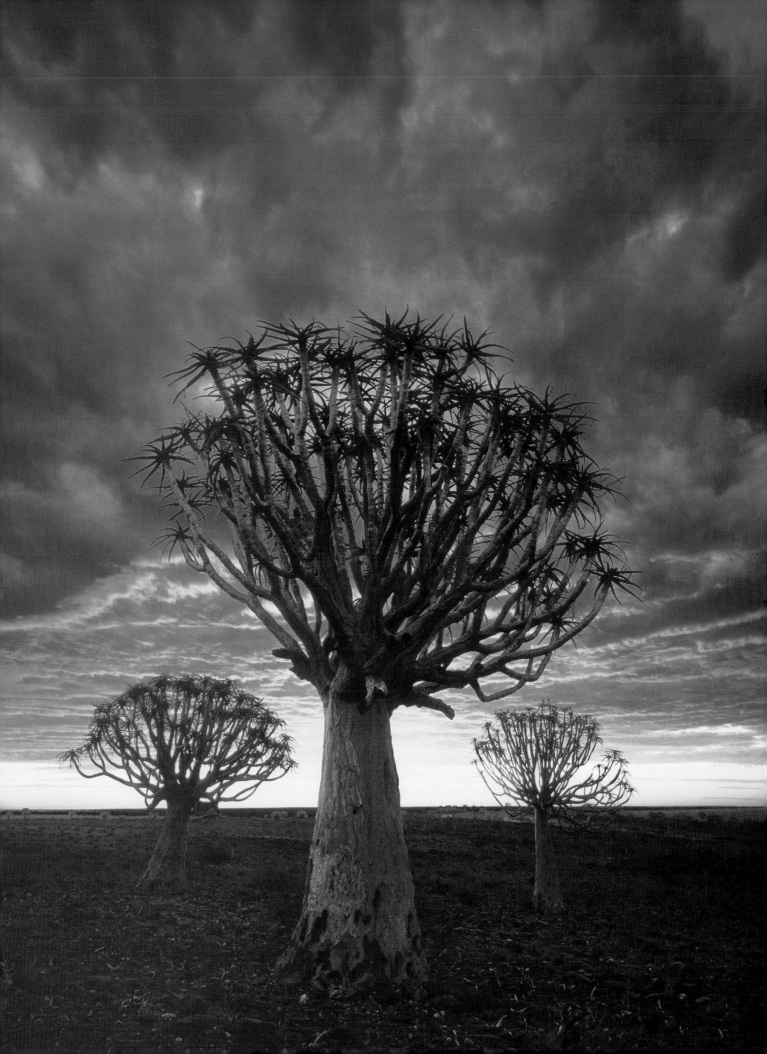

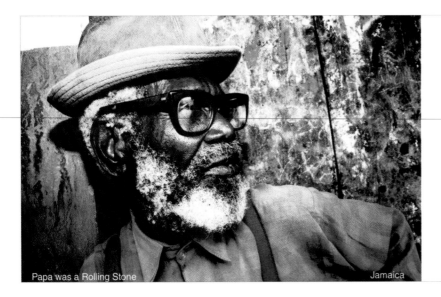

yaro@utopiaartproductions.com

Papa was a Rolling Stone Jamaica

Los Angeles 310 6215662

Yaro's promo card is memorable for it's atypical shape and vibrant color. Always include contact info in a prominent place on both sides of your card.

Filler. "I love to look at portfolios but on a weekly magazine, you don't often have the time. That's why we have a drop off time."

When mailing any type of portfolio, it is standard practice to include a self-addressed stamped envelope (SASE) or a completed FedEx form billed to your own account.

MAKE CONTACTS AT CONFERENCES

Filler recommends finding editors in more relaxed settings at workshops and seminars. For example, each winter, she and other top New York editors and photographers get out of the cold as invited guests at the FotoFusion seminar in Delray Beach, Florida (www.fotofusion.org).

The five-day event attracts professionals and amateurs who attend workshops and portfolio reviews.

I have taught this seminar often; it has always amazed me that even hobbyists can get the ear of many of the true agenda setters in advertising, photojournalism, editorial, nature, and fine art photography. In New York, the same people are practically inaccessible. Photographers like the legendary Arnold Newman or Douglas Kirkland can be found standing around ready to chat.

Other workshops afford opportunities, too. Although we all want to believe that our portfolios alone will be enough to get an assignment or job, making a personal contact will always be crucially important.

In New York, if Filler gets a call from a fellow picture editor at another publication recommending a photographer, she will find the time for a face-to-face review. The pattern is the same

in all other types of photography. This is one reason why it is so important to join trade groups and attend meetings. Your best chance of getting in the door will always be through a personal recommendation.

If you meet an editor or gallery owner at a conference, stay in touch with new work and new ideas. For wedding photographers, make a friendly follow-up call to prospective clients who come to see you. For any freelancer, in larger cities, you will always need to be creative in your approach when making an initial contact.

TELEPHONE CONTACTS

In most cases, do not make cold calls. You will only aggravate those whom you seek to impress. But there are a few tricks that might help you get directly to the right person, rather than an assistant.

Always learn deadlines. All creative people have them. In the magazine world, weeklies and monthlies are on different cycles. Never call an editor on a deadline day. For example, at *People*, Mondays and Tuesdays are crush days. Wednesday is ever so slightly more laid back.

Nothing is stopping you from calling a receptionist or assistant, however. Always be friendly. This year's assistant may be next year's boss. Ask when an issue closes and you will be able to figure out the least busy days, right after the deadline has passed. You might be able to sneak in a quick phone call to the top dog this way. If you get through, keep your pitch short, polite, and to the point.

Anticipate being told to drop off your book. Think of a valid reason (not too esoteric) why your work merits an in-person review. For exam-

YOUR BIGGEST MISTAKE

"Let your pictures be the thing that people remember, not your ego."

TERRY EILER
Photographer, Educator

ple, perhaps you have a well-researched story idea to discuss. Even if you do not get in, ask if the editor would be kind enough to look at your portfolio personally when you drop it off.

At newspapers, the early mornings and late afternoons are always busy. Try reaching a picture editor between ten and two o'clock. If you are applying for a job or internship and the advertisement says no phone calls, don't push your luck. Resist the temptation.

E-MAIL COMMUNICATION

Since everyone has an E-mail account, it's not difficult to reach even top-level agents, editors, art buyers, or curators directly. However, this is no guarantee that it will be an effective communication method. Everyone has a different style in regard to E-mail. I try to answer each one but receive nearly one hundred on most days. Sometimes, messages get snowed under the stack.

The safe bet is to never send images via E-mail, unless asked. Remember that you don't want your important work to be confused with advertising spam. Do, however, list your Web site as part of the "signature" at the bottom of your E-mail.

If you have luck receiving a reply to an initial E-mail query, you can always ask in your reply if it would be okay to E-mail one sample image. Once you have begun a brief dialogue via E-mail, mention the link to your Web site and hope it gets a look.

If your first message doesn't receive a response, try not to be offended. Send another message about a week later politely mentioning something like perhaps your own E-mail account

a slightly sneaky trick

Here's a trick that you can use to get through the support staff maze:

At many organizations, secretaries and assistants go home at five o'clock. When I was freelancing for *Life*, I always knew that if I called the Director of Photography, David Friend, at five-thirty, he would be likely to pick up his own phone. Many other art directors and editors work well past five, but remember not to bug them on deadline days. Never call without a valid reason.

(not your client's) has been acting up lately. Try to learn what time the person you need to reach comes into the office. Send an E-mail two minutes earlier and yours will be on top of the stack when she arrives.

Photographers' rep Gregg Lhotsky of Bernstein & Andriulli sees the work of thirty to fifty photographers a week through drop offs, promo mailers, and E-mails. He says he doesn't mind seeing a photo in an E-mail if it's already visible as part of the HTML page containing the message. "Just say, 'Hi. My name is Joe Photog. If you have a moment, please take a look.' But no downloading, attachments, and especially no Flash (the multimedia kind)," he implores. "Have the image already there with a link to the Web site."

Indeed, no prospective client is likely to open attachments of any kind unless they know you and have asked for a particular file. E-mails that contain unsolicited pictures that open automatically will likely get spiked if they take more

YOUR BEST MOVE

"Be willing to be bold and show your personal vision."

J. KYLE KEENER
Photographer

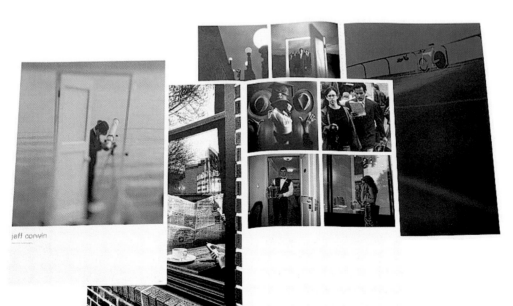

Seattle's Lost Luggage Brand Envy designs eye-catching cards and printed magazine format portfolio mailers for Jeff Corwin.

than a second to load. Some appreciate this type of marketing approach while others can't stand it.

WRITTEN CORRESPONDENCE

COVER LETTERS: Your cover letter will not be read unless the client first loves the portfolio. Keep the letter short and direct. Don't get overly esoteric by explaining how your belief in Eastern mysticism is the guiding force in your vision. A flowery or pseudo-intellectual approach will hurt you.

There are some essentials to include, however. First, be absolutely sure you have the correct spelling and title of the addressee. That's crucial. Second, know the client. Do your research and include a brief mention of why you would be the right fit for their needs. "Tell them in two or three sentences what's unique about you," says photographer Stephen Shames.

For letters going to photojournalism and editorial clients, good story ideas can get you brownie points. For advertising and commercial clients, be friendly and accessible. If you have a mutual acquaintance, it is okay to be a name-dropper.

For all types of work, don't forget to

Tempted by offers to leave his staff job for the lure of high paying freelance commercial work, studio wizard J. Kyle Keener stayed for the control and prestige he's given by his editors. Whenever he dreams up a concept, the *Detroit Free Press* devotes a full-page to his unique column.

say that you would be happy to provide additional samples. Keep your cover letter to just a few paragraphs. Chances are that it will be skimmed first and read more carefully if you are shaping up as a finalist for the job. At the end of the letter, mention how and when you can be reached.

BIOS, RÉSUMÉS, AND CVS: A brief bio of two or three paragraphs is a good idea to include with any portfolio package, whether in print form, online, or in any other format. It should be quick and direct, telling your story in the third person. Not your life story, of course, but the type of work you specialize in along with most important clients, publications, or awards.

In some genres of photography, a résumé is always expected. For any full-time job in photojournalism, it is a must. Some photographers include an objective and some do not. Remember to customize your objective for the specific job you seek.

Be sure that any listed work experience is relevant. It doesn't matter that you once worked in high school as a bagger at the local Safeway. If you are a student, be sure to get experience at school and local publications to show your dedication toward working in the field.

Relevant education and degrees are more important than grade point averages, which should only be listed if above 3.0. For freelance work, your educational background has little bearing on being able to score an assignment.

Make sure your résumé is well-organized and easy to read. List education, experience, and awards, if you have them. Don't get cute. Avoid putting a picture of yourself on the résumé or a too casual or flippant approach.

For job applications, list "References upon request" unless specifically told to include them. That way, you should get a call asking for references, alerting you that you have made the final cut. Then, quickly get on the phone to your references and ask them to be kind. Never assume that someone will agree to be a reference without asking first. I get calls from potential employers every month and the hardest question to answer is "What are her weaknesses?"

I am such a big fan of my students' dedication and fine work that I usually think of a way to turn a perceived negative in to a positive. "She works so hard, it's tough to get her to leave the computer lab at night!" I might say. Seriously, ask any potential reference how they would answer that question. Chances are you will learn some good suggestions for modest improvement.

The term "CV," for curriculum vitae, is used

DESIGN: TINA ULLMAN

Gary Kirksey's exceptional logo works well for his printed matter including letterhead, business card, invoice and delivery memo.

most appropriately in the academic world. The College Art Association (CAA) has an excellent primer on its Web site (www.collegeart.org) about proper form and style.

CLIENT LISTS: For all freelancers, boost your credibility by including a succinct client list organized by type of work. List editorial clients separately from corporate clients.

You don't need to list every client, only your most recognizable ones. If you live in Chicago and have shot jobs for Northwestern University, Sears, and Motorola, no need to list your assignments for the Cook County Forest District. (Not that there is anything wrong with working for any steady client that respects your style.)

STOCK LISTS: For freelancers, your Web site should include stock topic lists as well as major clients. When showing a portfolio, leave behind a printed copy along with your promo card. You never know which other types of projects art and photo buyers are working on.

CAPTION SHEETS: These are expected for photojournalists and narrative shooters. For editorial and other types of commercial photographers, your need for them depends on whether the work is self-explanatory. A cover tearsheet from *ESPN* magazine tells its own story. Caption sheets should always be written in the third person and present tense.

Art photographers should include a list of titles, organized by each thematic body of work. List the process used or any unusual technique.

BRANDING THROUGH GOOD DESIGN

Any pro knows that paperwork is a necessary part of the creative workplace. If your portfolio package is supplemented with well-organized printed matter, you may find yourself a steady client or job. You will likely be sending out delivery memos, invoices, and lots more cover letters.

Create a memorable and classy image for yourself through good design. Some photographers are natural designers and prefer to create their own look. Others benefit from contracting

or trading with a talented designer. In good design, avoid the overuse of color and competing graphic elements. Just as with your Web site, you want your images to be remembered, not glitz.

"It also helps to create an understated, classy logo so that your name is visually embedded in the mind's eye of the editor," suggests David Friend, *Vanity Fair* editor of creative development. His advice would be true for any photographer, regardless of specialty.

THE ONE-ON-ONE REVIEW

In-person portfolio reviews provide great opportunities. It is natural to be slightly nervous. If you are like me, when you get nervous, you start to talk. And talk and talk and talk. Instead, just be yourself. Remember that the person looking at your work may have been a lowly library researcher just last year. Everyone is on his or her own natural career path.

written materials for art photographers

Artist statements are expected for fine art photographers. Keep them brief and easy to understand, not buried in adjectives and self-indulgence.

If your exhibitions have been reviewed in the media, by all means, include clippings in your package. Do not send loose, messy tearsheets. Make color Xeroxes to a consistent and readable size. Even if the article is printed in black and white, color copies are better quality and worth the extra cost. As with a commercial portfolio, find a presentation style for clips that is organized and easy to flip through.

I am surprised that when I show my work to curators, they sometimes complement the organization of the exhibition media kits that I put together. That tells me there is an opportunity for more artists to pull together their work and supporting materials in a more saleable way. An exhibition portfolio needs to make a "sale" just like any other type.

No single approach is right for any fine art photographer. I use a one-inch wide ring bound notebook with a clear acetate cover. Inside, I place slide pages and each slide is individually labeled. In the pockets I include a cover letter, media reviews, titles, and a recent exhibition list listing solo and group shows. I use an inkjet printer to make the cover, which includes a photograph and logo for the exhibition.

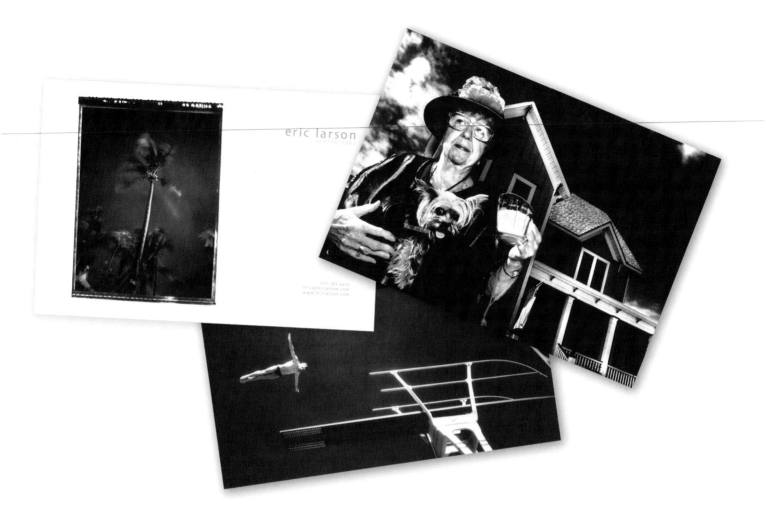

For smaller batches of promos, photographers like Eric Larson use their own inkjet printers, often with coated matte paper that allows dual-sided printing. For larger print runs, Modern Postcard is a perennial favorite.

Confident photographers exude a quiet fortitude. Answer questions readily but do not ramble on. It is best to sit quietly while the client takes in your magnificent work. Notice expressions and body language.

Be organized and do not fumble to locate materials. If you cannot quite tell if the client really likes your work enough to hire you, or is simply being polite, ask at the end if you are in the running. Relationships build over years, not weeks. You might hear, "Stay in touch. Keep sending me work." That really means, "I like your work, but you are not quite ready. I hope we'll be able to use you in the future." So, by all means, harvest each good contact over time.

At the end of the interview, leave a promo card. If you are given a business card in return, file it in your "Promising leads—People with great taste" Rolodex.

FOLLOW-UPS

There is nothing more aggravating than waiting for a response. Be patient and work on more than one opportunity at a time to avoid going stir-crazy. In commercial work, an art director may love your stuff but must shop it to the client along with a handful of other worthy portfolios. The client, in turn, may be waiting for budget approval, the completion of storyboards, etc.

Editorial decisions are often made by committee. Getting everyone together in the same room to look at your work may take time. Always have more than one copy of your portfolio to circulate. Patience is rewarded in time.

If you know you are a finalist, it doesn't hurt to make a brief E-mail query after some time has passed. Never annoy the client, however. Chances are that they may be waiting for a final decision just as you are. Sending a follow-up note through the mail saying how much you appreciated the review is a non-threatening, sensible approach.

ARE DELIVERY MEMOS NEEDED FOR PORTFOLIO DROPS?

A delivery memo is a signed document that acknowledges receipt of your work and its stated value. Whether to include one with a portfolio is a sensitive question with no universal answer. By having more than one portfolio copy, you could

lose one and still be in business. But it would be rare that any client would permanently lose your work. (Although this did happen to me once with a major museum.) Since original slides are rarely sent these days, in the worst case, you should be able to duplicate a portfolio without undue hassle.

Some experts will advise that you should always get a signed delivery memo for a drop of any kind. Let common sense be your guide. "We never do it," says Lhotsky. "The industry will always be relationship-based. By confronting with a delivery memo, it's just another barrier that doesn't allow the photographer to get in the door a little farther. Pick and choose your battles."

KEEPING YOUR FOOT IN THE DOOR

This might be more appropriately titled, "How to get your foot out of your mouth," jokes George Watson, president of the Society of Photographers and Artists Representatives (SPAR). Building a reputation over time involves constantly updated work but even more importantly, a pleasant disposition.

Horror stories abound about self-important photographers who insist on tooling around in rented luxury cars on location while the rest of the creative team shares a mini-van. Your pictures must set you apart; your personality absolutely must not.

To make it in the long run, clients need to depend on you. In any genre, the photographer is looked up to as a leader. Make the people around you feel at ease; it will show in your pictures.

"The hardest part is not getting a client, it's holding on to them," says freelancer Jake Wyman, a twenty-year veteran. "Pictures are a small part of it. Your personality and consistent execution are everything. Once you've established a relationship, and a reputation, they know who you are and trust you'll be able to do any job."

"It's the ability to consistently deliver outstanding performance. The saying at *National Geographic* is that a photographer is only as good as his or her last job," says its former director of photography, Tom Kennedy. "You have to be professional in every sense—not only stellar images but working within the editorial system and understanding its ethos. How you treat people and even meet expense limits can be as important as the images themselves," he says.

"Constantly challenge yourself to grow and take everything as an opportunity to more forward," Lhotsky says. He has known many so-called famous photographers who forget the need to grow. "No matter where you are on the totem pole, don't act like a rock star. You can't rest on your laurels. There's always someone coming up behind you."

TIMELINESS BREEDS HAPPINESS

Always be attuned to the needs of your client, even if small details seem minor to you. In photojournalism, a photographer gains trust by producing good pictures and writing consistently accurate captions. If you shoot a news assignment but forget to copy a pertinent "mugshot" from a school yearbook, you may not be trusted with another assignment, especially an important one.

Not only do you need to produce top-notch work, you need to do it in a timely fashion. As a former newspaper shooter, Pat Crowe knows how to work fast. Especially in corporate environments, "Assess a situation, figure out what to do, and get out," he says.

Bernstein & Andriulli promotes Daniela Stallinger's book, *Wienna*, with a refined series of oversized cards printed on matte stock.

PHOTOGRAPHER DANIELA STALLINGER
Represented by Bernstein + Andriulli New York City 212 682 1490

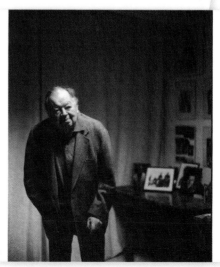

PORTRAIT FROM THE WIENNA BOOK: LEON KOHN AT THE MAIMONIDES CENTER

"Agencies appreciate that I can set up lights and be out of there before they can blink their eye. When I did an annual report for USAir, they loved that I could move around really quick." Crowe is a former National Photographer of the Year in Pictures of the Year competition.

PATIENCE PAYS

University of Miami professor Kerry Coppin knows it's important to build his art and academic reputation with an active exhibition record. His ability to find solo shows is astounding. In two years time, he has done more than a dozen including exhibitions at Pittsburgh's Silver Eye and Portland's Blue Sky Gallery.

"I'm constantly sending out little digital portfolios," he says. Each is a small box of twenty to thirty prints. He prints 5×7-inch black and white images centered on 8½×11-inch paper.

"It's frustrating not getting a response. In most cases, galleries don't have the mechanism to deal with unsolicited materials. Just be patient and follow up with another piece," he suggests. Coppin keeps a folder on his computer. When he receives a response he changes the highlight color of the file.

"Once, a year and a half went by. I was a little steamed and was just about to send out a fairly unpleasant letter. Just then, they called me up to ask if I wanted to have a show."

LOOK FOR UNDER-TAPPED MARKETS

Recent Florida college grad Eric Larson worked just one year for the *Fort Lauderdale Sentinel* before hanging out his own shingle. A native of Orlando, he had interned for Disney as a student. With a promise of steady freelance work for "the mouse house" he also started hunting for other opportunities.

A mention in *PDN* as a "Rising Star" helped. But it was a friend who introduced him to an art director at BBDO that opened up a surprising new avenue. "They liked my portfolio so they asked me to do a 'Photomatic' for Duracell. That's a test of a commercial storyboard without the expense of doing it on video or film," he explains.

Larson was able to hire four assistants and net a five-figure paycheck for a two-day shoot. Although the work will never be seen outside the client and ad agency, "I'm targeting a market I hope to move toward," he says.

PROMO CARDS AND MAILERS

With so much competition, photographers must advertise to stay in the minds of clients. Most freelancers send out promo cards regularly. With so many cards flying around, the results are mixed when it comes to landing new business this way. Still, sending an image on a postcard or foldout is a reminder that you are out there and ready to work. Busy art buyers and editors do not appreciate the alternative—cold calls from photographers.

"The whole point in self-promotion is to get them to call you," not the other way around, says Ohio University's Gary Kirksey. An effective promo card needs to be an attention-getter and representative of your style.

"It's expensive and takes a lot of your time, but should be a priority," says Seattle nature shooter Natalie Fobes. "People are looking for a personal touch. Your ultimate goal is for them to put your promo card up on their wall." Since Fobes targets both nature and corporate clients, she sends out two distinct styles.

If your card is lucky enough to make it up onto a client's crammed bulletin board, remember to print vital contact information on both sides. List your Web site prominently. After the card sits on the wall for a few months, the editor may admire the photo but forget who took it.

"I look at mailers all the time. If something

> ### YOUR BEST MOVE
> "Be courteous and professional. Treat people the way you want to be treated."
>
> GREGG LHOTSKY
> Photographers Rep
> Former President, Society of Photographers and Artists Representatives

a top-secret communications tip!

Once upon a time, a fax was a rare and important form of correspondence. Then, receiving a FedEx was indeed special. Now, a typical client may get several express mail packages each morning, piling up in yet another stack.

If you want to make a truly remarkable impression, go back to the good old days. Send a Western Union telegram (www.western union.com).

In my entire career, I have only received one. It was from the Pulitzer Prize board telling me that I had won. A Western Union operator called to read me the telegram. I was in such disbelief that I thought my friends were playing a hoax on me. I asked for the 800 number of the company and was stuck in "voice mail jail" for ten minutes before I received verification.

If you need to follow-up a VERY important meeting, or if you know you are a finalist for a great position or assignment, go ahead and try it! Note that mailgrams are sent like any other mail and do not carry the same impact.

Telegrams are expensive so think of a tightly written message. Just say something like, "Looking forward to hearing from you. I'm excited about the possibility of working together."

Keep this tip to yourself or telegrams will become passé, too ...

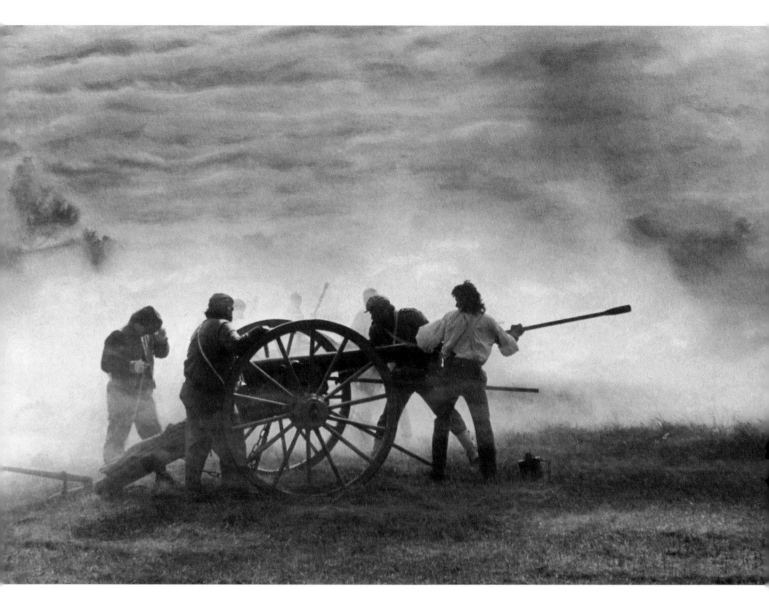

grabs me, I'll call a portfolio in," says Filler. She bookmarks Web sites and has an assistant file promos.

Early in their careers, photographers often buy mailing lists of potential clients. As time goes on, promos are sent to a more selective list. At first, a typical number to send might be as high as five hundred, too many to knock out of a typical inkjet printer. Companies such as Modern Postcard (www.modernpostcard.com) do good quality work at reasonable prices.

Experts urge that cards be sent regularly, as often as four times a year. One might be a non-denominational holiday card, for example. For high-end clients with huge photo budgets, it's a good idea to spring for something truly special once a year such as a die-cut foldout. Keep in mind; just like any type of advertising, the client must remember YOU, not the uniqueness of the presentation. One art buyer tells the story of

receiving a lunchbox adorned with images. "But who uses a lunchbox?"

The *PDN* Nikon Self Promotion Awards honor creative cards, campaigns, posters, and promotions. The winners are archived online (www.pdn-pix.com/contests).

WHAT ABOUT COMPETITIONS?

Contests are another way to get your name out there, especially if the winning photos are printed in annuals or posted online. Each genre of photography has its premier competitions; check with trade groups for guidelines. State and local contests are also worth entering.

I have to admit that contests helped me to become well-known and aided me in furthering my career. Winning them can open doors. Having said that, always remember that they are inher-

Commercial photographer Ray Carson finds a profitable specialty in doing hand-colored Civil War reenactment photos. He is the author of the book, *The Civil War Soldier: A Photographic Journey.*

YOUR BIGGEST MISTAKE

"Not following up on a lead."

RUTH ADAMS
Photographer, Educator

STAY CURRENT

Looking at contest-winning pictures is one way to stay up to date with current styles and trends in the world of photography. But don't ever try to copy or chase winning styles. Stay true to the power of your own visual talents. Do what you do because you have something vital to communicate through your photography.

Trying out a new packaging style or re-editing your work can lead to a dramatic new appreciation of your portfolio, though. Keep it current. "People can re-invent themselves. It has to be special, really unique, and lively," says Watson.

If you have worked long enough in your genre to become well-respected at it, don't fall into the trap of using your reputation as a crutch. The words of Tom Kennedy are worth repeating, "Step out of your comfort zone. Take that risk."

RATES AND RIGHTS

In writing this book, I have purposely tried to stay away from including too much detail on what to charge and how to keep from getting taken advantage of. Since rates are always changing, it is far better to stay up to date through online resources. For example, the Editorial Photographers Web site (www.editorialphotographers.com) has participatory forums that are a must read. To assist other photographers in setting pricing guidelines, its co-founder, Seth Resnick, posts his current fees. The EP Web site also posts free business form templates.

ASMP (www.asmp.org) helps its members learn how to price by type of client and size of market. Both organizations sponsor seminars for working photographers. The EP Outreach mentoring program answers frequently asked questions online and offers free workshops (www.editorialphoto.com/outreachep). To learn how to price, prepare business forms and understand copyright laws, the *ASMP Professional Business Practices in Photography* book is a must. It is available through any bookseller.

For photographers who target high-end advertising clients, a once a year "pull out all the stops" promo may be worth the expense. Seattle shooter Marc Carter commissioned Lost Luggage Brand Envy to produce a mini-portfolio notebook with eight images. It's a stunning piece that would be kept by most anyone who receives the unique burlap-wrapped mailing.

ently subjective. Send in your best work and then forget about it. Sometimes you might win and at other times you might feel robbed. My success with contests has as much to do with understanding how to edit effectively as it does with the pictures themselves.

Keep them in perspective. Compete only with yourself. Do not put your sense of self-satisfaction in the hands of yet another group of fickle judges. Instead, try comparing this year's portfolio to what your book looked like the year before. Professional and personal growth are truly important, not the number of plaques you can hang on your wall.

ASMP guides are also available through its Web site. For example, the *Copyright Guide for Photographers* is illuminating, as is the guide to pricing for electronic media.

Other good books include *The Photographer's Guide to Marketing and Self Promotion* by Maria Piscopo. I also recommend *Pricing Photography: The Complete Guide to Assignment and Stock Prices* by Michael Heron and David McTavish. For up-to-date stock photography pricing trends, Cradoc fotoQuote software provides a database of current rates by market (www.photoquote.com).

Young photographers often ask me how much they should charge. The guides and online forums mentioned here will help immensely. It is understandable that an up-and-coming photographer cannot charge as much as a more established one. However, if you price yourself too low, potential clients will wonder if you are really good. If you undercut local market standards, do it judiciously, by just a small amount. Your skills and services are valuable just like any other in the creative marketplace.

Learn the market and join photographers groups. Some clients have exploited new shooters by offering cut-rate contracts with reduced rights. Remember that each photographer has a responsibility not only to himself, but also to the photographic community. You can earn a good living through photography, but please respect the standards set by groups that are trying to preserve the industry's long-term health.

Kerry Coppin persistently sends out copies of "mini portfolios" to galleries. He has been asked to do more than a dozen solo shows in just two years. This untitled image is from Coppin's exhibition, "Umbra/ Dakar, Senegal."

appendix **one**

[CASE STUDIES]

See chapters 2, 8, 9, 10, 11 and 12 for exercises to help strengthen your editing ability.
Here are the answers to questions posed with each portfolio grouping:

> >

CHAPTER 2 | **EDIT TO WIN:** For my portfolio on vanishing ethnic minority groups, (page 30) I know I must include a strong sense of place and emotion. However, #5 and #7 are similar compositions of crying women. One needs to go. Of the two, the emotion and supporting compositional elements of #7 make it a more engaging image. While #5 is interesting, there is just a bit too much fill flash. The portfolio is more dynamic without it. Always cut any picture that can be picked apart for technical weaknesses.

CHAPTER 8 | **PHOTOJOURNALISM:** Brian Plonka's winning Pictures of the Year portfolio demonstrates a unique style and powerful content. It covers the bases with strong news, sports, and features. (Page 92 shows a selection of his winning work and does not include full picture stories, which are an essential element in any photojournalism portfolio.) Notice that three images include an American flag. To eliminate redundancy, one should be cut and the other two should be spread apart in sequence so the viewer focuses on content and not flags. While #3 might work well in a fine art or stock portfolio, it's missing the human element and story-telling ability. That's the one to eliminate.

CHAPTER 9 | **COMMERCIAL FREELANCE:** Fashion and entertainment photographer Yaro is known for lush color and sexy compositions. Notice that two of the photos on page 107, #3 and #4, are taken in front of the same building. Both are sensational but the styles are radically different. The one that clearly fits best with Yaro's other images is #3. The only black and white image, #4, breaks the style of the portfolio, despite its wonderful mood. For most photographers entering the freelance world, a cohesive and unique style will be remembered. If you wish to experiment with a new look or direction, separate that work in an entirely new portfolio or include a group of similarly conceived images in a complementary grouping within the overall portfolio.

CHAPTER 10 | **WEDDING:** Notice how the compositions of Stewart and Susan Powers mix tight and wide shots with joyous emotion. (page 121). Each picture from this couple's wedding shows them at their most attractive; the compositions are varied, too. Although any family would likely order #3 for their personal album, this photo of bride and father is a bit stiff and not needed in a competition album or portfolio. When putting together a wedding portfolio, show your "greatest hits" portfolio as well as a sample album. However, before landing the client, show only a very tightly edited album. Once you have the job, show a larger version with family groupings and other income-generating options.

CHAPTER 11 | **NATURE AND WILDLIFE:** Sean Fitzgerald's wildlife portfolio shows variety and thoughtful composition. (page 132) His pictures go beyond merely chronicling a particular species; he captures mood and emotion, too. However, #8 is out of place, even with its whimsical quality. Notice how the horizon cuts right through the penguins. Trying a wide-angle lens with wildlife can be a fine idea but isolate your subject within the frame for maximum impact. For this photo, the photographer could move just a few inches higher so sand frames the two penguins; they would no longer compete with the rocks in the background.

CHAPTER 12 | **FINE ART:** All but one of Anna Tomczak's photographs on page 143 complement each other. In all six, notice her careful use of a unified color scheme; red tones link each picture to the group. However, #1, as a portrait, is the only literally captured photograph. Although it is well-done, and would be a successful stock image, it breaks the abstract mood so beautifully captured in the rest of Tomczak's series of still-lifes.

< <

appendix **two**

PERSONALIZED PORTFOLIO REVIEWS

> > Find a way to get as much hands-on port-
folio feedback as possible. It will make a
tremendous difference in your ability to
find satisfaction and future growth.

Many conferences and seminars offer
one-on-one portfolio reviews. Typically,
you will see signup sheets for individual
slots. There is usually a mad rush to sign
up; be sure to arrive early to make an
appointment with the right reviewer for
you. Some reviews are included as part of
conference fees. Others ask for an addi-
tional fee.

**The author and several of the profiled
photographers are available for limited
personal portfolio reviews. To learn more,
visit www.photoportfoliosuccess.com or
select the Books link at the author's Web
site (www.johnkaplan.com).** < <

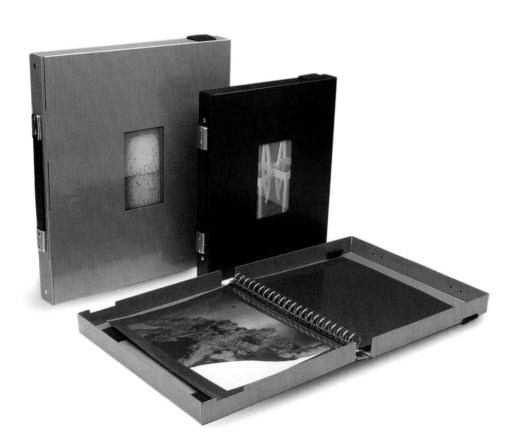

appendix **three**

[WORKSHOPS]

This is not meant to be an exhaustive list, but instead a gathering of many of the most-respected workshops and seminars to further develop your craft, as well as your portfolio. There are other fine choices. When considering taking a workshop from individual photographers, don't be afraid to ask for references.

GENERAL WORKSHOPS AND SEMINARS
These well-known workshops feature an annual schedule with a variety of topics. For additional offerings, see www.shawguides.com.

American Photo/Popular Photography Mentor Series
www.mentorseries.com
212-767-6689

Anderson Ranch Arts Center Workshops
www.andersonranch.org
970-923-3181

Ansel Adams Gallery Workshops
www.anseladams.com
888-361-7622

Maine Photographic Workshops
www.theworkshops.com
877-577-7700

Nikon School
www.nikonschool.com
631-547-8666

Palm Beach Photographic Centre Workshops
www.workshop.org
561-276-9797

Santa Fe Workshops
www.santafeworkshops.com
505-983-1400

PHOTOJOURNALISM
Also see General workshops and seminars listings

Eddie Adams Workshop
www.eddieadams.com
845-482-4112

Missouri Photo Workshop
www.mophotoworkshop.org
573-882-4882

Mountain Workshops
www.mountainworkshops.org
270-745-4143

National Press Photographers Association (various)
www.nppa.org
800-289-6772

"Perpignan" International Photojournalism Festival
www.visapourlimage.com
mail@2e-bureau.com

Sports Photography Workshop
www.richclarkson.com
303-295-7770

Sports Shooter Workshop
www.sportshooter.com
661-287-9358

Truth with a Camera Workshop
vme@macs.net
757-483-2557

COMMERCIAL
Also see General workshops and seminars listings

Advertising Photographers of America (various)
www.apanational.org
800-272-6264

American Society of Media Photographers (various)
www.asmp.org
215-451-2767

Brooks Institute Weekend Workshops (various)
workshops.brooks.edu
888-304-3456

Editorial Photographers (various)
www.editorialphoto.com
outreachep@editorialphoto.com

Steve McCurry Workshops
www.midgewink.com
651-994-7362

PDN PhotoPlus Expo
www.photoplusexpo.com
866-693-1007

Professional Photographers of America (various)
www.ppa.com
800-786-6277

WEDDING
Also see General workshops and seminars listings

Professional Photographers of America (various)
www.ppa.com
800-786-6277

Wedding and Portrait Photographers International (various)
www.wppi-online.com
310-451-0090

NATURE AND WILDLIFE
Also see General workshops and seminars listings

Frans Lanting
www.lanting.com
831-429-1331

George Lepp
www.leppphoto.com
805-528-7385

Nature Photographers Network (various)
www.naturephotographers.net
631-289-2369

North American Nature Photographers Association (various)
www.nanpa.org
303-422-8527

Freeman Patterson
www.freemanpatterson.com
506-763-2189

Photography at the Summit
www.richclarkson.com
303-295-7770

Rocky Mountain Photo Adventures (various)
www.rockymountainphoto adventures.com
303-747-2074

John Shaw
www.johnshawphoto.com
206-463-5383

Joseph Van Os Photo Safaris (various)
www.photosafaris.com
206-463-5383

Art Wolfe
www.artwolfe.com
206-332-0993

FINE ART
Also see General workshops and seminars listings

College Art Association (various)
www.collegeart.org
212-691-1051

Photo Imaging Educators Association (various)
www.pieapma.org
702-651-5941

Society for Photographic Education (various)
www.spenational.org
513-529-8328

Woodstock Photography Workshops
www.cpw.org
845-679-9957

appendix **four**

[PORTFOLIO SOURCES]

Listed below are top sources for portfolio cases, wedding albums, and related supplies. Effective packaging is vital but having memorable pictures is most important of all. If you can't afford a fancy case, have your portfolio spiralbound at a local print shop.

> >

PORTFOLIOS AND MATERIALS MANUFACTURERS

Advertiser's Display Binder Company
www.adbportfolios.com
201-795-3515

ArtZ
www.artzproducts.com
800-789-6503

Brewer-Cantelmo
www.brewer-cantelmo.com
212-244-4600

House of Portfolios
www.houseofportfolios.com
212-206-7323

Light Impressions
www.lightimpressionsdirect.com
800-411-7038

Lost Luggage
www.lost-luggage.com
888-567-8456

Pina Zangaro
www.pinazangaro.com
800-926-7462

Print File
www.printfile.com
407-886-3100

Stone Editions
www.stoneeditions.com
888-640-0033

Vue-All
www.saundersphoto.com
716-328-7800

WEDDING ALBUM MANUFACTURERS

Art Leather
www.artleather.com
888-252-5286

ArtZ
www.artzproducts.com
800-789-6503

Capri
www.caprialbum.com
800-666-6653

Digicraft
www.digicraftonline.com
877-280-4551

Jorgensen Albums
www.jorgensen.com.au
011-61-8-9249-5644

Leather Craftsmen
www.leathercraftsmen.com
800-275-2463

Renaissance
www.renaissancealbums.com
914-939-6878

White Glove
www.wgbooks.com
714-841-6900

Zookbinders
www.zookbinders.com
800-810-5745 < <

4

[INDEX]